SEEING STRAIGHT

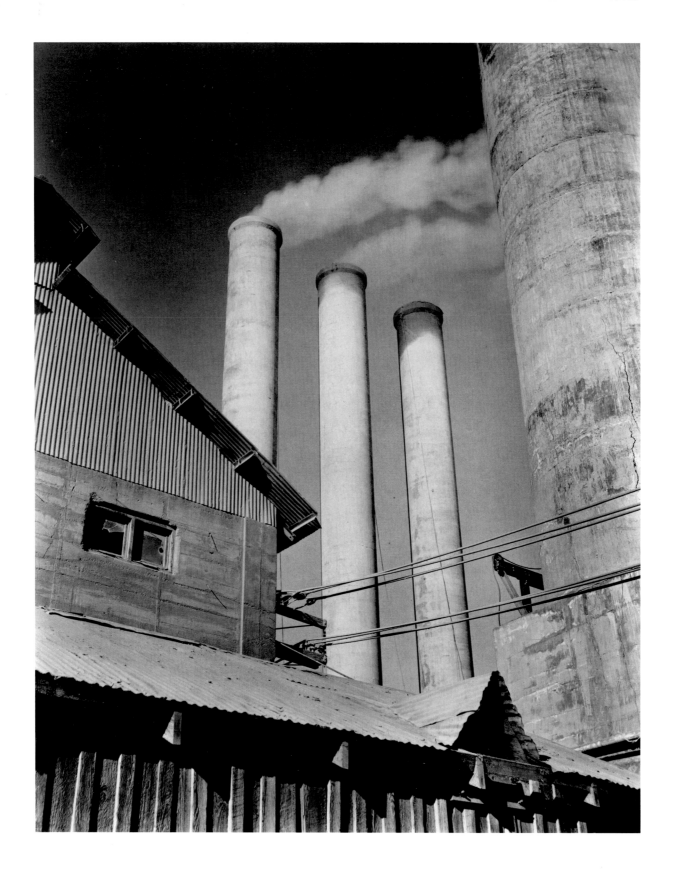

SEEING STRAIGHT

The f.64 Revolution in Photography

Edited by
THERESE THAU HEYMAN

Foreword by
BEAUMONT NEWHALL

Essays by
MARY STREET ALINDER
THERESE THAU HEYMAN
NAOMI ROSENBLUM

THE OAKLAND MUSEUM, OAKLAND, CALIFORNIA

This book is published on the occasion of a major traveling exhibition, *Seeing Straight: The f.64 Revolution in Photography*, organized by The Oakland Museum with the generous support of The National Endowment for the Arts, a federal agency.

THE OAKLAND MUSEUM
Oakland, California
October 24, 1992–January 10, 1993

THE AKRON ART MUSEUM
Akron, Ohio
January 30–March 28, 1993

THE SANTA BARBARA MUSEUM OF ART
Santa Barbara, California
May 31–July 18, 1993

CENTER FOR CREATIVE PHOTOGRAPHY
Tucson, Arizona
September 19–November 14, 1993

MINNESOTA MUSEUM OF ART
St. Paul, Minnesota
December 12, 1993–February 27, 1994

WORCESTER ART MUSEUM
Worcester, Massachusetts
March 29–May 29, 1994

Library of Congress Catalog Card No. 92-60753
ISBN 0-295-97219-x

The Oakland Museum
Art Department
1000 Oak Street
Oakland, California 94607
510 / 238-3005

Design:
Gordon Chun Design
Berkeley, California

Copy Photographs:
M. Lee Fatherree, frontispiece, pp. ix, 2–5, 8, 11 (bottom), 14 (top), 16 (bottom), 17, 39, 78–85, 92, 96, 100–101, 103–104, 106–107, 116–117, 119, 122 (right), 124, 131, 133–134, 137, 139–141, 144.
Ben Blackwell, pp. 51, 69–72, 76, 97, 99, 118.
Jon P. Fishback, pp. 146–149.
Edward Dyba, pp. 136–137.
Schopplein Studio, p. 73.

NOTE: In some cases the lenders of vintage photographs for the exhibition of *Seeing Straight* differ from the sources for copy prints used in this catalog.

Frontispiece:
Willard Van Dyke
Cement Factory, c. 1933
Collection of Barbara M. Van Dyke

Contents

PREFACE

James and Mary Alinder
Alma Lavenson Associates, Courtesy of Susan Ehrens
The Brooklyn Museum
Center for Creative Photography
Alice Putnam Breuer Erskine
The Estate of Wallace Putnam
Jon P. Fishback
The J. Paul Getty Museum, Malibu, California
Paul Hertzmann and Susan Herzig
Imogen Cunningham Trust
International Center of Photography
Richard Lorenz
Mills College Art Gallery, Oakland
Museum of Fine Arts, Museum of New Mexico
The Oakland Museum
Rondal Partridge
Ron and Kathy Perisho
San Francisco Museum of Modern Art
Seattle Art Museum
Michael Shapiro Gallery
Peter Stackpole
Barbara M. Van Dyke
Michael Wilson Collection
Sandra and Steven Wolfe

The Oakland Museum, as "the Museum of California," has for many years collected and exhibited art of special significance to our state. In the past three decades, an important focus of the Art Department has been on photography; subjects ranging from daguerreotypes to collage instant prints have been studied, exhibited, and published.

Seeing Straight: The f.64 Revolution in Photography investigates the activities of a group of progressive photographers who, sixty years ago, met and exhibited their work at 683 Brockhurst Avenue in Oakland. Their work and theories constitute a major contribution to the history of photography.

I want to thank Therese Thau Heyman, senior curator of prints and photographs, for initiating this project and for serving as curator of the exhibition, editor, and project director of this publication and other activities pertaining to the exhibition. This is the most recent of many important exhibitions organized by Mrs. Heyman for The Oakland Museum; on behalf of the entire museum community I extend our deep gratitude for her distinguished work here.

Philip E. Linhares
Chief Curator of Art

ACKNOWLEDGMENTS

It is a pleasure to acknowledge the lively and rebellious group of photographers who met and exhibited their work in Oakland as Group f.64. Although their fame and influence is international, there have been relatively few exhibitions devoted to the seminal work of these artists. In 1969 the Oakland Art Gallery, antecedent of The Oakland Museum Art Department, presented a select collection of rarely seen works in *f.64 and before*, an exhibition for which Willard Van Dyke served as adviser and Katie and Gene Trefethen as patrons. Nine years later Jean Tucker, curator at the St. Louis campus of the University of Missouri, published a handsome illustrated catalogue to accompany the Group f.64 exhibition she organized and circulated to Oakland. More recently, the University of New Mexico and the San Francisco Museum of Modern Art have organized exhibitions of aspects of Group f.64, supported in large part by a gift from Henry Swift. The present show is the first that takes the Group's 1932 exhibition list, matches works to titles, and supplements these eighty works with portraits of the group from the 1930s.

To bring together *Seeing Straight: The f.64 Revolution in Photography* and to produce this book required the generous and enthusiastic support of many people and institutions. To the National Endowment for the Arts, a federal agency, our appreciation for its early and substantial support. I would like to thank the curators, scholars, collectors, gallery owners, and other representatives of museums and archives who contributed to the success of this project.

Among the people who gave us access to the artists' archives that added substantial information, we thank Barbara M. Van Dyke and Murray Van Dyke.

This exhibition of vintage works has benefited from the generous loans of photographs, principally from James and Mary Alinder, Gualala, California; Fraenkel Gallery, San Francisco; Paul Hertzmann and Susan Herzig, San Francisco; Scheinbaum and Russek Ltd., Santa Fe; Michael Shapiro Gallery, San Francisco; Vision Gallery, San Francisco; and Stephen Wirtz Gallery, San Francisco. Since private collectors and colleges are often asked to lend their treasures, we are grateful for significant loans from Alice Erskine, Art League; our Oakland neighbor

Mills College, a venue of an original f.64 show, courtesy of Katherine Crum; Merrily and Tony Page; Ron and Kathy Perisho; Michael Wilson Collection, Los Angeles; and Sandra and Steven Wolfe.

The staffs of many museums found creative solutions to our need for excellent vintage prints. We thank Virginia Adams and Pam Feld of the Ansel Adams Publishing Rights Trust, with assistance from Andrea G. Stillman; Kristina Amadeus for The Wallace Putnam and Consuelo Kanaga archives; Nancy Boas, independent curator; Susan Ehrens and the family of Alma Lavenson; Jon Fishback for the Preston Holder family collection; Andrea Hales, Kate Ware, Cory Gooch, and Joan Dooley of the J. Paul Getty Museum; and Elizabeth and Rondal Partridge of the Imogen Cunningham Trust directed by Richard Lorenz. For scholarly direction we thank Miles Barth, International Center of Photography; Mark Citret; Amy Conger, independent scholar; M. Lee Fatherree; Weston Naef, J. Paul Getty Museum; S. Benett Fong, Sandra Phillips, and Thom Sempere, San Francisco Museum of Modern Art; Ted Greenberg and Steven A. Nash, The Fine Arts Museums of San Francisco; Barbara Millstein, The Brooklyn Museum; Victor La Viola, Dianne Nilsen, Terence Pitts, and Amy Stark Rule of the Center for Creative Photography; Dianne Sachko-Macleod, University of California at Davis; David Travis, The Art Institute of Chicago; Stephanie Turnham and Steven Yates, Museum of New Mexico; and Zora Foy, Emily Wolf, Jenny Stern, Jennifer Burzynski, and Caroline Peters, who assisted with images and information.

David Featherstone, Lorna Price, and Fronia Simpson contributed valuable editorial assistance, from interpretive judgments to line editing.

At The Oakland Museum we are indebted to many staff members, notably Drew Johnson, who coordinated all aspects of the exhibition, checklist, and book illustrations; Kathy Borgogno, who oversaw production of the manuscript; and Arthur Monroe, Christine Droll, and Janice Capecci for registration. Thanks go also to Phil Mumma, Associate Director for Public Programs, and Mark Medeiros, Chief Financial Officer, for their enthusiastic support and capable work.

T. T. H.

FOREWORD

Group f.64, an informal society of young photographers dedicated to a functional aesthetic of the camera, was formed in the San Francisco Bay Area in 1932 in protest to the sentimental and imitative type of photography known as pictorialism, which was then being exhibited by camera clubs, admitted to the walls of leading museums, and widely published in periodicals. Naming the society after the lens setting that permits greatest depth of field, the seven founding members thus expressed their passion for extreme sharpness and precise rendition of detail. They advocated the use of large-format view cameras and repudiated soft focus, textured printing paper, hand-manipulated prints, and other contrived effects. In choosing subject matter, they turned away from the emotive and romantic, concentrating instead on the seemingly commonplace to reveal often unseen beauty.

Pictorialism, then popular, especially among amateurs on the West Coast, was a backwash of the turn-of-the-century style that had long been abandoned by Alfred Stieglitz, Edward Steichen, and other members of the Photo-Secession society. This type of photography was epitomized by the anecdotal, highly sentimental, erotic, hand-colored prints of William Mortensen. Contrary to the tenets of Group f.64, the pictorialists believed that no photograph unaltered by the photographer could be considered a work of art. Such photographers could show their work in many different exhibitions. Labels documenting where the images had been shown were pasted on the backs of photographs, and sometimes there were more labels than there was space for them.

The members of Group f.64 first exhibited their photographs together at the M. H. de Young Memorial Museum, San Francisco, in 1932, along with four invited guests who shared their beliefs. This exhibition, which took place from November 15 to December 31, 1932, consisted of eighty prints. Surprising to us today is the fact that the original price list shows that all prints, including many now-famous images, were priced at ten dollars, except for Weston's, which were fifteen dollars.

It was very unusual in that period for a major museum such as the de Young to show photographs, particularly photographs that were then radical in their point of view and opposed to the prevailing West Coast aesthetic.

Lloyd Rollins, who was the director of the de Young Museum at the time, had previously shown the work of several individual members of the group (Edward Weston and Willard Van Dyke). Yet this collective show exemplified a unified aesthetic never presented to the public before in a major museum exhibition—an aesthetic demonstrating the group's belief that creative photography could be defined only in straight prints.

The importance of Edward Weston to Group f.64 and its aesthetic should, perhaps, be stressed. Although Weston was very independent and not particularly interested in the group and its progress, he joined because he was friendly with Van Dyke and Ansel Adams. In many ways, Weston's working methods and photographs epitomized the group's philosophy: his use of an 8-by-10-inch view camera and natural light, as well as his direct presentation of subjects, which were contact-printed on glossy paper for maximum rendition of detail and mounted on white board. In addition, his development as a photographer mirrored the transformation other members of the group were experiencing in their own work. Weston had begun as a pictorial photographer; we do not know exactly what he photographed in that style, however, since he destroyed all his negatives from that period. He once told me that he did a good job of scraping his glass negatives clean. By the time Group f.64 was organized, Weston was already internationally known, but with the widespread acceptance of pictorialism, he refused to send his sharp, direct photographs to exhibitions, having already made images that embodied the aesthetic of Group f.64.

Although the popular conception at the time was that members of Group f.64 adhered rigidly to narrow technical constraints and that "straight photography" did not permit alteration of the image, Weston himself was not so dogmatic. During that era, young photographers like myself had the impression that none of the group members ever dodged a print; but Weston, whose work I admired, made it clear to me that this was, for him, too rigid an understanding of "straight photography."

By the time my wife, Nancy, and I first visited Edward Weston in Carmel in 1940, Group f.64 had dissolved, but I had been greatly influenced by what I had read about

"straight photography" and believed in their aesthetic. After we arrived, Weston suggested that we go out photographing together the next day. He was wonderful about sharing his vision. If he had any serious-minded people with him, he would invite them to look on the ground glass after he made an exposure; this was a lesson showing that what you saw in his camera, placed on a tripod, was not what you had experienced from the same vantage point. Although I remember being ashamed to be using my small camera (a 3¼-by-4¼ Avus), compared to his huge 8-by-10, he did not belittle me; and later he invited me to develop my negatives and make prints in his darkroom. However, when I emerged with prints still wet in the tray (including my *Shell and Rock, Point Lobos, California*, 1940), Weston suddenly asked me, "Why haven't you dodged these prints?" Astonished, I replied, "Dodge, Mr. Weston, I thought you never dodged!" And then he showed me how to do it. From this experience I became aware that "straight photography" could be more a general approach than a rigid set of rules.

Although the Group f.64 manifesto contained what could be interpreted as a disclaimer to dogmatism, stating that "there are a great number of serious workers in photography whose style and technique does not relate to the *métier* of the Group," their debates in the press and their other statements gave the impression that the parameters of their aesthetic were narrow in relation to the possibilities for creative photography. The Farm Security Administration photographers of the 1930s, for example, made thousands of images that might never have existed had they followed the principles of Group f.64. Consequently, the importance of Group f.64 to the history of photography should not be magnified. Nonetheless, our appreciation of "straight photography," which has continued strongly to the present time, is clearly due to the example of Group f.64.

Beaumont Newhall

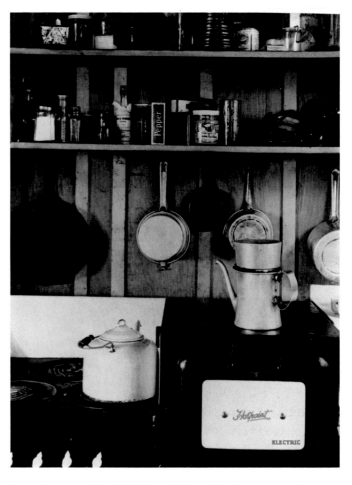

Fig. 1. Beaumont Newhall, *Edward Weston's Kitchen*, 1940. Collection of The Oakland Museum.

America's leading historian of photography, BEAUMONT NEWHALL has been prominent in every aspect of the field for fifty years. Professor Newhall served as curator of photography at the Museum of Modern Art in New York from 1940 to 1945, and as curator and director of the International Museum of Photography at George Eastman House. He is the author of many books, including the standard, *The History of Photography from 1839 to the Present Day*, and *Masters of Photography*, which he wrote with his wife, Nancy. He currently resides in Santa Fe, New Mexico.

Self-Portrait: The Members of Group f.64

GROUP *f*.64

Edward Weston in His First Carmel Studio, 1932

BY IMOGEN CUNNINGHAM

Courtesy of the Imogen Cunningham Trust

2

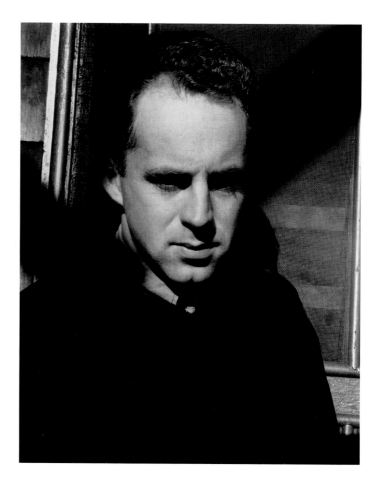

Portrait of Willard Van Dyke, c. 1932
BY MARY JEANETTE EDWARDS
Collection of The Oakland Museum

Willard Van Dyke, 1933
BY IMOGEN CUNNINGHAM
Collection of The Oakland Museum, gift of the artist

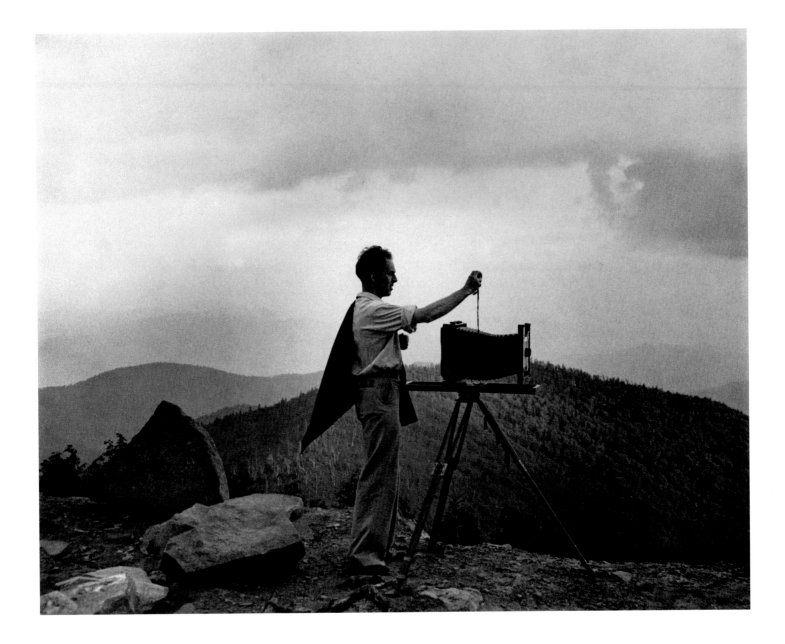

Willard Van Dyke with View Camera, 1930s
BY PETER STACKPOLE
Courtesy of Peter Stackpole

4

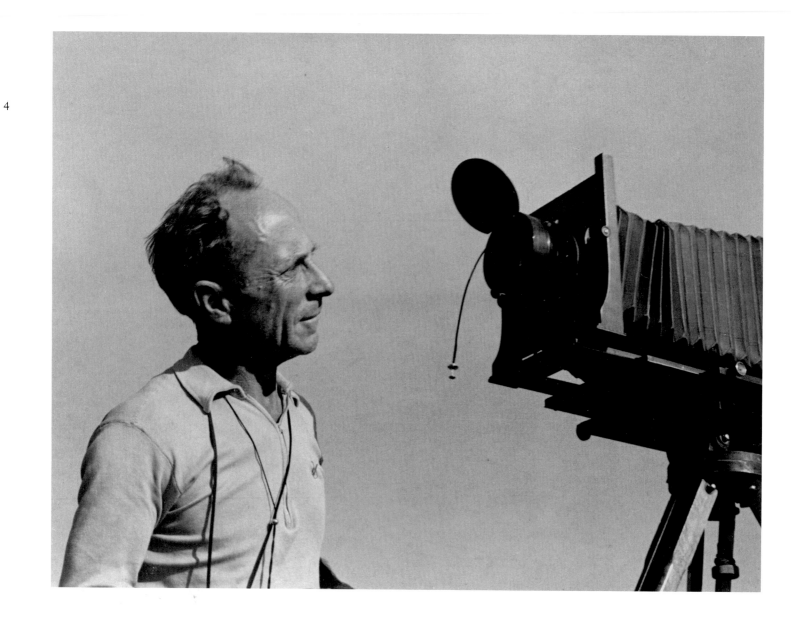

Edward Weston with Camera, 1930s
BY WILLARD VAN DYKE
Collection of Michael Wilson

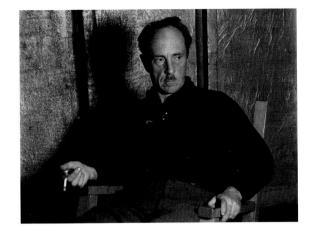

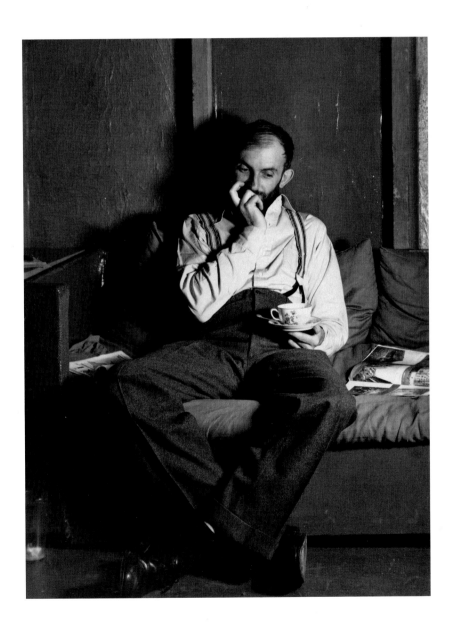

Edward Weston at 683 Brockhurst St., 1932
BY WILLARD VAN DYKE
Collection of The Oakland Museum

Ansel Adams at 683 Brockhurst St., c. 1932
BY WILLARD VAN DYKE
Collection of The Oakland Museum

6

Portrait of Imogen Cunningham, c. 1930
BY EDWARD WESTON
Courtesy of the Imogen Cunningham Trust

Portrait of Imogen Cunningham, 1934
BY HENRY SWIFT
Courtesy of the Imogen Cunningham Trust

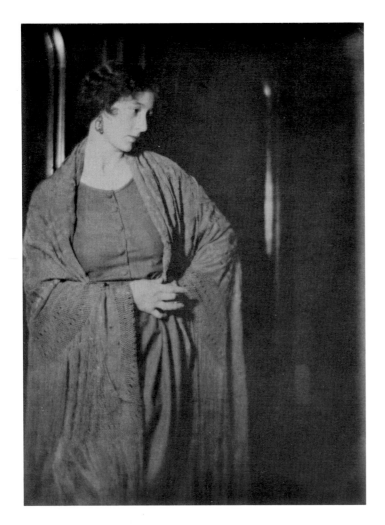

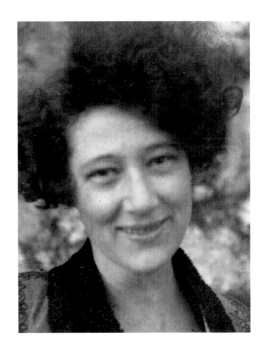

Consuelo Kanaga, n.d.
BY LOUISE DAHL-WOLFE
Courtesy The Estate of Wallace Putnam

Portrait of Consuelo Kanaga, n.d.
PHOTOGRAPHER UNKNOWN
Courtesy The Estate of Wallace Putnam

Alma Lavenson (with camera), 1942

BY IMOGEN CUNNINGHAM

Courtesy of Alma Lavenson Associates and Susan Ehrens

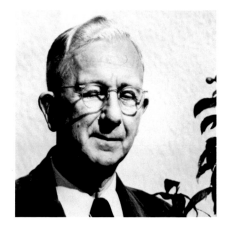

Self-Portrait, 1932
BY ALMA LAVENSON
Collection of The Oakland Museum, gift of Susan Ehrens
in honor of Alma Lavenson

John Paul Edwards, 1930s
PHOTOGRAPHER UNKNOWN
Courtesy of Norman Donant

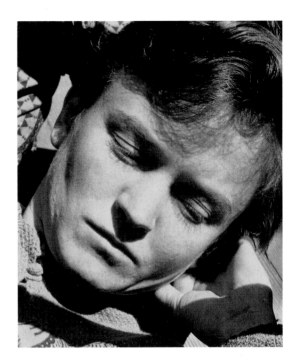

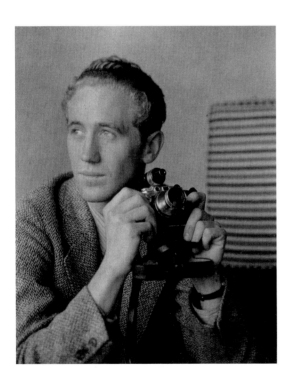

Portrait of Peter Stackpole, c. 1932
BY SONYA NOSKOWIAK
Courtesy of Peter Stackpole

Sonya Noskowiak, 1928
BY IMOGEN CUNNINGHAM
Collection of the J. Paul Getty Museum, Malibu, California

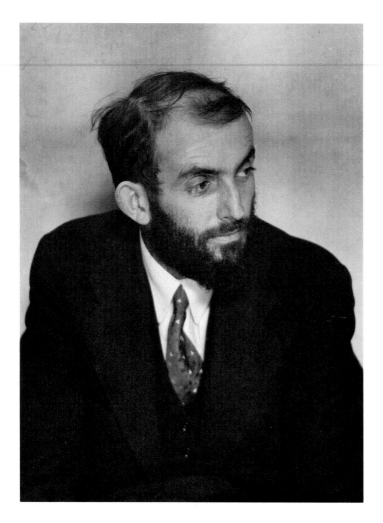

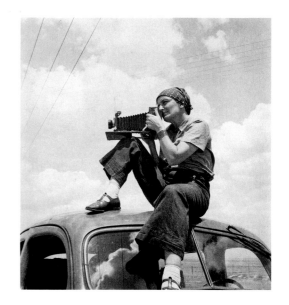

Ansel Adams, April 1935
BY DOROTHEA LANGE
Collection of The Oakland Museum, Dorothea Lange Collection,
gift of Paul Schuster Taylor

Dorothea Lange, 1934
BY PAUL S. TAYLOR
Collection of The Oakland Museum, Dorothea Lange Collection,
gift of Paul Schuster Taylor

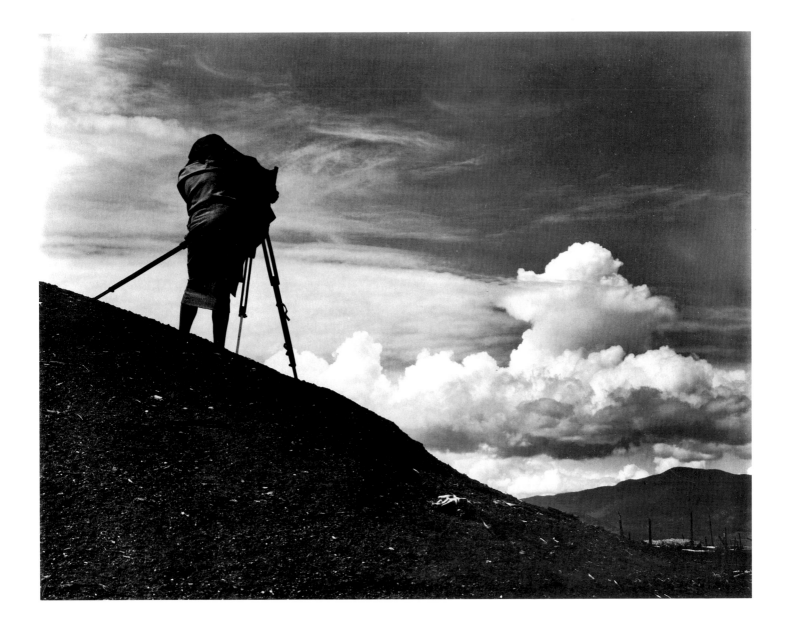

Sonya Noskowiak, Taos, 1933
BY WILLARD VAN DYKE
Collection of Barbara M. Van Dyke

Preston Holder, c. 1934
BY WILLARD VAN DYKE
Collection of Barbara M. Van Dyke

Portrait of Henry Swift, c. 1918
PHOTOGRAPHER UNKNOWN
Courtesy of Don Ross

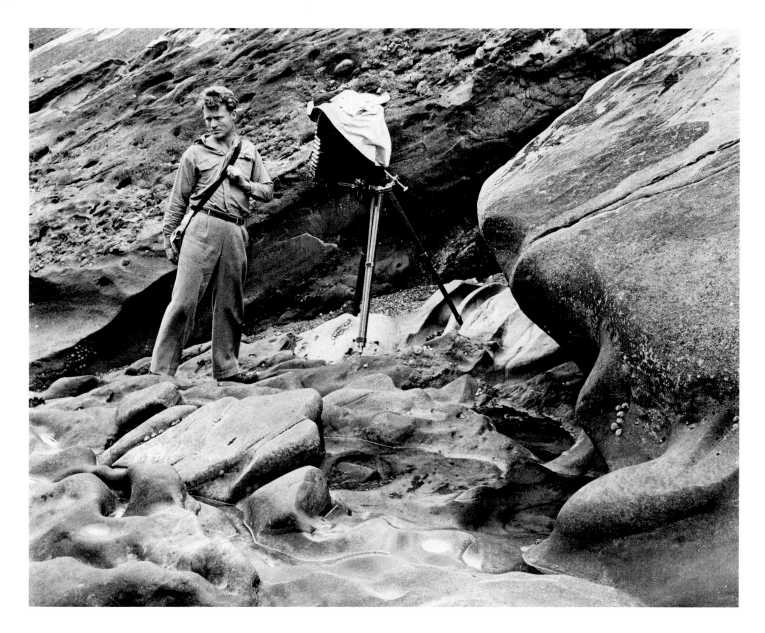

Brett Weston and Camera at Point Lobos, 1942

BY EDWARD WESTON

Collection of The Oakland Museum, gift of Tom Curran

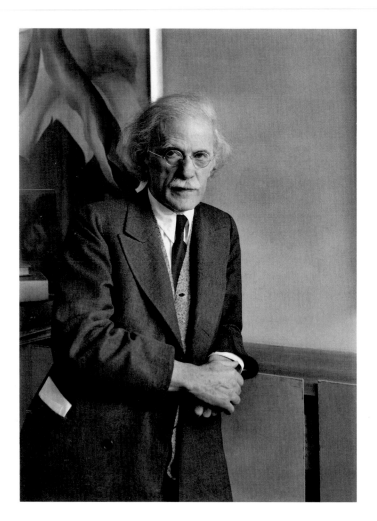

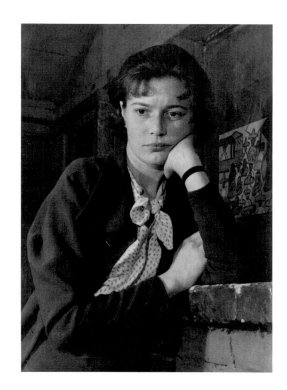

Alfred Stieglitz at An American Place, 1934
BY IMOGEN CUNNINGHAM
Courtesy of the Imogen Cunningham Trust

Mary Jeanette Edwards at 683 Brockhurst St., c. 1934
BY WILLARD VAN DYKE
Collection of Barbara M. Van Dyke

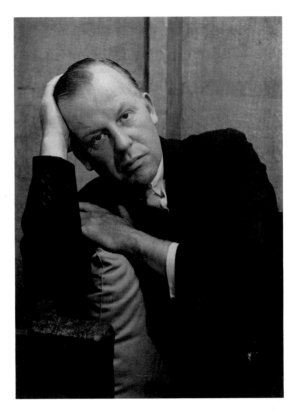

Portrait of Albert Bender, n.d.
PHOTOGRAPHER UNKNOWN
Collection of Mills College Art Gallery, Oakland, California

Lloyd La Page Rollins, c. 1934
BY WILLARD VAN DYKE
Collection of Barbara M. Van Dyke

Perspective on Seeing Straight

Therese Thau Heyman

The New Deal, Reporting, and Straight Photography

In late 1932, even before President Franklin D. Roosevelt took office, his advisers were framing programs, promised during his campaign and known as the New Deal, that were intended to lift the country out of the debilitating depression. An important step toward that goal was the creation of new agencies charged to assist displaced rural workers and their families.

For any aid program to gain public and congressional support, the need for assistance had to be clearly and memorably stated. Urban voters and elected officials needed to be educated about conditions in rural areas where they did not venture. Roosevelt turned for help to two Columbia University academics, Rexford Tugwell and Roy Stryker, who were engaged in assembling cultural histories and were just beginning to realize that the almost century-old medium of photography could vitally transform written government reports into dynamic evidence. Photographs were thought to provide a truthful record, an independent eye viewing an undeniable reality. Intensifying the impact of facts, they could provide the novel means to gain sympathetic, immediate, and responsive political attention.

The photographs that eventually accompanied reports of the Farm Security Administration (FSA) in the late 1930s were direct, clear, and in many respects like the work of the photographers who had formed Group f.64 in the San Francisco Bay Area in the year of Roosevelt's election. Although the FSA work was decidedly not "art," its elements of composition and selection were essential to effective reporting. This photographic work was accomplished at a time when it was assumed that the photographer found, but did not invent, the reality whose image he captured, an approach that soon came to be called "documentary photography." Most people believed that photographs could constitute accurate records of events and conditions, and they had sound reasons for their belief.

Photographic veracity had a long-established tradition in the United States. In the nineteenth century, photographers created a picture of the American West

Fig. 2. Consuelo Kanaga, *San Francisco Kitchen*, 1930. International Center of Photography Permanent Collection, gift of Mr. Wallace Putnam.

that confirmed the stories of mountainous scenes inspiring wonder and awe. Their views verified the astonishing news of the discovery of gold in Northern California and validated for distant families the safe arrival of hordes of adventurers who went West to make their fortunes.

By the turn of the century, the government-commissioned photographic surveys of federal land holdings were complete, published, and widely available. Photography had become a populist phenomenon, practiced by a select and growing amateur group that accepted these mammoth-plate exploration records and thousands of cabinet-card portraits as the plainspoken and truthful language of pictures. Photography preserved memory, created records, validated personal genealogies, and stopped time in ways

heretofore not accessible to ordinary people. When, in the late years of the nineteenth century, the invention of the hand-held camera gave photography to the populace at large, its place in the American social fabric was already ingrained.

Photographers began to expand the basic syntax of representation and validation in order to create an elegant form of romantic photographic language, one they hoped would be fully recognizable as fine art. Their painterly visions, embodied in soft-focus, manipulated prints and tonalist studies, evoked poetic moods and employed romantic scenes that suggested quasi-literary narrative (fig. 3). They hand-colored surfaces and used inky pigments on textured matte papers to achieve self-consciously artistic images conveying personal and interpretive content. Their images created a busy inter-change among camera club juries.[1] In the West, large numbers of pictorialist photographers continued to take prizes at Bay Area salons even as Roosevelt was preparing to take office. In the next few years, however, a revolu-tion in photography started to brew, and it was more widespread and potent than has been recognized.

Pictorialist thinking and theory was at its most articu-late in the mid-1920s. William Mortensen, a leading and vocal pictorialist, later explained, "The business of a work of art is to make an effect, not to report a fact." Creating effects was pictorialism's high calling, Mortensen went on: "Photography must learn to avail itself of selection to the same comprehensive degree that older arts do: by this it must stand or fall as art. Otherwise . . . the camera has no more artistic potentiality than a gas-meter."[2]

Such claims, seen as outrageous to some, fired a debate that soon became hostile and acrimonious, and Bay Area photographers who engaged in it did not simply return to recording facts. They countered old-style pictorialism with a revolutionary style—"seeing straight." The lines were drawn: one observer noted that Edward Weston had "dared more than the legion of brittle sophisticates and polished romanticists ever dreamed."[3]

Weston had turned away from pictorial practices (fig. 11, p. 39) eight or nine years before Group f.64 was formed, and he articulated his thoughts in a series of steps in his daybooks. He minced no words in this 1930 entry:

> I wrote an article, published this July with examples of my work in *Camera Craft*, a photo magazine which offers its readers just what they want. . . . I tempered my words, fearing the editor might not stand up under full blast. But seeing some unusually awful reproductions in the same issue by one Boris, with a laudatory article by the editor, I

Fig. 3. Anne Brigman, *The Pool*, c. 1910. Inscribed: "683 Brockhurst St." Collection of The Oakland Museum, gift of Mr. and Mrs. W. M. Nott.

spent an hour writing him my mind. These cheap abortions which need no description other than their titles, "Pray," "Greek Slave," "Orphans," "Unlucky Day," have nothing to do with Art, nor Life, nor Photography. So I not very gently explained. But why did I waste my time? I know the Editor's policy, his outlook from his writing and magazine in general: backing my work and opinions, his publication would fail!

I am in a mood to stir things up![4]

A reformed pictorialist, Weston often led the attack against shimmer and simper, crusading to attain the

"straight" image that Williard Van Dyke came to call "pure photography." Earlier, in 1927, Weston had promised:

> Sometime I want to give an exhibit printed on glossy paper. This shall be my gesture of disapproval for those who try to hide their weakness in "arty" presentation. [This long-held plan received fresh impetus after he viewed the International Salon of Photography at Exposition Park, in Los Angeles.] Unable to definitely use Form these pictorialists resort to artistic printing. . . .
>
> That exhibit, excepting two or three prints, if reprinted on glossy paper, stripped of all subterfuge, would no longer interest even those who now respond. . . .
>
> Those "pictorialists" were deadly serious, I grant,—so serious that the result was often comic. I took Brett, hoping to find material for discussion: there was nothing to discuss. . . . After noting the numbers of four photographs that had some value I referred to the catalogue, finding that each one was by a Japanese. Perhaps my exhibit in the Japanese colony has borne some fruit,—I could feel my influence.[5]

None of this occurred in isolation from the other arts during these years. Important exhibitions of Bauhaus abstract art at the Oakland Art Gallery included a Lyonel Feininger solo show (April–May 1930), a show of German posters (September 1930)—which apparently included photographic material—and a Blue Four exhibition (1931). Galka Scheyer,[6] who identified herself on gallery letterhead as the "foreign representative of the Oakland Art Gallery," actively promoted German expressionist painters in the Bay Area; and in 1930 Rudolph Schindler also spoke at the Art Gallery on the relationship of architecture to the Bauhaus show.

The nexus from which change proceeded in Bay Area photography may well have been the activities of Galka Scheyer. She visited Weston in Carmel on more than one occasion in the late 1920s, and in 1930 he noted that she was a "dynamo of energy"; her insight was "of unusual clarity"; she had "an ability to express herself in words, brilliantly. . . . She is an ideal 'go between' for the artist and his public."[7]

We cannot know whether the full awareness of a new aesthetic for photography can be attributed to Scheyer's activities and enthusiasm. In any event Weston saw himself in the forefront of a revolution. "Yesterday [March 7, 1930] I made photographic history: for I have every reason and belief that two negatives of kelp done in the morning will someday be sought as examples of my finest expression and understanding."[8]

Weston's diary entries allowed him to date his artistic

growth, confident of his own originality, and he took on the pictorialists at every turn: "I have already made a showing, and hope that my next exhibit will be on glossy paper. What a storm it will arouse from the 'Salon Pictorialists.' . . . Now all reactions on every plane must come directly from the original seeing of the thing, no secondhand emotion from exquisite paper surfaces or color: only rhythm, form and perfect detail to consider."[9]

THE ORIGIN OF GROUP F.64

Group f.64 was initiated by Willard Van Dyke and his friend Preston Holder, of whom he wrote:

> [He] saw things much the way I did. I had gone back to the University after five years [in 1931] to take a few courses that interested me. A student in one of the courses happened to see a few of my photographs in a local bookstore . . . and introduced himself. We became close friends, drank wine and read Hart Crane and Robinson Jeffers together. Of course we both had blue-papered covers of James Joyce's *Ulysses* and carried them everywhere as a protest against the Philistines.[10]

Holder soon acquired a camera and the two men took trips: "After one afternoon of art and wine . . . Preston suggested that we ought to form a group of like-minded Western photographers and begin to exhibit our work together. I was excited about the idea; it appeared to me that this would provide an opportunity to make a strong group statement about our work. . . . I, for one, felt that it was time for the Eastern establishment to acknowledge our existence."[11]

Van Dyke knew that Alfred Stieglitz had been patronizing to Weston when Weston went to New York in 1922. He also believed that Weston's photographs were superior to Paul Strand's, that Imogen Cunningham's plant forms and nudes were very fine, and that Ansel Adams was beginning to understand the Sierra. Not long after the talk with Holder, when Weston was in town and a party was arranged for him at 683 Brockhurst, Van Dyke brought up the question of forming a group. In addition to Weston, Van Dyke, and Holder, the party guests included Ansel Adams, Sonya Noskowiak, Imogen Cunningham, Mary Jeannette and John Paul Edwards, and Henry Swift.

"Here [at 683 Brockhurst] we named the f.64," Van Dyke remembered. "Photography opened a whole new world to me. I was so excited that there were other photographers around this area who saw things much the

same way." Several names were tried in the liquid party atmosphere of that first discussion:

> We got together one night . . . and I presented the idea of our working together. I said besides that I've got a wonderful name for it, U.S. 256 [after the old rapid rectilinear lens that Weston used to get the maximum depth of field and to make his negatives appear sharper]. Well there was this kind of blank look around the room and then Ansel who was the scholar of the group, said, "Oh, you mean in the uniform system 256 equals f 64. But don't you think f 64 would be a better name. Nobody is going to be using the uniform system much longer and besides that beautiful f followed by a 6 and 4," and he drew it out, like that and you could suddenly see the cover of the catalogue or the announcement and the graphics were there and Ansel won.[12]

James Alinder's lively interview with Preston Holder in 1975 includes that photographer's memory of the naming of the group. He describes a drunken ferryboat ride with Van Dyke from San Francisco back to Oakland, during which they talked about how the f would produce nice, Bauhaus-inspired graphics. Holder said the group should be called "f/64, because that's what you want to stop down to anyway and that's a good rationale for it, a catchy name and a good symbol."[13]

THE GROUP F.64 EXHIBITION STATEMENT

Despite the many diverse activities of the leading members of Group f.64, they crafted a strong unifying statement, as did other avant-garde art movements. Their six-paragraph proclamation is notice of a revolution. It appeared at the group's first exhibition at the M. H. de Young Memorial Museum and was issued in the name of the group to make its ideas directly available to museum visitors and, more pointedly, to photographers—especially to pictorialists, whose style was then still publicly accepted—and to their critics. It was purposely framed in plain language, with few technical terms (see p. 53). It was a rallying cry to the "great number of serious workers in photography whose style and technic does not relate to the *métier* of the Group. . . . The members of Group f.64 believe that Photography, as an art-form, must develop along lines defined by the actualities and limitations of the photographic medium, and must always remain independent of ideological conventions of art and aesthetics that are reminiscent of a period and culture antedating the growth of the medium itself."

It is likely that the statement was written and produced by Van Dyke, with help on the wording from Holder. A clue to authorship is the Americanization of "technic," since Van Dyke uses this form in letters to Weston.[14] Van Dyke's deft use of language, particularly in his early writing,[15] shows a clear, precise style that avoided the doctrinaire and yet was audacious.[16]

Weston's few references to the group occur in a short daybook chapter, entitled by Nancy Newhall "F64"; many readers have been led to these two pages. There Weston noted, "Some have expressed astonishment that I should join a group, having gone my own way for years." This short entry has led many later authors to assume that, at this time, Weston was preoccupied with personal achievements and less with the goals of Group f.64. In his introduction to his solo show in New York in 1932, Weston cautioned, "Too often theories crystallize into academic dullness—bind one in a straitjacket of logic,—of common sense, very common sense."[17] With that, he explained that in an uprooted society the camera can be a means of self-development. If there was one idea that held the group together, it was this belief in the power of photography as a means of personal expression.

As to how well individual members accomplished this goal, opinion varied. Years later, Adams remembered: "In the wild heat of formation . . . mutual excitement, wonderful things happen. And then the thermostat goes on. The f 64 group made a great contribution, [an] affirmation of certain basic facts in photography that would not have been needed if the general level of photography had been high enough."[18]

Adams saw Group f.64 as "an organization of serious photographers without formal ritual of procedure, incorporation, or any of the limiting restrictions of artistic secret societies, Salons, clubs or cliques." The group would accept "any photographer who in the mutual favorable opinion of all of us, evidences a serious attitude, a good straight photographic technique, and an approach that is basically contemporary," admitting that "friendly but frank disagreements exist among us."[19] He named seven photographers who had been considered for membership, adding Consuelo Kanaga and Dorothea Lange and in his gallery show dropping Sonya Noskowiak.

THE GROUP F.64 EXHIBITION

The group of photographic friends came together as a loose organization some time after a solo exhibition of Edward Weston's work opened at the M. H. de Young

Memorial Museum in San Francisco's Golden Gate Park in December 1931. The seven original members were Ansel Adams, Imogen Cunningham, John Paul Edwards, Sonya Noskowiak, Henry Swift, Willard Van Dyke, and Edward Weston. They arranged to exhibit their work collectively at the de Young, inviting four other like-minded artists to participate: Preston Holder, Consuelo Kanaga, Alma Lavenson, and Brett Weston.

The exhibition, which opened on November 15, 1932, and was on view for six weeks, was composed of eighty photographs. Each of the seven group members showed nine prints (Adams had ten); their guests, four apiece. The museum's checklist was arranged by artist, suggesting a similar arrangement within the gallery spaces. Seen together, the images established a varied but singular point of view. For the most part, objects were seen closely, framed by the sky or similarly neutral backgrounds. Nothing was moving, and there was great attention to the finely detailed surface textures of the subjects. There was little in the photographs to suggest either the modern industrial world or the troubles of the times.

Most accounts of Group f.64 agree in repetitive fashion that it was primarily social and short-lived; that its exhibitions were limited to a single venue; that after that first venue the group disbanded and the works were not seen together again; and that the audience was thus limited to those who saw the show at the de Young between November 15 and December 31, 1932.

Yet in interviews with these now-famous photographers, in their notes and letters, and in newspaper reviews beginning with the exhibition, there are indications that these assumptions are hasty. Hurried notes, a few initials in exhibition lists, and recently discovered letters refer not to one but to a series of shows. Los Angeles, Portland, Carmel, Seattle, and still other sites are mentioned as venues at which the photographs were seen before they were finally returned to the lenders in late 1935. Even with the newly discovered letters from Weston to Van Dyke and Adams's notes, it is still not possible to know precisely how the first show was augmented when it traveled. Reviews suggest a larger show of one hundred works in Portland.

The *San Francisco Chronicle* reviewed the Group f.64 exhibition at the de Young Museum on November 27, 1932. Neglecting to account for either the significance of this initial exhibition or the content of the group's statement, the reviewer nonetheless praised the "beautiful work on view. . . . These photographers, like other talented brethren of the lens, are admirable portrait artists,

imaginative creators of abstract patterns, who look for charm in boats, in scenery, in every small growing thing that is nourished at the bosom of Mother Earth."[20]

An annual report of the Seattle Museum of Art listed a Group f.64 exhibition from October 4 to November 6, 1933.[21] This exhibition then apparently went to the Portland Museum of Art; two printed discussions reviewed f.64 work as well as that of a complement of local Oregon photographers exhibiting at the same time. In November 1933, a reviewer in the *Spectator* noted that "from the viewpoint of the artist, the display of prints in the downstairs galleries at the Museum of Art is one of the most interesting exhibitions of photographic art ever shown at the museum. . . . The work of Edward Weston particularly shows fine technical composition and artistic viewpoint. . . . The entire group seems to feature the objective representation of carefully selected form."[22]

In addition to these northern venues, portions of the Group f.64 exhibition appeared at the 683 Brockhurst Gallery and at Mills College in Oakland,[23] at Ansel Adams's Geary Street gallery in San Francisco, and at the Denny-Watrous Gallery in Carmel, as well as in Los Angeles. There is mention of a possible New York venue. Weston, as the experienced member who had shown work in New York, wrote to Van Dyke on January 27, 1933, questioning the wisdom of going to New York with an exhibition "that may be a bad move or gesture for me to make this year. . . . don't you think that the group is a bit hasty in wanting to show this year?"[24]

F.64 PHOTOGRAPHY: A NEW DIRECTION

A confirmed pictorialist, the reviewer Sigismund Blumann, writing in *Camera Craft* in May 1933, provided the first considered review of Group f.64's premier exhibition of the previous fall.

> The name of the organization was intriguing. The show was recommended to us as something new, not as individual work might go but as a concerted effort specifically aimed at exploiting the trend. We went with a determined and preconceived intention of being amused and, if need be, adversely critical. We came away with several ideals badly bent and not a few opinions wholly destroyed. . . . The Group is creating a place for photographic freedom.
> . . . [Y]ou will enjoy these prints. You will be impressed, astounded.[25]

Blumann went on to reveal that his own preference was for the familiar and the romantic view, but here he clearly

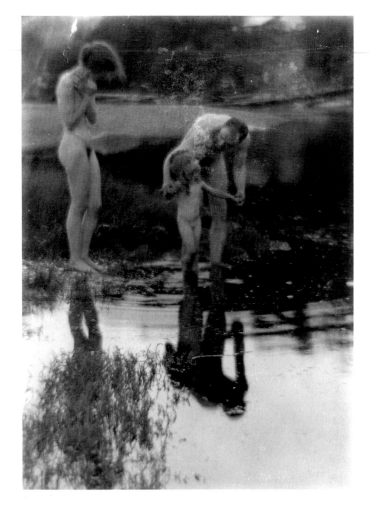

Fig. 4. Imogen Cunningham, *Family on the Beach 2*, c. 1910. Courtesy of the Imogen Cunningham Trust.

recognized a new force abroad in photography.

Blumann's encouraging words were countered, however, by other voices. Albert Jourdan, a little-known and quite bitter photographer from Portland, Oregon, condemned the straight photography movement as unoriginal. In his aptly titled essay "*Sidelight #16, The Impurities of Purism,*" he leveled his most dismissive criticism of Group f.64.[26] Jourdan recounted his initiation into pure photography in 1931, describing the transfer of the "Latter Day Purist" movement from Germany, which brought "the carcass across the Atlantic and the continent, gave it a few shots . . . and, very recently, proclaimed it a 'definite renaissance,'"—all this because German photographers were on view in Oakland in 1930. In Jourdan's view, "Moholy-Nagy is one originator of Pure photography, along with other Bauhaus members," all of whom, Jourdan noted, worked before Weston.

While it is not surprising that the transmission of

European and Eastern ideas to the West Coast would take time, and in painting this was often the case, European photographers recognized that several Americans had taken the lead sometime between 1913 and 1920. The eight or nine years it took Weston to "convert" hardly seems reason for Jourdan to impugn his work or his goals.

The importance that the exhibition has assumed is hard to reconcile with the idea of only one venue, considering the storm of written protest that soon arose in the pictorialist and camera-club press; one viewing at the de Young would hardly have provoked the number of articles that were eventually published. Furthermore, the group's statement of purpose called for frequent shows. It is therefore more likely that its impact, and the resulting publications that justified or refuted the premises of the group, came about because the show, or versions of it, did in fact appear in other West Coast cities where photography was an important and current amateur interest.

Most histories have overlooked these subsequent versions of the initial Group f.64 exhibition. A few reasons for this apparent oversight may be found in contemporary events. Despite the group's marked activity during 1932 and 1933, the newspapers were generally preoccupied with the seriously depressed economy, which overshadowed all other news, and gave only the briefest attention to announcements about art. Publicity for Group f.64, therefore, may not have been what one would expect. To compound the problem, the newspaper the *Carmelite* had gone out of business, making it more difficult to give the Denny-Watrous exhibition adequate notice in Carmel, where Weston was based.

In addition to their involvement with Group f.64, members were actively pursuing their own careers. In 1933 Ansel Adams went to New York and had a momentous meeting with Alfred Stieglitz, the acknowledged leader of fine-art photography and owner of the influential gallery An American Place. On the West Coast, Willard Van Dyke and Mary Jeannette Edwards had taken on the demanding task of establishing their gallery at 683 Brockhurst, in Oakland, as a center and forum for West Coast photographers, in an attempt to bring national and specifically eastern attention to their work.

During the months before the de Young opening, Edward Weston was engaged in the production of his beautiful new book, *The Art of Edward Weston*, which was on press in late September 1932 and available for signing when the Group f.64 exhibition opened in San Francisco in mid-November. The magazine *California Arts and Architecture* carried a prominent picture endorsement for the book in its November 1932 issue—just the kind of

publicity the group would have wanted for its show.

Perhaps the most likely reason for the curious silence about the later six versions of the Group f.64 exhibition can be traced to the then-director of the de Young Museum, Lloyd La Page Rollins, and his championing of photography. Although he was personally the sponsor of Group f.64, the museum's board of directors did not support this direction. Rollins ran into trouble with his board as a result of the space that photography had come to occupy in the galleries. It seems that he had replaced many of the not-very-distinguished paintings the directors had donated to the museum with new photography exhibitions. The board asked him to resign in April 1933, just five months after the opening of the Group f.64 exhibition.

The f.64 show was still sent to its subsequent venues and listed in *Camera Craft* as an exhibition available for travel, but we may speculate that both promotional materials for the touring museums and dedication to the project were in short supply. In his daybooks, Weston had earlier explained that the show would go to the de Young "out of consideration for Rollins," who had requested that the group not open its own gallery to compete with his program. After Rollins's departure, however, the issue of competition was moot. Necessity now required a place in other galleries to promote "straight seeing." The first Bay Area private gallery to take up this challenge was 683 Brockhurst.

AESTHETICS OF GROUP F.64

If we analyze the de Young checklist of the Group f.64 show, we find images of still life, bits of landscape, posts, bones, and sky, a few industrial buildings, portraits, and nudes or figure studies (p. 67). The subjects were ordinary in the sense that they were encountered frequently, and yet most had a commanding presence when photographed. An emerging aesthetic proved broader than the group's manifesto, more generous in its means: filters, dodging, and arranging still lifes were all accepted in one case or another.[27] Isolated instances of technical manipulation evidently met the group's ideal of an "art-form" obtained by "simple and direct presentation through purely photographic methods."

Despite their distancing as a group from the pictorialist tradition, at least four of the members had produced fine pictorial work in the 1920s, and three continued to do so until 1931 (fig. 4). Their established friendships, however, clearly went back to the pictorial

days. Roger Sturtevant, whose early experimental work was chosen by Weston for an important exhibition and who was a close friend of many Bay Area photographers, remembered a congenial opening in the mid-1920s when Edward Weston was in San Francisco. It drew many photographers, who were then pictured in a series of hilarious pantomimes. Weston and Anne Brigman posed in costume as the father and mother of photography, with the "children"—Roger, Johan Hagemeyer, and Imogen Cunningham—framed about them in poses of adulatory prayer. Roi Partridge, Imogen's husband, was identified as photographer for this set of snapshots (fig. 5).[28]

As one would expect, the Group f.64 photographers photographed each other. Willard Van Dyke recollected the circumstances when he took these pictures in the 683 Gallery in 1932 (see Self-Portrait section).[29] On other occasions they posed for each other with their 8-by-10 cameras.

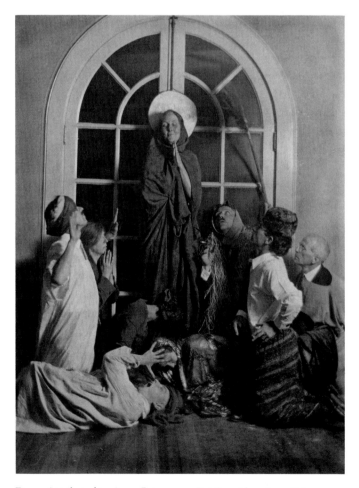

Fig. 5. Attributed to Anne Brigman or Roi Partridge, *Anne Brigman and Friends in Costume,* c. 1920. Collection of the J. Paul Getty Museum, Malibu, California.

Willard Van Dyke, a central figure in the foundation of Group f.64, continued to provide a focus for Bay Area photography. In 1928, two years after he left the University of California at Berkeley, Van Dyke helped make and show lantern slides for lectures by the much-honored but unconventional tonalist photographer Anne Brigman. Her studio at 683 Brockhurst Street was the center of creative activity and a meeting place for artists.

Brigman's ardent love of nature surfaced even in domestic decisions.

> When the barn at 683 Brockhurst was remodeled, as a studio, a problem arose in building the bathroom. The only logical place to put it had a lovely tree happily growing in that exact spot . . . of course there could be no question of removing the tree. All the carpenters had to do was build the walls around it, provide a hole in the roof for its trunk, and then hang the shower from one of the lower branches. A true daughter of Zeus, Annie never interfered with nature.[30]

With the specific intention of establishing a gallery for photography, Van Dyke and his friend Mary Jeannette Edwards, whom he wanted to marry, had taken over this studio by 1930, after Brigman went to live in Southern California to be near her sister, renting it for twelve dollars a month.

Van Dyke stated that while he and Mary Jeannette certainly did not consider themselves competitors of Stieglitz, they felt that by establishing a gallery for photographers, they could provide "an atmosphere on the West Coast that could be useful to Western artists. I think . . . our first exhibition, on July 28, 1933, was a retrospective of Edward's work. The prints were displayed in chronological order . . . from 1903 when he began . . . to his most recent photographs."[31]

Although the couple changed little of the charming character of 683, its board-and-batten walls did present an aesthetic problem for the exhibition of photographs. A photographer friend of Mary Jeannette's father, a talented designer, lived near Chinatown in San Francisco, where he had access to treasures for the resourceful. Van Dyke describes the process: "First he covered the whole surface with monk's cloth . . . that he pasted over the wood. Then he brought enough tea paper to cover the surfaces . . . with the gold or silver metallic material. Then he sponged water paint in colors of violet and blue over the tea paper and wiped it lightly before it dried. This left a colored, textured surface with flecks of glowing metal

shining through." With this renovated space, the gallery, as its stationery stated, was "devoted to contemporary expression in black and white."[32]

"Camera Club Notes," a column in *Camera Craft*, reported on the new gallery and its opening exhibit, describing "this charming little gallery . . . opened by two young people with a splendid enthusiasm for photography. For a long time we have felt that the Pacific Coast is a particularly fertile field . . . that here are many of the finest photographers."[33] Weston's new landscapes caught the attention of the reviewer, who then listed the gallery owners' future plans for shows by Adolph Dehn, a lithographer; twenty-five prints by Ansel Adams, "well-known for his sympathetic photographs of this city and for his splendid prints of the high Sierra"; and works by Willard Van Dyke and Imogen Cunningham. Van Dyke closed the season with a juried show of what he defiantly called the "First Salon of Pure Photography." He remembered that "Weston laughed at the word, 'pure,' but we all were astounded at the response."[34] Hundreds of works were submitted for consideration, which indicated that many photographers agreed with the group's ideals and encouraged straight photography. This response suggests that after the period of innovation and diffusion, f.64 had had an effect. Many photographers had accepted the premise of an unmanipulated kind of image making.

Edward Weston made it possible for Van Dyke to justify continuing in photography and opening the gallery. When Van Dyke talked to him about having been offered a job as district manager for an oil company, Weston replied, "To work at something just to have financial security could be compared to the life of a cow that spent its whole life filling its belly." Extrapolating from this thought, Van Dyke recalled, "He knew that I had talent but if I decided to go on and develop it, I had to realize it would require sacrifice and uncertainty." Weston referred to this as the decision to "turn down the bitch goddess Success."[35]

GROUP F.64 MEMBERS

The members and associates of Group f.64 were generally well-educated in the ways of commercial photography by the early 1930s. They were mainly self-taught, although two were experienced darkroom assistants to more mature photographers (Noskowiak for Edward Weston, Edwards for Lange). Their ages in 1932 ranged from forty-nine (Edwards) to twenty-one (Brett Weston), but most were in their thirties or early forties. They all tended to accept

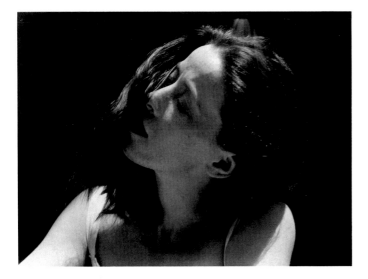

Fig. 6. Imogen Cunningham, *Martha Graham, 12*, 1931.
Courtesy of the Imogen Cunningham Trust.

the authority of Edward Weston's years of photographic experience.

Although Weston did not give lessons as such, when asked, he was often willing to give critical opinions on the work of others if they seemed genuinely ready for direct and straight seeing. Before Group f.64 came together, he had been considered the mentor and leader, role model and inspiration for his son, Brett, and for Henry Swift, who visited him in Carmel. Since Swift bought pictures as well and remained an amateur who entered only a few exhibitions, he has been considered largely in terms of his financial support for the group. But it is notable that those who knew Swift remember him as an outstanding student, athlete, and the kind of person who excelled at everything he undertook. Moreover, he seemed able to search out the best in whatever field he chose.[36]

The situation was quite different when Van Dyke went to study with Weston in November 1929. Weston noted that Van Dyke "knows enough to make me feel I have little to give him . . . [he] will go a long ways from present indications."[37] Van Dyke, already skilled in the technical side of photography, was eager for the experience of watching and working with Weston and, as their letters indicate, discussing the work of eastern photographers, new photography books, exhibition catalogues like the one of Paul Strand's work, and critical reviews, as they visited back and forth in Carmel and Oakland.

An easy drive from the Bay Area, Carmel was an ideal place for Edward Weston. A small town with a large population of writers, painters, and art students, Carmel

lies along a spectacular curve of the California coast. Visitors and locals found some essence critical to their aesthetic needs in the region's environment and topography, and many of them brilliantly described the setting. It was beneficial to bohemians, for Carmel was then, as it still is, a tolerant and uninquisitive community.[38] And it was also a frequent stopover for adventurous thinkers and vocal advocates of modern art such as Galka Scheyer and Walter Arensberg, both of whom spent time there.[39]

Imogen Cunningham described her first contact with the medium: "I was pretty much on my own in photography. I followed the International Correspondence School program book, using glass negatives and then worked at the University of Washington Botany Department."[40] Her first major exhibition consisted of ten pictures in the landmark *Film und Foto International* of 1929, in Stuttgart. Cunningham's photographs of Martha Graham (fig. 6), made in Santa Barbara in the summer of 1932, appeared that year in *Vanity Fair*, then the leading fashion magazine in America. That success led to more assignments in Hollywood with stars and celebrities, as well as a dreary exchange of letters in a continuous campaign to be paid fairly for her work.[41]

Ansel Adams also began photography early, at age fourteen, with a Brownie Box Kodak, but for many years he remained equally devoted and skilled, in a more schooled way, to music, perhaps uncertain whether to turn to the piano or the camera.

John Paul Edwards was the eldest and most experienced of the Group f.64 photographers. An avid amateur, he entered many pictorial salons, as labels on the backs of his works still attest. Adams noted in his description of the group's members:

> Let me say here . . . if all pictorialists who have real ability would admit change, expansion, and exploration as has John Paul Edwards, there would be many more good photographers in the world today. In many respects his progression and development may be the most substantial of all of us: he has not advanced in jumps and starts, he has not changed his point-of-view overnight. . . . He makes good photographs.[42]

How did its members recollect the emotional energy in Group f.64? Weston, whose photographs and beliefs led and transformed the group, saw its function as purely educational. Van Dyke recalls that members saw each other socially from time to time. However, tracking Weston's letters, Van Dyke's replies, the visits back and forth, notes from Mary Jeannette, and relationships between father and daughter (John Paul and Mary),

father and son (Edward and Brett), lovers (Edward and Sonya, Willard and Mary Jeannette), and protégés (Alma to Imogen, Willard to Edward, Henry to Edward), shows that this group had remarkably close ties. They were in constant communication; the telephone was not yet commonplace, and they wrote letters, which they saved. "We are all friends, free from politics; and I have no desire to be the founder of a cult," Weston recorded.[43] But he did at one point reconsider his involvement with Group f.64, having a sense that he was actually creating a "Weston's group." For a few days, Weston actually resigned in a letter he sent to Adams, but he immediately rescinded in another letter, all of which he recounted to Van Dyke in a third.[44]

Peter Stackpole is notable among the associates who were later asked to join Group f.64. Stackpole visited the de Young show and admired Weston's photographic prints, yet his own photographs were made with a small, hand-held camera. "Catching the world of people and events with a hand-held camera was still fascinating to me," Stackpole said, "But I felt I needed an important subject—a great big subject. . . . When I saw the towers of the Bay Bridge going up, the clouds of uncertainty finally cleared."[45] There has been much speculation about the "associates" of the group, as only Brett Weston, Alma Lavenson, Consuelo Kanaga, and Preston Holder were listed and included in the first show, while additional names were put forward more informally later. Some of these other photographers were not clearly identified in subsequent shows. William Simpson's pictures from the period are preserved in a family collection, and his position as artist for the *Oakland Tribune* in the 1930s suggests that he was active and proficient when Willard Van Dyke recommended him to the group. Stackpole's bridge series occupied him from 1934 through 1935, the final years of f.64, and therefore the set would have not been ready before the group disbanded.

Stackpole was determined to show that his photographs from a 35-millimeter negative could be as sharp as 8-by-10-inch contact prints. Today, thinking back on the influence of f.64, Stackpole notes that his contact with Willard Van Dyke was crucial.[46] Van Dyke and his gallery offered a sounding board, a way for the twenty-one-year-old Stackpole to meet with recognized photographers. From this spectacular bridge-building photographic series, Stackpole continued to grow as a creative picture maker, as one of the first four *Life* magazine staff photographers, and then as recorder of wartime and peacetime California.

Women in Group f.64

The study of Group f.64 invites speculation about why so many women were empowered through their association with a male friendship group that might have ideologically subjugated women as darkroom assistants and mere receptors for male creativity.

Very likely the question of how women were accepted in the group was colored by the changing circumstances of women after World War I, when the "New Woman" emerged out of the battle for the right to work and vote. As early as 1913, eager women writers explained admiringly that Anne Brigman and Laura Adams, a successful San Francisco portrait photographer, could be independent in photography, as this work was "suitable" for women, needing no large capital outlay, no long schooling or learning beyond the usual education of women. Women's "intuition" was cited as justifying their special talent for portraiture, particularly—it comes as no surprise—portraits of children.[47]

Imogen Cunningham, on her own after European study and schooling in chemistry, began an innovative and provocative series of male nude studies of her husband, Roi Partridge, who was pictured faunlike in settings of the Washington hills and mist-covered lakes. For financial support she also pursued studio portrait work photographing children and their families, while continuing to keep in touch with the magazines and shows that led the way toward modernism.[48] Cunningham's direct and no-nonsense personality led to her willful decision in 1934 to go to New York despite Roi's disapproval. The trip resulted in divorce. (Anne Brigman had taken a similar trip, with similar results, in 1910.) Cunningham continued executing portrait commissions to support her twins and slightly older son, all under the age of nine. Perhaps because she assumed these responsibilities, she was considered by her male colleagues as a professional, a fine-art photographer, an equal, and a friend. In 1928 Weston sent her a gloriously complimentary letter, telling her that her photographs were much the best in all of the San Francisco salon.[49] Possibly her sense of fun and sharp wit provided powerful weapons in any struggle for parity with the men in the group. Cunningham was always treated with respect.

Sonya Noskowiak's initial position in the group was as a dependent, more in the line of woman-helper and only later as a competitor, a peer. Her progression from being Johan Hagemeyer's receptionist in his Carmel studio, where she met Weston, to becoming Weston's general helper, darkroom assistant, and then his model,

mistress, and companion is well known. The daybooks chart the circumstances of their relationship as well as the egocentric appreciation that Weston accords her own photographs in January 1930, almost her very first: "A negative of Neil's hands, the back of a chair, and a halved red cabbage. Any one of these I would sign as my own. And I could not give higher praise. She is a surprise."[50]

Consuelo Kanaga was an unusual participant in the f.64 exhibition of 1932. Young, naïve, and working on her own for newspapers, she was dependent on her patron and sponsor, Albert Bender, who was also important to the careers of many members of Group f.64. She knew them but was shy about these connections, reluctant to become involved. In her letters to Bender, she repeats her reservations and doubts.[51] Her pictures, even at this time, were of social themes (fig. 2). She made black-and-white photographs illustrating blacks and whites holding hands. Her 1928 portrait *Frances* (pl. 76) was considered outside the ordinary, as the Bay Area black population was then small. Unlike Arnold Genthe, who sought the exotic and alien "other," Kanaga pictures Frances as a child, who happens to be black. The message of racial understanding could be pictured as innocent, its potential conflicts easily resolved. Kanaga's interest was in the way black-and-white photography could make social statements, and only in passing did she consider photography as a fine art.[52]

When Alma Lavenson went to Carmel in 1930 to meet Weston, he urged her to reconsider the soft-focus atmosphere of her prints.[53] She was self-taught, and like the others in Group f.64, she had learned the craft in a thorough manner. She renovated a childhood playhouse to serve as a darkroom and created photographs by first visualizing them in her mind. She accompanied her friends as they painted and etched scenes at the Oakland waterfront, and she photographed that active port. Its warehouse buildings and ships' riggings became a favorite f.64 subject.[54] From the outset, Lavenson's pictures were successful in competitions.[55] Although she did not know other photographers at first, she did subscribe to camera magazines, and she had good equipment; her family, through a successful mercantile business, was well able to afford it. With letters of introduction from Albert Bender, a family friend, she met Imogen Cunningham, Consuelo Kanaga, and, most significantly for her photography, Edward Weston.

Lavenson realized that the greatest influence on her activity as a photographer was Cunningham: "I met her in 1930, somehow or other we became close friends and we remained close friends until she died forty years later. I photographed with her and we travelled together. . . .

She never criticized my work, she never praised it."[56]

These remarkable women were acknowledged as peers by their Group f.64 male contemporaries. Only later did a silence come to surround their work— a silence created by exhibition curators, art dealers, and photographic historians in the 1950s. Although Lavenson and Cunningham continued to live and photograph in the Bay Area, they were not singled out for solo shows until their careers were validated by their remarkably long lives. As Cunningham noted, she and other women photographers in their fifties were invisible; only when she reached seventy did she become a celebrity.[57]

GROUP F.64: ART AND LIFE

The basis of the group's manifesto began with light: its chemical action on sensitized surfaces described the process of photography. Light was the only legitimate medium for photography, and much of the success of an artist-photographer lay in controlling it. In the West, light meant sunlight, filtered sunlight—in Weston's case, cheesecloth was stretched over the porch to form a roof outside Hagemeyer's studio. With this setup Weston obtained a very beautiful, high, strong light. Here he made the portraits that earned him his living. Charis Wilson, who later became Weston's wife, remembered that the light there pleased him, and he photographed such local notables as Robinson Jeffers and Lincoln Steffens.[58] The cheesecloth over the porch was equally good for still lifes. Every time Weston waited for a sitting to arrive, he turned to setups. Most of the images from 1930 to 1932 that Weston included in the Group f.64 show were made on this porch.[59]

Weston's controversial 1931 set-up image, *Rock and Shell Arrangement* (pl. 44), appeared to alter the scale of reality, for the shell filled the mouth of an enormous mountainscape. This work provoked furious letters, which Weston ignored; he insisted on including it in Merle Armitage's book, *The Art of Edward Weston*, as well as in the de Young's Group f.64 exhibition. The issue revolved around a definition of reality. In the 1930s, some critics of photography expected pictures to be "true to nature." In the storm of protest that followed this book's publication, Weston's friend Ramiel McGehee said, "It is a stunt and if the book was mine, I would neatly with a safety razor blade remove the print from the book. It's the first time I've known you to make nature talk a language not her own."[60] Weston denied the "stunt": "I don't have to please the public" (a brave

statement but hardly consistent with his pleasure in receiving good reviews). Weston explained the motive for publishing the picture: "It deeply moved an intelligent audience as I was moved when I first saw its presentation on my ground glass." This image is a still life set out-of-doors. In using the word "arrangement," Weston signaled the viewer that the picture was simply that: a placement by him. He noted, "I did not add that word as an apology, rather to forestall criticism from *naturalists* that thought I was 'nature-faking.' "[61]

As the decade continued, the problems of the depression became more widespread, affecting artists and photographers already accustomed to existing on meager commissions and few sales. On the West Coast, in San Francisco, and even in Carmel, critics questioned the premise of art. The criticism leveled at the members of Group f.64 was that their photography did not consider economic or social problems; it continued to center on things seen for their beauty. As Weston noted in February 1932, he knew that he was on uncertain ground, and that there were "right thinkers" who would have preferred art to function as a missionary to improve sanitary conditions; in 1933 he added, "I am 'old fashioned' enough to believe that beauty—whether in art or nature, exists as an end in itself. . . . If the Indian decorating a jar adds nothing to its utility, I cannot see why nature must be considered strictly utilitarian when she bedecks herself in gorgeous color, assumes magnificent forms."[62]

The matter may have seemed clear to Weston, but to Van Dyke and others, the argument that photography could describe social concerns was compelling. Van Dyke wrote a long and appreciatively perceptive article on Dorothea Lange, whose work he included in a show at 683. He accompanied Paul Taylor and other photographers in a significant visit to the self-help cooperative United Exchange Association (UXA) in Oroville, California. A trained agricultural economist, Taylor was an effective advocate for liberal economic views and the necessity for new jobs. Drawn to the photographers involved in 683, particularly Dorothea Lange, whose innate sympathy and direct vision in photography matched his own, he provided the clear example of what photography could accomplish if it were made to function politically, as it did when Lange's photographs led to the funding of a migrant workers' camp.

Despite their differences of opinion on photography as a political tool, Adams and the others kept in close contact with Lange and Taylor. Later Adams developed many of Lange's Farm Security Administration negatives for her in his Yosemite studio, disagreeing with the FSA policy of insisting that photographers send their film to Washington for processing.

However, Weston's and Adams's strongly held view of art for art's sake was often condemned, and already by 1932 it was suspect. Weston wrote in his daybook that his kind of photographing could be compared to the work of a "Bohemian dabbler . . . frittering away on daubs and baubles to decorate the homes of our great democracy, using art as an excuse to loaf, to be supported like poodles, and petted by sexually unemployed dowagers—art patrons!"[63]

Willard Van Dyke, socially aware and impressionable, had changed his outlook. He and Paul Taylor applied for a Guggenheim grant for a film on the UXA but were turned down. Ironically, in 1937 Weston received the first such fellowship awarded to a photographer—to photograph landscape.

THE LEGACY OF GROUP F.64

Many factors, including the departure of several members from the Bay Area and Carmel, caused Group f.64 to break apart.[64] Weston went to Santa Barbara to be with his son; Willard Van Dyke left for New York and a career making movies (beginning with *The River*). Although Mary Jeannette Edwards stayed at 683 Brockhurst, it is clear that she felt deserted. Returning some prints to Weston, she remarked in a letter, "I think the only course open to the group is not to show as f.64, but as a group of Western Photographers. There is such diversity in work and point of view."[65] In August 1935 she added, "Now I realize that my little 683 must be given up, as soon as I am economically able to make the move."[66]

Did the photographers who continued to be active evolve new ways of seeing and composing their photographs? Or did their growing fame rest on the gradually increasing understanding on the part of the general and museum-going public that photography, the pervasive language of the times, was uniquely significant? Ansel Adams evolved as a photographer, building on his extraordinary vision and technique, his passionate feeling for the California land, and his ability to enlarge the meaning of landscape photography as central to environmental concerns.

Weston applied his straight photography to a broader landscape on his Guggenheim trip and, in a darker view, to the final pictures of Point Lobos, but illness overcame him before major change could develop and be resolved in his work. The photographs he showed at the f.64

exhibits proved to constitute, as he thought, many of his most successful pictures.

Looking back, Group f.64 provided a rallying place for like-minded photographers to gather, state their aims, and exhibit their carefully composed black-and-white images in defiance of the then-reigning pictorialist tradition. That the proponents were young, bold, and optimistic about their chosen medium was important to the quality of the group's success. As an informal Oakland meeting place and gallery, 683 Brockhurst encouraged the revolutionary Bay Area modernist aesthetics, which resulted in straight seeing and "pure photography."

Individually, four f.64 members combined their shared vision, adapting straight, clearly seen images for very diverse purposes, ranging from picturing California's stark beauty to addressing social issues. More remarkable, from this group of eight, four of the best-known and most celebrated photographers of the period emerged—Edward Weston, Willard Van Dyke, Imogen Cunningham, and Ansel Adams. One can postulate that although each of them was committed to making photographs, their collaborative effort, their entwined relationships, and their spirit of rebellion clearly benefited the younger members. f.64 gave an intriguing name and a specific location to a modernist movement that for the next forty years characterized American fine-art photography. Cunningham captured the irony of their love of photography with humor and a determination to undermine pompous aims when she observed, "You have to be really crazy to stay in it, the way a photographer is treated. . . . You really have to be a mad person to stick to it. We did all seem to stick."[67]

NOTES

The abbreviation "CCP" refers to the Center for Creative Photography, University of Arizona, Tucson.

1. In most large cities by the early 1900s amateur photography enthusiasts gathered together in camera clubs, which provided technical support, social activities, and juried exhibitions.

2. William Mortensen, "Venus and Vulcan," *Camera Craft* (May 1934): 206. Mortensen contributed five installments of this article between March and July 1934.

3. Ansel Adams, "Book Review," *Creative Art* (May 1933): 386.

4. Edward Weston, *The Daybooks of Edward Weston: Two Volumes in One*, Vol. 1, *Mexico*; Vol. 2, *California*, ed. Nancy Newhall (New York: Aperture Foundation, 1981), 2:174.

5. Weston, *Daybooks*, 1:8.

6. As an ardent proponent of avant-garde art, Galka Scheyer introduced European works to the Oakland area, including constructivist and abstract paintings plus examples of the Blue Four, organized lectures and exhibitions, and proposed purchases to the City Council of Oakland, while continuing to teach at Anna Head, a private girls' school in Berkeley.

7. Weston, *Daybooks*, 2:151.

8. Weston, *Daybooks*, 2:146.

9. Weston, *Daybooks*, 2:147. Weston does not seem to recognize that Paul Strand had presented these ideas in his 1923 lecture to the Clarence White School.

10. Willard Van Dyke, "Unpublished Autobiography," p. 52; Collection of CCP, courtesy of Barbara M. Van Dyke.

11. Van Dyke, "Autobiography," p. 54.

12. Willard Van Dyke, transcript of lecture given at The Oakland Museum, July 14, 1978, p. 5.

13. James Alinder, "The Preston Holder Story," *Exposure* 13, no. 1 (February 1975): 4.

14. Undated letter from Willard Van Dyke to Edward Weston, envelope postmarked September 8, 1933; Collection of CCP, courtesy of Barbara M. Van Dyke.

15. See also Willard Van Dyke's introduction to Weston's 1933 show at 683 Brockhurst and his article on Dorothea Lange's documentary style, "The Photographs of Dorothea Lange," *Camera Craft* 41 (October 1934): 461–67.

16. Mary Alinder believes that Adams's typewriter was the one used and that he may have been the author (see her essay in this volume); however, in my opinion, Adams's writing style at this time tended to simplify and overstate for emphasis in teaching. Imogen Cunningham states unequivocally, "In the main, the person who started this was Willard. I've been told that Ansel Adams claims he started it, but I would swear on my last penny that it was Willard who did it"; University of California Oral History, Regional Cultural Project, Berkeley, 1961, p. 11. This uncertainty of authorship reflects the imperfect recollections of the artists themselves, and should not obscure the fact that the manifesto was, essentially, a consensus document.

17. Weston, *Daybooks*, 2:246.

18. Adams, quoted in Ira Latour, "West Coast Photography: Does It Really Exist?" *Photography* [London] (May 1960): 20–25. Van Dyke credits this as the goal of his photography in a 1934 statement for his show at 683 Brockhurst.

19. Ansel Adams, unpublished typescript statement in the collection of Amy Conger, and seen also in the papers of Beaumont Newhall. This four-page piece appears to have been a draft to introduce the f.64 show at Adams's Geary Street gallery.

20. *San Francisco Chronicle*, November 27, 1932, Music and Art section.

21. The *Seattle Times* announced the Group f.64 exhibition at the Seattle Art Museum on October 1, 1933, in the *Art Museum* column.

22. Review, *The Spectator* 54, no. 13 (November 4, 1933): 16. Interestingly, Naomi Rosenblum points out that "objective" is the very word Strand used in 1917 to discuss the new realist style.

23. The Mills College exhibition, February 11–28, 1934, included work by Lavenson, Cunningham, Van Dyke, Adams, and Weston, as well as Dorothea Lange and Margaret Bourke-White. It was reviewed

in "A Record of Actuality" in the *San Francisco Argonaut,* March 8, 1934.

24. Undated letter from Edward Weston to Willard Van Dyke, envelope postmarked January 27, 1933; Collection of CCP, courtesy of Barbara M. Van Dyke. "The f.64 exhibition shows up well at Denny-Watrous. They wish to give us another (free) week, O.K.?" He adds, "I do not want to hold up the group."

25. Sigismund Blumann, "The F.64 Group Exhibition," *Camera Craft* 40 (May 1933): 199–200.

26. Albert Jourdan, "The Impurities of Purism," *American Photography* 29 (June 1935): 348–56.

27. John Paul Edwards, "Group f 64," *Camera Craft* 42 (March 1935): 107–12.

28. Roger Sturtevant, transcript of interview on his collection and Dorothea Lange, The Oakland Museum, February 1977, pp. 1–5. Although Sturtevant was unable to locate this set of pictures at the time of the gift to The Oakland Museum, I have seen examples in Michael Wilson's collection and also at the J. Paul Getty Museum.

29. Van Dyke, lecture, July 14, 1978, p. 16.

30. Van Dyke, "Autobiography," p. 32.

31. Van Dyke, "Autobiography," p. 50.

32. Statement printed on the 683 Gallery stationery; courtesy of Barbara M. Van Dyke.

33. "Camera Club Notes," *Camera Craft* 40 (September 1933): 388.

34. Van Dyke, "Autobiography," p. 50. Curiously, the word "Salon" suggests the pictorial tradition they wanted to leave behind.

35. Van Dyke, "Autobiography," p. 48. Although Van Dyke writes of this period in his autobiography, another account of Van Dyke's decision to leave the Shell Co. and commit to photography was related by William Alexander in *Film on the Left: American Documentary Film from 1931 to 1942* (Princeton, N.J.: Princeton University Press, 1981), pp. 130–44. In that interview Alexander notes that Van Dyke was radicalized when, after trying to organize a union at Shell, he was forced to choose between working a sixty-hour week or losing his job. Recently, when he compiled material for his autobiography, Van Dyke recalled the influence of Edward Weston, and likely both situations led to his choosing photography.

36. Interview with and letter from Don Ross, September 1991, The Oakland Museum. Ross, a photographer, was a friend of Swift's and other members of Group f.64.

37. Weston, *Daybooks,* 2:136.

38. Therese Thau Heyman, "Carmel: Beneficial to Bohemia," in *EW 100: Centennial Essays in Honor of Edward Weston,* Untitled 41 (Carmel, Calif.: The Friends of Photography, 1986), pp. 37–49.

39. An early supporter of modern art and a financier of New York's Modern Gallery, which had opened after the Armory Show, Arensberg benefited from the advice of the European artist Marcel Duchamp. After 1915 Duchamp joined him at his New York salon, which included Francis Picabia, Charles Sheeler, and Man Ray, among others.

40. Imogen Cunningham, University of California Oral History, Regional Cultural Project, Bancroft Library, Berkeley, p. 20. Also, Cunningham is known to have worked for the Curtis Studio and traveled to Dresden.

41. See the Archives of American Art files, Smithsonian Institution, Washington, D.C., of correspondence between Cunningham and

Vanity Fair on payments for assignments that were often regarded by the magazine as free-lance pieces done on speculation, but which Cunningham regarded as responses to requests.

42. Adams, unpublished statement, p. 4.

43. Weston, *Daybooks,* 2:265.

44. Letter from Edward Weston to Willard Van Dyke, September 1933; Collection of CCP, courtesy of Barbara M. Van Dyke. Weston's few references to f.64—and long mentions are absent from his writings —has led one noted scholar, Amy Conger, to speculate along these lines. Weston, the innovator, was overwhelmed with requests for shows at the same time that he was finding very few paying portrait sittings to pay his increasing bills. This lack of reference is consistent with the hurried tone of the letters Weston wrote to Van Dyke about f.64 matters. Possibly, too, Weston was influenced by the December 23, 1932, *Carmel Pine Cone* recap of *WASP* (a local little magazine, then newsletter, of criticism) reviewer Edward Radenzel who had blasted the de Young show. "To me, the work on the walls struck such a sharp line of demarcation at those points where Weston's example began and ended, that I left, thinking I had seen a show of his work and a number of inferior people who had been following in his wake." An experienced artist, Weston was surely ready to discount many commonplace reviewers, but the possibility of sending an uneven show to the mecca of photography, New York, after the numerous safer West Coast sites, was a worry to him. See also Weston's note in a letter to Van Dyke, February 20, 1933: "I am chairman of the foundation of Western Art, L. A. with the power of an absolute dictator, a one man jury, I expect to select most of first from f.64, and don't want accusations of 'politics.' . . . keep this to yourself."

45. Peter Stackpole, *The Bridge Builders: Photographs and Documents of the Raising of the San Francisco Bay Bridge* (Corte Madera, Calif.: Pomegranate Press, 1984), p. 118.

46. Peter Stackpole, interview with the author, October 1991.

47. Laverne Mae Dicker, "Laura Adams Armer, California Photographer," *California Historical Society Quarterly* (Summer 1977): 139.

48. Cunningham, Regional Cultural Project, pp. 100–104.

49. Weston, *Daybooks,* 2:4. Archives of American Art, Smithsonian Institution, Washington, D.C., listed alphabetically, no roll no., Cunningham.

50. Weston, *Daybooks,* 2:141. Years later Noskowiak moved away and worked for the *San Francisco Chronicle* and the Public Works of Art Project.

51. Although there is an extensive archive of letters from Consuelo Kanaga to Albert Bender in the Bender Collection, Mills College Library, Oakland, the letters generally refer only to her mental state and not to her photographic activities. I am grateful to Barbara Millstein, curator at the Brooklyn Museum and author of the 1992 Kanaga exhibition and publication, for suggesting this source to me as well as sharing many of her valuable insights on Kanaga.

52. "A Visit with Consuelo Kanaga, from the Icehouse," *Camera* 35 (December 1972): 53, and University of California Oral History, Regional Cultural History Project, Dorothea Lange, p. 87. Kanaga recalled her beginning in photography at the *San Francisco Chronicle:* "When I started on the newspaper, I learned just the fundamentals of printing and developing; no nuances. Everything had to be sharp, etched on the glass plates. The editor would look up and down the row to see the sharp cut line. And, if anything wasn't so sharp he'd say, 'what's the matter, losing your eyesight?'" Then, with her interest in photography whetted, she joined the California Camera Club, where

she met many "wonderful" people including Dorothea Lange, the innovative documentary photographer of San Francisco depression-era street scenes. Lange later described Kanaga as "unconventional with great courage and an ability to go anywhere and do anything."

53. See Susan Ehrens, *Alma Lavenson: Photographs* (Berkeley, Calif.: Wildwood Arts, 1990), p. 5.

54. Ehrens, *Lavenson*, p. 90.

55. Ehrens, *Lavenson*, p. 4.

56. Charis Wilson's remarks, "Founders of Photography" symposium transcript, The Oakland Museum, March 9, 1986, p. 9.

57. Imogen Cunningham, lecture at The Oakland Museum, 1974, author's notes.

58. Wilson remarks, "Founders of Photography," p. 2.

59. Wilson remarks, "Founders of Photography," p. 2.

60. Wilson remarks, "Founders of Photography," p. 5.

61. Weston, *Daybooks*, 2:267.

62. Weston, *Daybooks*, 2:243.

63. Weston, *Daybooks*, 2:243.

64. For a compelling discussion of this and other f.64 relationships that led to the breakup, see Michel Oren, "On the Impurity of Group f.64 Photography," *History of Photography* (Summer 1991): 119–27.

65. Letter from Mary Jeannette Edwards to Edward Weston, undated but probably 1935; Edward Weston Archive, Collection of CCP.

66. Letter from Mary Jeannette Edwards to Edward Weston, August 3, 1935; Collection of CCP.

67. Imogen Cunningham, quoted in Latour, "West Coast Photography," *Photography*, p. 62.

In her position as senior curator of The Oakland Museum Art Department, THERESE THAU HEYMAN has specialized in prints and photographs of California and the West. She organized the exhibitions *Picturing California: A Century of Photographic Genius* and *Her Story: Narrative Art by Contemporary California Artists.* An on-going interest is the investigation of 1930s documentary photography in the archives of Dorothea Lange (1895–1965) as they relate to the broader issues of government support of photographic surveys.

f.64 and Modernism

Naomi Rosenblum

The origins and uniqueness of the kind of photography produced by the Californians associated with Group f.64 have been a subject of some confusion. Reflecting this puzzlement, Imogen Cunningham held that f.64 "has always been considered reflective of American work. It is not only American, it's western." Then, in an exercise in hyperbole, she went on to claim that "it isn't even American; it's western."[1] Her wish to separate the work of California modernists from a nationwide stylistic trend that seemed to her dissimilar is understandable, but it is also inaccurate. While distinctively Californian, the roots of Group f.64 are to be found in the changes in sensibility that had been taking place in the United States during the previous two decades. And these in turn cannot be disassociated from European avant-garde ideas in the arts that unfolded during the early years of the twentieth century and then flourished again after World War I. Indeed, Group f.64 may be seen not so much as a separate development but as a particular summation of—perhaps even a coda to—a direction that had been maturing for a quarter of a century. That the beneficent California climate contributed a special flavor to this late-blooming branch should not obscure the international character of the modernist tree from which it issued.

This "tree" had come to maturity in both the United States and Europe in the ten years between the Versailles Treaty of 1919 and the stock market crash of 1929, although it had germinated earlier in the century. During this period of transformative political ideas and social customs, the concepts that we recognize as the forerunners of our own time took on their characteristic forms, becoming established "as a philosophy and a creed."[2] In terms of cultural expression, this period was markedly different from the era before the beginning of World War I. Then, what has sometimes been called the "feminization" of the arts placed a high value on traditional standards of beauty and on mysticism and organicism as the goals of visual art. The most esteemed art was thought to be inward-looking, concerned with psychological or spiritual matters. The effect of this creed on expressive photography was to prescribe both subject matter and treatment. In particular, the requirement that artistic photographs should obscure the mechanical nature of

their origin resulted in camera images that mimicked the hazy indistinctness of the tonalist painting of the late nineteenth century. When forward-looking artistic photographers did embrace up-to-date subjects such as railroads or bridges, they turned these entities into symbolic statements by stressing atmospheric effects.

As American industrialism expanded following the end of World War I, cultural expression became more and more concerned with technology and its products, both actual and psychological. In consequence, the forms depicting the mechanisms and structures of an advancing industrial society underwent transformation as well. A vivid sense of this change can be seen in a comparison of Alfred Stieglitz's 1902 photograph *The Hand of Man* (fig. 7) and Charles Sheeler's 1939 *Wheels* (fig. 8). Stieglitz's image of a locomotive—an unusual theme for artistic photography in its time—presents this utilitarian object in a romantic light. In itself, the engine is not beautiful, but the image celebrates its role as part of a larger whole in which it, rails, sky, and cityscape all participate in evoking an almost mystical sensation of energy. Thirty-seven years later, Sheeler's sharper lens revealed both the beauty and the power of the mechanism itself, but paid no attention at all to context. Contrasting the specific characteristics of metal and steam, the photographer focused on essentials, without reference to philosophical ideas originating in literary expression.

Not all modernist images were directly concerned with mechanical forms, but there can be little argument that machines and modernism were closely intertwined in the modernist ethos, especially in the seminal period. So closely, in fact, that one forward-looking commentator claimed that one who "has not seen a modern locomotive . . . has not seen modern art."[3] Actually, the call for artists to concern themselves with what came to be known as the "authentically embodied logos of modern life" had been sounded in the opening years of the twentieth century, heeded (as we have seen) by Stieglitz as early as 1902.[4] This message began to exert a greater pull on other photographers toward the end of the first decade, when Alvin Langdon Coburn and Karl Struss found their themes in the utilitarian edifices and new industrial construction underway in New York City. But while their

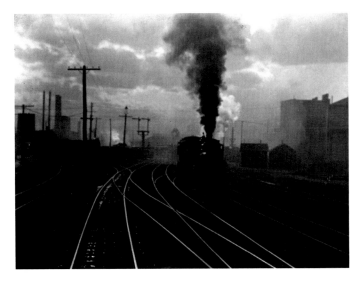

Fig. 7. Alfred Stieglitz, *The Hand of Man*, 1902. Collection of the
National Gallery of Art, Washington, D.C., Alfred Stieglitz Collection.

Fig. 8. Charles Sheeler, *Wheels*, 1939. Collection of the Museum of
Modern Art, New York, given anonymously.

subject matter was modern, their artistic sensibilities were
still rooted in an older tradition, and their images had an
evocative rather than factual appearance.

The formal transformations that marked the onset of
modernism began to appear in the United States in the
second decade, brought on by a conjunction of events.
One was the by now well-documented introduction of
avant-garde European art to American viewers though
the agency of Alfred Stieglitz's Photo-Secession gallery—
291—and journal, *Camera Work*. Aided by Edward
Steichen, whose European contacts were crucial to this
enterprise, Stieglitz showed the cubist and fauvist work of
Picasso and Matisse in 1910. He later exhibited sculpture
from Africa and the work of children, both of which were
touchstones of the modernist belief that non-Western
ideas and untutored naïveté were important concom-
mitants of artistic expression. Gallery 291 was a meeting
place for photographers as well as painters, several of
whom had been exposed to European ideas on their
sojourns abroad, and the most advanced camera artists of
the time were brought into contact with new ideas there.
Thus Morton Schamberg, Charles Sheeler (who had
spent time in Paris), and Paul Strand were introduced to
Stieglitz, to each other, and to avant-garde concepts quite
early in their careers.

The 1913 Armory exhibition in New York City was a
major event in educating the American artist-photogra-
pher about modernism; certainly Schamberg, Sheeler, and
Strand visited it and discussed its meaning for photogra-
phy in general and for their own work in particular. In the
heady years following this grand display of the latest con-
temporary expression in both Europe and the United

States, these three figures encountered more advanced
notions about the themes that art might embrace and
the forms it might take through their association with
the Modern Gallery and the group that congregated
around Walter Arensberg and his stars from France,
Marcel Duchamp and Francis Picabia. Considered the
link between the European and American avant-garde,
Picabia's cubistic handling of the urban scene and his
representations of commonplace mechanisms such as
light bulbs and spark plugs, which were motivated by his
experiences in New York, had profound effects on the
work of the three photographers. None followed the path
of ironic wit marked out by the irreverent French dada-
ists, however. In general, Americans were greatly more
responsive to the rational aspects of modernism than to
its playfulness or mordant humor; their "dominating
reverence for external fact" eventually came to be seen
as the most significant element setting them apart from
their modernist European colleagues.[5]

By 1917, the year that Schamberg, Sheeler, and
Strand exhibited photographs in a three-person show at
the Modern Gallery, the tenets of modernist expression in
photography were in place. Besides the thematic changes,
which validated commonplace objects as subject matter,
the new approach involved formal modifications. These
embraced both the ways of putting the image together
and the manner in which the forms were represented, and
were motivated by pleasure in material qualities, in clear
and exact representation, and in visual design. In terms of
organizing the picture plane, views with conventional
perspective were avoided, at first through the selection of
high vantage points that obliterated the horizon line and

flattened the picture plane.

As an understanding of cubism's ideas and methods became clearer, the simple planar *japonisme* of this point of view gave way to a more complex integration of forms, exemplified by Strand's experiments during the summer of 1916 with a variety of geometric and organic elements, among them ordinary kitchen crockery. By arranging different elements and positioning the camera in a variety of ways, modernist photographers learned how to control form to make the image visually readable from various directions, indicating to one contemporary observer that "the camera . . . had proved cubism."[6] The most advanced formal thrust in this direction was in fact directly inspired by cubist painters associated with English vorticists, but the nonobjective vortographs Alvin Langdon Coburn created in 1915 proved to be a little-traveled byway rather than a main artery for American modernism. Indeed, Americans drawn to the extremes of avant-garde experimentation found a more nourishing atmosphere in Europe, which became home to Francis Bruguière and Man Ray as well as Coburn.

Early American modernists no longer observed the sense of scale and distance that had once been an important aspect of the reality evoked by photographic images. Instead, they brought the lens close to the object portrayed, excised it from its surroundings, and framed it in an unusual way, at times slicing through portions of the subject. What Edward Weston would call "the life force within the form" became a major preoccupation, and commitment to the object, "clearly comprehended and reproduced without artistic transformation" (which Europeans called *neue Sachlichkeit* and Americans, objective realism), eventually would become a major element in the California modernist approach.[7] Combined with pictorial ambiguities regarding size, scale, and vantage point, it was to be the distinguishing characteristic of much of the work produced by Group f.64.

To return to the teens: the application of modernist precepts to express the meaning and vitality of the urban industrial scene occupied Schamberg, Sheeler, Stieglitz, and Strand in the years following their early experiments with cubist photography. Before his untimely death in 1918, Schamberg took on machinery as the subject for his paintings and city architecture as the theme of his photographic work, producing images in which tightly integrated forms suggest the interlocking planes of a cubist work while evoking the geometric density of the city. In their urban imagery of the late teens and early twenties, Sheeler, briefly, and Strand, to a greater extent, attempted to combine aspects of cubism with the vitalist concepts that were integral to the philosophical ideas advanced by the group of artists and writers around Stieglitz. Though rooted in an older sensibility, Stieglitz's own images of city architecture and his project in portraiture, for which he photographed the face, hands, and torso of Georgia O'Keeffe over a long period of time, made use of similar strategies, as is evident in the numerous close-ups and severely cropped views.

When Strand turned his attention to actual machinery, he employed all the techniques of this new vision to express both the seductive elegance and ruthless power represented by the new industrial might (fig. 9). He termed such representation "objectivity," explaining it as a concept grounded in the camera's technological instrumentality—what the camera does best—and in the character of the urban-industrial life being recorded. That these photographers "were affiliated with the cause of modern art" was quickly recognized by critics of the period, one of whom held that "the impersonal lens has furnished proof of fundamental truths in modern art."[8]

An important aspect of the shift from prewar pictorialism to modernism involved substituting a highly differentiated textural definition for the all-encompassing softness of pictorialist depiction. The new sensibility mandated using sharper lenses and closing down the aperture to extend the depth of focus. Sharpness became the defining logo of modernist style. Conventional pictorialists had begun to adopt the close-up and often incorporated other aspects of modernist formal organization, but they continued to favor a soft, somewhat indistinct image, effectively separating themselves from the modernist school during its early years. By the early 1920s, however, sharper depiction was generally acknowledged to be more appropriate to the mechanized character of contemporary life, which prompted even these reluctant hold-outs to rethink their positions. Weston, confronting both the industrial landscape of Ohio and the crisp images of Sheeler and Strand during a trip to New York in 1922, recognized the astringent quality of highly delineated forms. Noting that he was "deeply impressed with Sheeler's photographs of New York," he revised his approach to become the leading maker of crisp imagery.[9] He was followed in this direction by Imogen Cunningham, whose work during the teens, concerned with literary symbolism, had appeared to be enveloped in a gauzelike scrim. The southwestern photographer Laura Gilpin, who had been introduced to modernist ideas of design at the Clarence White School but had retained the soft treatment prescribed by her pictorialist mentors, also turned to sharper imagery after 1922.

Fig. 9. Paul Strand, *Lathe, Ackeley Shop, New York*, 1923. Copyright ©
1971 the Aperture Foundation, Inc., Paul Strand Archive.

Modernism's message had been understood and
accepted by a small number of artistic photographers
working in rarefied artistic precincts in the eastern
United States during the teens, but its rapid spread
throughout the nation, as well as in Europe, after World
War I, was the result of developments on both sides of the
Atlantic. As cities on the Continent reawakened from
the chaos engendered by war and revolution, the camera
came to be seen as the most appropriate means for direct-
ing attention to a newly emerging mental and physical
landscape—one based on technology and eager to move
away from the sentimental myths of the past. In 1920 the
British photographer Ward Muir gave voice to this credo
when he declared that "photography should be straight
and true to the facts of modern life," which included, he
noted, "gasometers and factory chimneys."[10]

Visually more adventurous than their American
counterparts, photographers in France, Germany, and the
Soviet Union employed collage, montage, and various
forms of light graphics to represent the speed and contra-
puntal aspects of modern life. But they also relied on

strategies that had formed the arsenal of earlier American
experimentation: the bird's-eye view and unusual vantage
point, the close-up, and, above all, the razor-sharp ren-
dition of objects in reality, excised and reseen. The new
objectivity or new realism, as this aspect of modernism
was known, celebrated fabricated items and mechanized
structures with which modern life seemed increasingly
filled; it also refashioned the manner in which common-
place objects were seen so as to present the ordinary in
an extraordinary light. The affirmative implications of the
style were sounded by Albert Renger-Patzsch, the fore-
most proponent of realism in Germany during the mid-
1920s, when he urged "an increase in joy one takes in an
object."[11] Another affirmation came in the claim by the
Soviet artist Alexander Rodchenko, that the new realism
would enable people to see the world "from all vantage
points" rather than from the "biased conventional" eye-
level view that, to his mind, was the legacy of Western
capitalist artistic practice since the Renaissance (fig. 10).[12]
The wide currency of this point of view is evident in its
repeated assertion that "photography is put to its best
purpose . . . when it does not show things as they have
been perceived for generations, but instead presents new
approaches that are bolder and not yet exhausted."[13]

Objectivity, as it turned out, was not only a means
by which photographers might express their sense of the
changing contours of modern existence but a tool by
which industrial enterprises could promote acquisition of
their products. With its ability to bring the viewer close
to a substance, to render detail, to play up contrasts in
forms and textures, to remove objects from normal con-
texts and endow them with special attributes, the objec-
tive photograph took on added prestige and power in
commercial exchange during the latter part of the twen-
ties and into the thirties. Prompted by the expansion of
advertising in Europe, where several American firms
opened branch offices in the late twenties, professionals
such as Aenne Biermann and Renger-Patzsch in Ger-
many, Germaine Krull and Emmanuel Sougez in France,
and Hans Finsler in Switzerland took advantage of the
preciseness and clarity of the objective style to publicize a
range of products from glassware to blast furnaces. And in
the Soviet Union, the style served publicity purposes of
those calling for a new society in that it helped develop
"people's capacity to see from all sides."[14]

In Europe, realistic public relations images were part
of a larger arsenal of modernist strategies, which included
montage and photograms. In the United States, realism—
variously called "objectivity" or "precisionism"—became
the prevailing mode in sophisticated commercial camera

37

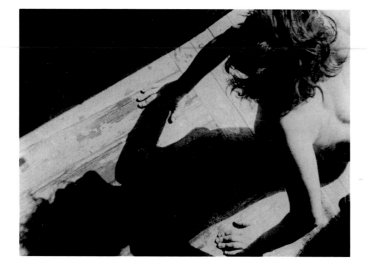

Fig. 10. Alexander Rodchenko, *Untitled* (Nude and Shadow), 1930s. Collection of the San Francisco Museum of Modern Art.

38

representation. Those working for advertising agencies, trade journals, and slick magazines were concerned to present the object itself and to provide, through the astute management of light and form, a seductive aura for the entity being pictured. Thus, images fashioned by Paul Outerbridge and Edward Steichen during the early twenties to sell products and publicize personalities, and by Anton Bruehl, Sara Parsons, Charles Sheeler, and Ralph Steiner somewhat later, all rely on the camera's ability to isolate the object and allow the eye to dwell on a satisfying visual relationship of tone and form. Steichen's portraits for *Vogue* and *Vanity Fair*, for example, usually present the sitter in close-up, with great attention paid to contour and textural detail, but are often devoid of recognizable context and background. When such elements are present, as in the image of the actress Anna May Wong, they direct attention to the design, or what one practitioner called "pure form."[15] Despite the importance of this element in the work of American advertising photographers, however, an affinity did exist between American and European concepts; it can be gauged by the claim that modernist practice would "awaken the spectator to the beauty and power of the commonplace."[16]

With modernist style firmly established, the emphasis in advertising photography on the object itself began to diminish toward the end of the decade and into the early 1930s, giving way to more symbolic representation. Already in 1929, Margaret Bourke-White, the foremost professional in the era of late modernism, was canting the camera more precipitously to give the machined products and industrial structures confronting her lens a sense of the dynamism she believed integral to the American

enterprise system. Focusing on the same structure as Sheeler had some years earlier, she endowed the blast furnace at the Ford River Rouge plant with a greater sense of vitality, albeit with less stability. That machine imagery continued its dominant role in the East was evident in the entries in the photographic section of the 1932 mural exhibition at New York's Museum of Modern Art, most of which depicted metal structures, steel mills, and chemical paraphernalia.[17] Ironically, at the moment of this paean to industrial dynamism, the system being celebrated had begun to crumble.

Photographers unconcerned with industrial subject matter and those who had grown unhappy with the commercialization of life under its aegis were subject to the same influences as those who used the style to market products and personalities. Those drawn to organic and natural formations—to rocks, trees, plant life, the human face and figure—made use of the same strategies as those for whom the machine symbolized the ultimate good in contemporary life. In fact, in the mid-1920s, the early modernist Strand turned away from the urban-industrial scene. In a reaction against what he perceived as the unfeeling commercialism of machine culture, he photographed natural phenomena on the New England coast and in the Far West. Initially, he applied the same modernist principles to depictions of indurate and foliate matter as he had to urban structures and machine tools. It was this consistency of approach that came to the attention of Ansel Adams when both men found themselves in Taos, New Mexico, at the same time about 1930. This meeting established another link between the modernist style as it developed in the East and was transferred to the West. As Adams himself noted, his "understanding of photography was crystallized" by seeing the "uncluttered edges and beautifully distributed shapes" in the negatives shown him by Strand.[18]

One can see in nearly all the significant portrait work of the 1920s similar stylistic concerns. In the almost microscopic detail of skin pore and hair follicle, the manner of cropping and framing, and the absence of background information, portraits produced during the 1920s by Biermann, Lucia Moholy, and Florence Henri in Europe, by Weston and Tina Modotti in Mexico, by Rodchenko in the Soviet Union, by Stieglitz and Steichen in the United States all bear similar stylistic hallmarks. This consistency suggests that whether serving commercial or private needs, modernism had become an international preoccupation. Similarly, the treatment of the nude by European and American photographers can be seen to share ideas about detail, definition, cropping,

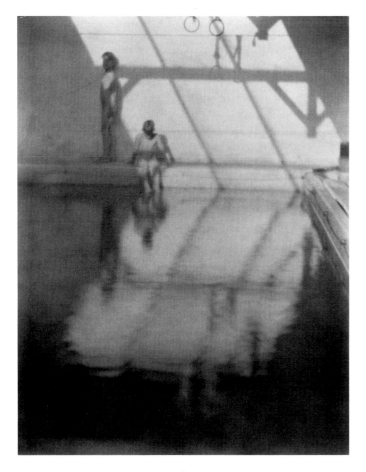

Fig. 11. Edward Weston, *Bathing Pool*, c. 1919. Collection of
The Oakland Museum, purchased with funds donated by
Dr. and Mrs. Dudley Bell.

to visual ideas emanating from Europe than from across
the Pacific, most California photographers in the early
twenties were still debating the merits of realism versus
idealism and promoting the importance of soft-focus
lenses. Although the Pan-Pacific expositions of 1915
showed a selection of contemporary art from Europe, the
Far Eastern presence at the shows and an active Japanese
photographic community in California prompted photog-
raphers engaged by the artistic aspects of the medium to
look at these sources, as is apparent in Weston's elegantly
simple scene of bathers (fig. 11). The orientalizing mode
accorded well with pictorialist concerns, as can be seen in
the work of John Paul Edwards, which displays the flat-
tened planes and tonal areas suggestive of Japanese prints
along with the atmospheric haziness considered appropri-
ate in pictorialist practice. The popularity of the Califor-
nia pictorialist salons, which in the late twenties and
early thirties were fielding the largest number of entries
in pictorial salons nationwide, was another factor in the
slow acceptance of modernist ideology on the West
Coast. What is more, a strongly developed sense of
western individualism allowed photographers to go their
own way, so that even those affiliated with Group f.64
had differing objectives. Perhaps most important, the
power of advertising, which had been instrumental in
promoting modernism among European and East Coast
practitioners, was hardly a presence in California until
the late twenties.

Nonetheless, change came, heralded first by transfor-
mations in Weston's style in 1922 and then in the work
of Cunningham, who had settled in Oakland in 1920.
Weston served as a main conduit for East Coast ideas to
his circle of pictorialist photographer friends, which
included, besides Cunningham, Johan Hagemeyer, Alma
Lavenson, Sonya Noskowiak, and Margarethe Mather.
Furthermore, by the mid-twenties, Cunningham, and one
presumes others as well, had become aware of the changes
that had taken place in European photography through
following photography exhibits and publications from
abroad. Certainly, her plant photographs can be stylisti-
cally related to the work being done in Germany by Karl
Blossfeldt and Renger-Patzsch.

The effect of this assimilation of ideas about close-up,
greater definition, and unusual cropping, and, above all,
about the significance of design is notable in Cunning-
ham's handling of the nude. Interested in this theme from
her earliest days as a photographer, her vision changed
from one of symbolist evocation to one of modernist
intention, but the severity of geometric forms and their
compression within the frame were softened by both her

and decontextualization, although in handling this
particular theme, photographers often paid even greater
attention to formal elements—to contour and the play of
form and light across the two-dimensional field—than to
revealing the individual body.

Proof of modernism's international appeal was con-
firmed by the 1929 *Film und Foto* exhibition at Stuttgart,
for which Steichen and Weston made the American
selections. The work on display, which was solicited from
photographers in Germany, Holland, the Soviet Union,
and Switzerland as well, represented such a complete
break with the past that it was immediately referred to as
"the new photography" or "the new vision."[19]

How did California photographers react initially to
the modernist ethos? At first, with hauteur. "We take
pleasure," one wrote in 1920, "in the absence of picket
fences and in the fact that none have stooped so low as to
seek beauty beneath an automobile chassis," a reference,
of course, to the winning Strand images in the Wana-
maker competition of 1918.[20] Far from the burgeoning
industrial developments on the East Coast and less open

feminine sensibilities and a feeling for decorative qualities. With Cunningham focusing on formal effects, with Weston hailing images that would reflect the medium's inherent capacity to see the "veriest" detail, with Adams recognizing the aesthetic possibilities of straight photography, indeed, with even traditionalists calling for "truth and straight-forward rendering" as a requisite for camera art, modernist style became firmly settled in California in the early thirties.[21] There, it developed its own character, seen with greatest clarity in the work of the photographers associated with Group f.64.

What gave this work its special particularity? For one thing, the themes that moved Californians obviously were different from those that excited easterners and Europeans. The machine figured much less prominently in western imagery, although it was not entirely absent. The open spaces of the West brought about a culture defined by the automobile and the gas tank, prompting Hagemeyer, Lavenson (plate 67), and Weston to address this aspect of advancing mechanization. Their images attempt to impose a satisfying visual order in this impingement on the natural landscape. But for the most part, California modernist photographers concerned themselves with what surrounded them in such abundance: the landscape, the flourishing organic growth, and the still viable rural life. Pointing their lenses at the kind of agrarian objects that had vanished from the artistic consciousness of many eastern urbanites—fence posts, barn roofs, and rusting farm implements—they treated these objects with the same sharp scrutiny as were lathes and blast furnaces in the East. However, even in California, these themes looked to a vanishing way of life, and the energy contained in the images derived in many instances from formal design rather than from the kind of intense belief in the future that had motivated easterners enamored of machine culture.

The pronounced patterning and attention to contour and texture in California modernist photographs of organic matter also set them apart. Studies of vegetables by Weston, of plants and flowers by Cunningham, Lavenson, Noskowiak, and Henry Swift, seen through the lenses of large-plate cameras, seem motivated more by the design of natural forms than by scientific curiosity about how such forms grow and develop or what they might mean in the context of contemporary life. The impress of design principles is clearly visible in Adams's treatment of the natural and constructed landscape. Willard Van Dyke's handling of rural and industrial themes during the period just prior to the formation of Group f.64 is similar. In a sense, "the thing itself" was exactly that; the reso-

nances were for the most part contained by the emphasis on aesthetics. In this respect, Cunningham's handling of foliage seems more decorative than that of Renger-Patzsch; his studies suggest that nature and manufacture share a sense of orderliness and appropriate design, while her plants are self-contained entities that make no claim beyond the immediate pleasure one derives from them.

For all of the focus on utter clarity, on previsualizing the finished image, and on complete honesty in printing, Group f.64 photographers seem to have been more concerned with pictorial requisites than were other modernists. Although Weston publicly announced in 1932 that he found the word "pictorial" irritating because it suggested that photographers follow painters, by 1937 he had reinstated himself as a pictorialist, denying the "validity of the Purist/Pictorialist distinction."[22] Adams, who had dropped the term from his lexicon, also had second thoughts. Group f.64 images may not be as far removed from pictorialism as these photographers claimed at the time. In retrospect, Edwards probably was quite acute in his recognition that adherents to f.64 had "no basic controversy with the photographic pictorialists."[23]

To both groups, producing authentically pleasing visual entities was paramount; only the techniques and strategies were dissimilar. For all their desire to disassociate themselves from the narrative genre aspects of pictorialism, exemplified by the extreme sentimentality of William Mortensen's images, Group f.64 photographers followed a wavering course between "the literal and symbolic, the actual and the typical, the particular and the universal."[24] The earlier modernists in Europe and New York had regarded their style as a new way to fashion the image and a new way to think about life and its meaning. The visual style they adopted reflected "the state of mind that substitutes the shingle for the pompadour, the vitamin for the viand, gin for burgundy, and Hemingway for Henry James."[25] Group f.64 members spoke of being for "reality"; and less affected by industrialization (or the economic crash of 1929), their reality was of a different nature. In concerning itself so emphatically with formal issues, their work made a distinctive contribution to modernist camera production at the same time that it confirmed that the golden era of American modernism was on the wane. At its most characteristic, modernist photography had expressed an acceptance of contemporary life in industrialized societies, an issue that had barely begun to touch the California consciousness.

NOTES

1. Imogen Cunningham, quoted in an unsigned article in *Aperture* 11, no. 4 (1964): 157.

2. William S. Lieberman, *The Art of the Twenties* (New York: Museum of Modern Art, 1979), p. 6.

3. Adam Hall Shirk, "Prestidigitation," *The Soil* (January 1917): 84.

4. John Dewey, quoted in "A Portfolio of Photographs of Iron, Steel, Coal, and Ships by Margaret Bourke-White," *Fortune* (February 1930): 77.

5. Katherine Grant Sterne, "American vs. European Photography," *Parnassus* (March 1932): 16.

6. Marius de Zayas, "How, When, and Why Modern Art Came to New York," intro. and notes by Francis M. Naumann, *Arts* (April 1980): 105.

7. Walther Petrie, "Bildung an die Dinge," *Das Kunstblatt* 13 (1929): 247, quoted in Ute Eskildsen, *Aenne Biermann: Photographs, 1925–1933* (London: Dirk Nishen, Publishers, 1988), p. 16.

8. Reviewer for the *New York Evening World*, quoted in de Zayas, "Modern Art," p. 105.

9. Edward Weston, *The Daybooks of Edward Weston*, ed. Nancy Newhall, 2 vols. (Rochester, N.Y.: George Eastman House, 1961), 1:7.

10. Ward Muir, quoted in David Mellor, *Modern British Photography, 1919–1939* (London: Arts Council of Great Britain, 1980), p. 6.

11. Albert Renger-Patzsch, "New before the Object," in Christopher Philips, ed., *Photography in the Modern Era: European Documents and Critical Writings, 1913–1940* (New York: Museum of Modern Art/ Aperture, 1989), p. 108.

12. Alexander Rodchenko, "The Paths of Modern Photography," in Philips, ed., *European Documents*, pp. 261, 257.

13. Franz Roh, "The Value of Photography," in Philips, ed., *European Documents*, p. 161.

14. Rodchenko, "Paths of Modern Photography," in Philips, ed., *European Documents*, p. 261.

15. Paul Outerbridge, "Seeing Familiar Objects as Pure Form," *Arts and Decoration* (May 1923): 23.

16. William Rittase, "Why I Am a Pictorial Photographer," *Photo-Era Magazine* (December 1930): 301.

17. Julien Levy, "Photo-Murals," in *Murals by American Painters and Photographers* (New York: Museum of Modern Art, 1932), pp. 11–12.

18. Ansel Adams with Mary Street Alinder, *Ansel Adams: An Autobiography* (Boston: Little, Brown & Co., 1985), p. 109.

19. Paul Renner, "The Photographer," in Philips, ed., *European Documents*, p. 164. See also Laszlo Moholy-Nagy, *The New Vision: From Material to Architecture* (New York: Brewer, Warren and Putnam, 1930).

20. James N. Doolittle, "Third Los Angeles Salon," *Camera Craft* (January–December 1920): 50.

21. Edward Weston, "Photography—Not Pictorial," *Camera Craft* (July 1930): 320; John Vanderpant, "Because of the Cause, or Giving the Reason Why," *Camera Craft* (December 1929): 574.

22. Michel Oren, "On the Impurity of Group f.64 Photography," *History of Photography* (Summer 1991): 125.

23. John Paul Edwards, quoted in Jean Tucker, *Group f.64* (St. Louis: University of Missouri–St. Louis, 1978), p. 20.

24. Oren, "Impurity of Group f.64," p. 125.

25. Katherine Grant Sterne, "Photography Review," *New York Times*, December 6, 1931.

NAOMI ROSENBLUM is an art historian specializing in the history of photography. Formerly on the faculty of the Parsons School of Design, she is the author of *A World History of Photography* (Abbeville, 1984, 1987), numerous articles on Lewis Hine and Paul Strand, and is currently at work on a history of women in the medium.

The Limits of Reality: Ansel Adams and Group f.64

Mary Street Alinder

Although recognized today as one of the major photographers of the twentieth century, Ansel Adams struggled throughout the 1920s and 1930s to find his vision. His leadership role in Group f.64 was critical both to the movement's success and to the maturation of his personal aesthetic.

A native of California, Adams combined his early love of Yosemite with his musical training to create an earnest, disciplined approach to photography. Progressing from an emphasis on technical mastery to a consideration of photography's expressive potential, by the early 1920s he had embraced the dominant pictorialist style, which insisted that photography must imitate other art forms to be accepted as art itself. Using such standard pictorialist techniques as soft-focus lenses, matte-surfaced printing papers, and textured, colored mounts, Adams created such traditional landscapes as the view of lodgepole pines from the Lyell Fork of the Merced River (fig. 12).

A glimmer of what would later be seen as Adams's photographic style, the grand and complete landscape, is apparent with his making of *Banner Peak, Thousand Island Lake* in 1923 (fig. 13). "It seemed that everything fell into place in the most agreeable way: rock, cloud, mountain, and exposure."[1] This image remained a solitary achievement for a number of years. At the age of twenty-one he could not reliably produce the view he saw before him in a finished print. He chalked up the success of this image to luck.

On April 10, 1927, Adams was introduced to Albert Bender, the owner of a small insurance agency who used his considerable energies and a large percentage of his less considerable income in the support of artists and fine books.[2] Bender was an early patron of Edward Weston and became Adams's first benefactor. After viewing Adams's images of the Sierra Nevada, Bender announced that he would sponsor a portfolio of his photographs. As an enchanted Adams sat watching, Bender picked up the telephone and sold fifty-six copies that very day. In a letter to his fiancée, Virginia Best, dated April 25, 1927, Adams described the upcoming portfolio, *Parmelian Prints of the High Sierras*, and added, "My photographs have now reached a stage when they are worthy of the world's critical examination. I have suddenly come upon a new

Fig. 12. Ansel Adams, *Lodgepole Pines, Lyell Fork of the Merced River, Yosemite National Park, California*, 1921. Courtesy of the Trustees of the Ansel Adams Publishing Rights Trust.

style which I believe will place my work equal to anything of its kind."[3]

The previous week, on April 17, Adams had indeed made the biggest artistic breakthrough in his life, creating a photograph in a new style: *Monolith, The Face of Half Dome* (fig. 14). As Adams stood on a high ledge above the floor of Yosemite Valley and focused his camera lens on Half Dome, he recognized, after making one exposure, that the information in the negative could not communicate the powerful emotions he felt in Half Dome's presence. Adams's epiphany was the knowledge that he must determine how the final print would appear before the negative was exposed. He later termed this concept "visualization," and it became the cornerstone of his photographic technique. That day in April 1927, by the simple act of removing a yellow filter and replacing it with a deep red one, Adams intentionally altered reality to intensify the natural drama of the scene. Blue sky, gray rock, and beige snow fade from view, replaced with the details of Half Dome's shattered face richly transcribed in black, its mass framed against ebony sky and ringed in brilliant white snow.

Albert Bender had made Adams's career as a photographer possible. He introduced Adams to the affluent

Jewish community of San Francisco, which championed his photography by purchasing portfolios and prints. Through Bender, Adams became friends with many of the artists and writers of Carmel and Santa Fe. Following his trip to the Southwest with Bender in 1927, Adams returned there time and again. New Mexico became second only to California in his affections. After meeting the writer Mary Austin in Santa Fe, Adams collaborated with her to produce the book *Taos Pueblo*, published in 1930, in which Austin's descriptive text was joined with twelve of Adams's original photographs into one volume.

The images for *Taos Pueblo* were made mostly during 1929 and early 1930. Adams photographed the pueblo in its entirety, emphasizing a cubist vision with bright light and contrasting shadows. The Ranchos de Taos church, built from the earth at its feet, rises directly as a mountain, immutable and ageless. Every one of the twelve *Taos Pueblo* images was directly seen, sharply focused; the only manipulation was the subtle use of yellow filters to secure cloud definition. In contrast, Adams's Parmelian portfolio, published just three years earlier, included both the dramatic *Monolith, The Face of Half Dome* (fig. 14), and the soft-focus *Lodgepole Pines* (fig. 12).

With *Taos Pueblo* about to appear, Adams returned to New Mexico, staying at the estate of the heiress Mabel Dodge Luhan. Through Luhan, Adams met key artists from Alfred Stieglitz's circle in New York: Georgia O'Keeffe, John Marin, and Paul Strand. During an interview in 1945, Marin described his first encounter with Adams: "I was at Mabel's in Taos—guess it was around 1929—when in came a tall, thin man with a big black beard. Laughing, stamping, making a noise. I said to myself, I don't like this man. I wish he'd go away. Then all the other people hauled him to the piano—and he sat down and struck one note. *One* note. And even before he began to play, I knew I didn't want him to go away. Anybody who could make a sound like that I wanted for my friend always."[4]

At Luhan's, Adams shared a cottage with Paul Strand and his wife, Becky. Strand was the first serious photographer with whom Adams had talked extensively. Having brought no prints to Taos, Strand shared his recent negatives with Adams, who recalled the experience as eye-opening. In his autobiography Adams wrote, "My understanding of photography was crystallized that afternoon as I realized the great potential of the medium as an expressive art. I returned to San Francisco resolved that the camera, not the piano, would shape my destiny."[5] Strand must certainly have shared his own photographic philosophy and his change to glossy printing papers.[6]

Attempting to sort out the various influences, Adams

Fig. 13. Ansel Adams, *Banner Peak, Thousand Island Lake, Sierra Nevada, California*, 1923. Courtesy of the Trustees of the Ansel Adams Publishing Rights Trust.

43

confessed during an interview in the 1970s, "I'm trying to get the bridge between my experience with Strand and my change of style. My change *was* very definite after that. . . . Then I saw Paul Strand's negatives, and the approach was something so tremendous to me that I literally changed my approach. And I can say that when I came back to California the seed of the Group f/64 movement was sown."[7]

Adams returned to San Francisco to prepare his first national exhibition for the Smithsonian Institution. *Pictorial Photographs of the Sierra Nevada Mountains by Ansel Adams* opened in January 1931.[8] It was the last time he permitted the word "pictorial" to be used to describe his work. Adams exhibited sixty prints grouped into three categories: Sierra Nevada, Sierra Nevada Winter, and Canadian Mountains. The images had been made between 1921 and 1930 and summed up what Adams had achieved in photography up to that point. The reviewer for the *Washington Post* decreed, "His photographs are like portraits of the giant peaks, which seem to be inhabited by mythical gods. . . . This is surely an art that appeals to the imagination through the mind of the artist."[9]

On returning from Washington, Adams mounted an exhibition of these same photographs at his San Francisco home, complete with an exquisitely printed list of titles. With a decade of his work around him, Adams was in an excellent position for self-evaluation. Describing this period, Nancy Newhall wrote, "One morning in the spring of 1931, Ansel woke in a kind of vision. 'It was like the Annunciation! Suddenly I saw what photography

Fig. 14. Ansel Adams, *Monolith, The Face of Half Dome, Yosemite National Park, California, 1927.* Courtesy of the Trustees of the Ansel Adams Publishing Rights Trust.

44

could be!' It was a severe and humbling vision. . . .
Now he saw that only by accepting its limitations and applying them to their logical conclusions, could he achieve what he now realized was a tremendously potent pure art form."[10]

Unable to reconcile new doctrine with old content, he changed his printing paper and his subject matter. Perhaps Adams saw his work of the past few years as illustrative of various Sierra Club projects; the intent was not pure, and therefore neither was the subject matter. Sidestepping his favorite model, the Sierra, Adams began photographing commonplace objects found around the docks and beaches of his hometown San Francisco, from lichen-encrusted anchors to a beautifully lit, casual pile of ropes on a dock. Adams also produced his first sequence, of wrecked ships, concentrating on details of their rusted metal countenance. On assignment for Mills College that year, Adams made his first close-up detail from nature, *Leaves, Mills College.* Playing about in his studio, he photographed *Scissors and Thread* in close-up and with

natural light to reveal "the microscopic revelation of the lens."[11]

It was at this time, early 1931, that he began to use glossy papers.[12] In 1933 Adams wrote, "Almost overnight the fussy *accoutrements* of the Pictorialists were discarded for the simple dignity of the glossy print."[13] Also in 1931 Adams's involvement with the serious photographic community of San Francisco blossomed when he accepted the position of photographic critic for the *Fortnightly*, a short-lived review of literature, music, and the arts. Writing the reviews forced him to formalize his own photographic philosophy. San Francisco needed a photography critic: the new, young director of the M. H. de Young Memorial Museum, Lloyd Rollins, unhesitatingly (and revolutionarily) included photography within that grand museum's halls and scheduled exhibitions of the work of Eugène Atget, Edward Weston, Imogen Cunningham, and Ansel Adams.

On November 6, 1931, Adams's first column appeared, critiquing an exhibition and book by the French photographer Atget, who had died four years before. "This book [*Atget, Photographe de Paris*] represents Atget's significant and lonely gesture in the direction of austere expression, consummated in the use of clear images, smooth honest papers, and in the complete absence of affected imitation of other art forms. The Pictorialist is on the wane: the blurred indefinite poetic prints are slowly but surely passing into historic oblivion."[14]

Adams's last review for *The Fortnightly* was of Imogen Cunningham's exhibition at the de Young. The self-righteousness of the new convert to glossy paper is evident.

> [T]he quality of *light* in her prints is not convincing. I venture to diagnose this deficiency of luminosity as something inherent in her choice of papers for her prints; if she were to use a smooth, glossy surface the true qualities of the photographic image would be revealed to greater advantage. The luminous factor in photography is independent of the tonal key of the print. . . .
>
> Yet Miss Cunningham's art easily dominates in her exceedingly fine technique of visualization: she knows what she wants to do and succeeds in doing it well within the limitations of her medium. Her work is very beautiful and sincere.[15]

One can imagine Cunningham's scorching reaction to this younger and less successful photographer's suggestions for improvement.[16] Weston's letter in response to Adams's review exists:

Your article I appreciated fully, it was an intelligent consideration, by far more so than I get because it was a subject close to your own heart. . . . Photography as a creative expression . . . must be "seeing" plus. . . . The "plus" is the basis of all arguments on "what is art." . . . I don't want just seeing—but a presentation of the significance of facts, so that they are transformed from things (factually) *seen*, to things *known*: a revelation, so presented —wisdom controlling the means, the camera—that the spectator participates in the revelation."[17]

Adams and Weston discovered each other worthy comrades. They agreed on most matters and respected their differences. Humorously sparring in person and through the mails to more finely tune their philosophies of life and photography, their close friendship lasted until Weston's death in 1958.

Adams's solo exhibition was the next to be presented at the de Young, during February 1932. Three galleries of his photographs, eighty in all and many made during the previous year, covered a much greater diversity of subjects than had his Smithsonian show just one year earlier.[18] One reviewer described "a number of semi-abstractions, stones, details of wood, and many of sea rocks and shipwreck [*sic*]. There are also series of prints of New Mexico, Canadian Rockies, Yosemite winter subjects, and city views."[19]

In a statement written for the de Young, Adams declared that his pictorialist period had ended in 1930.

For the past year work has been chiefly studies and experiments in pure photography. . . . The prints in this exhibition represent my attempts to define photography as an art form. I am convinced that through the medium of the camera the artist can evolve a highly individual art expression completely independent of the other traditions of the graphic arts, yet securely based on fundamental aesthetic principles. If one speaks in the language of photography one must not use the syntax of painting or etching and expect convincing results. . . . Photography at best is the recording of the physical and emotional aspects of the subject *as it appears in the camera* guided by a discerning and selective imagination of the artist. And the artist must have a clear and complete conception of the final effects of the print *before* he operates the shutter of his lens. . . . the photograph is completed before it is taken.[20]

Adams's aesthetic of straight photography was now fully in place.

Lloyd Rollins continued his support of photography at the de Young with two subject-oriented competitions,

A Showing of Hands[21] and *California Trees*. In the words of a historian, the intent of the second exhibition "was to stimulate interest in trees as features of our landscape, to encourage their preservation, and to suggest, via photographic art, their beauty and spiritual appeal."[22] Of the eight hundred photographs submitted, 160 were hung in the de Young from September 21 to October 21, 1932. The first prize of one hundred dollars was awarded to Edward Weston for an image of a Joshua tree. Second prize went to Alma Lavenson for *Snow Blossoms*, fourth to Ansel Adams for *Sugar Pine*, and seventh (and last) place to Willard Van Dyke for *Detail of Madrone*. Others exhibiting who were to become associated with Group f.64 included Henry Swift and John Paul Edwards. These two competitive shows doubtless sorely tried the patience of photographers such as Weston, Adams, and Van Dyke. With his sponsorship of theme exhibitions, Rollins showed that he did not fully understand the serious intent of the photographers.

For their own part, Bay Area straight photographers came to congregate at 683 Brockhurst, a photographic gallery in Oakland operated by Van Dyke and Mary Jeannette Edwards, daughter of John Paul Edwards. During the run of *California Trees*, Adams, Cunningham, Weston, Sonya Noskowiak, and John Paul Edwards were among those photographers invited by Van Dyke and Edwards to a party in their gallery to discuss the state of photography. Though Weston was the senior member, it was Adams and Van Dyke who insisted they proclaim as a group their united stand for straight photography. It was decided this could best be accomplished by exhibiting together, and they talked of renting a space in San Francisco. In his daybooks Weston wrote, "This idea was abandoned out of consideration for Lloyd Rollins who has done so much for photography during his directorship at the museum. Lloyd felt we would be directly in competition with him, and offered an alternative; to give us a group show."[23] Virginia Best Adams, Ansel's wife, had not been present at the party at Van Dyke's house, but she remembers that at least one or two further meetings of the group took place at the Adamses' home in San Francisco.[24] Preston Holder, Van Dyke's classmate at the University of California, Berkeley, recalled that the group met three or four times on occasions that were probably more social than business. According to Holder, "Ansel did two incredible musical gestures when we were drinking. One of them was to play a tune on the piano with oranges in his hands and the other was the Blue Danube Waltz played with his *sitz platz*. At any rate he was very human."[25]

Probably because he lived closest to the museum and

also because of his enthusiasm, Adams played a central role in organizing the de Young exhibition. It was he who was responsible for the exhibition announcements (see back cover flap). His account of cash receipts, dated December 2, 1932, and recorded neatly in Virginia's hand, credited ten dollars paid by Weston, Edwards, Cunningham, Swift, and Van Dyke. Weston wrote Adams, "Here is my check for $10.00. Thanks for allowing Sonya to come in on my check; $20.00 *would* be a bit hard on me under present obligations."[26] Thus, assuming the honorable Adams also anted up, each of the seven members shared in the expenses, putting their money in service to their cause.

The people behind the great movements in modern art, such as the surrealists, futurists, and dadaists, had proclaimed themselves with manifestos. So, too, did the members of Group f.64. Their one-page statement was mostly written by Adams. Drafts were produced on his typewriter and contain his handwritten corrections,[27] although the content was surely ratified by the group. It reads like unadulterated Adams and harkens back to his own statement for his de Young exhibition earlier that year.

> The name of this Group is derived from a diaphragm number of the photographic lens. It signifies to a large extent the qualities of clearness and definition of the photographic image which is an important element in the work of members of this Group. . . .
>
> . . . The Group will show no work at any time that does not conform to its standards of pure photography. Pure photography is defined as possessing no qualities of technic, composition or idea, derivative of any other art-form.[28]

At the de Young show, with the exception of Adams, who showed ten, the original gang of seven exhibited nine prints each and the four invitees, four. Adams's selection was a bravura display—three portraits, three details, one architectural study, and three landscapes. Two of his portraits, frame-filling head shots of Annette Rosenshine and Domenico Brescia made in the studio with artificial light, were perhaps the least successful of his images, intentionally looking more like sculpture than flesh and blood. More engaging is the environmental portrait *Gottardo Piazzoni in His Studio* (pl. 65).

Both *Pine Cone and Eucalyptus Leaves* (pl. 62) and *Boards and Thistles* (pl. 63) were mainstream f.64 style: commonly found objects, sharply focused lens placed directly before the subject, great depth of field, and a full range of tones printed on glossy papers. Natural light warmed and enlivened these inanimate subjects, just as

Adams's studio lighting had deadened his animate ones. *Factory Building* (pl. 64) does not become part of Adams's mature vision but appears to reflect the influence of Weston and Charles Sheeler. *Cottonwood Trunks, Yosemite Valley* (pl. 58) is a graceful image dominated by soft tonalities made in low light levels; it could have been made by any number of photographers.

The final three images are much more arresting. *Nevada Fall, Yosemite Valley* (pl. 57) is a direct translation of the Group f.64 practice of filling the picture space with the object itself. Adams had been doing that for years, but his earlier photographs of waterfalls had been static compositions. Here, Nevada Fall, framed by water-slickened granite and a filter-darkened sky, cascades powerfully out of the picture plane, right at the viewer. Two years later, in 1934, it was published with this caption: "A superb study of water, considered by the photographer his best landscape photograph."[29]

Golden Gate (pl. 56) is another image that has remained memorable. "One beautiful storm-clearing morning I looked out the window of our San Francisco home and saw magnificent clouds rolling from the north over the Golden Gate. I grabbed my 8 x 10 equipment and drove to the end of 32nd Avenue . . . [and] dashed . . . to the crest of a promontory. From there a grand view of the Golden Gate commanded me to set up the heavy tripod, attach the camera and lens, and focus on the wonderful evolving landscape of clouds."[30] Most likely made in April or early May 1932 with his new 8-by-10-inch view camera, *Golden Gate* has a sky on the scale of eternity, embellished with mounding clouds and dwarfing the earth below. Prior to this, his photographs had emphasized the land.[31]

Lake and Cliffs (pl. 59) is a masterpiece; John Szarkowski has described it as "an astonishing, it seems to me, unprecedented photograph." *Lake and Cliffs* is one of the earliest abstract photographs made directly from nature. Adams chose a telephoto lens to make this negative, which isolated the scene, eliminating the sky and telescoping cliff, ice, and water into an insistently two-dimensional, flat image. According to Szarkowski, "This is not a landscape for picnics, or for nature appreciation, but for the testing of souls."[32]

What was the common denominator between these photographs by Adams and those by the others in Group f.64? What made them enduring monuments to straight photography? The photographs were all made with view cameras and sharply focused lenses, printed on glossy papers with simple mounts. Subject matter tended to be everyday things, from leaves to wheels to vegetables.

Group f.64 photographs largely reflected Edward Weston's definition of straight photography, emphasizing close-up details and textures, the subject purposely isolated from the distractions of a background. This definition applies to seven of Adams's images, but not those last three: *Golden Gate, Nevada Fall,* and *Lake and Cliffs.* Adams was born overlooking the Golden Gate, and yet it took him until that day in 1932, after thirty years of seeing it, to find the unique atmospheric conditions. His vision did not specify a quiet day, a regular day—which is what Weston would have happily chosen. For Adams it must have been a day like no other.

Pure photography did not mean no manipulation; it was agreed that negatives and prints could be manipulated as long as a prescribed list of techniques considered to be photographic in nature was used. The choice of lens could alter spatial relations and relative scale. The tonal contrast of the negative could be enhanced or diminished during development. Dodging and burning during the printing of the image could lighten or darken specific areas of the photograph. But all of these techniques could be used only to a limited degree, so that they did not interfere with the essence of the reality of the scene before the photographer.

In 1935 John Paul Edwards described the group's technical recommendations in his article "Group F:64" published in *Camera Craft*.[33] He carefully stated, "K1 and K2 color filters provide an ample range of color correction for nearly all subjects." These yellow filters were allowed to separate clouds from their blue background. But Edwards selected the word "correction," meaning "to conform to a known truth."

In 1935 Adams wrote for a British publication:

As one function of photography is the translation of colours into various degrees of *grey,* so related as to preserve the *emotional* effect of the colour, it is apparent that the photographer must often exercise the controlling powers of his filters in order to achieve this emotional translation. . . . Over-correction, in the strictly technical sense, means the distortion of relative values of colour. However, technical over-correction may sometimes be useful in the emotional presentation of the subject material. This control is legitimate in straight photographic procedure.[34]

Contrast this with Edward Weston's opinion, printed in the same book. "The mechanical camera and indiscriminate lens-eye, by restricting *too personal interpretation,* directs the worker's course towards an *impersonal revealment* of the objective world. 'Self-expression' is an objec-

tification of one's deficiencies and inhibitions."[35]

Adams's differences with both Weston and Edwards were clear and deep. He was driven to photograph romantic interpretations of the essence of the scene through his own emotions. He had discovered with *Monolith* that a great shift in tonal values produced the impact he desired. With *Nevada Fall* he had also chosen to shift reality with a filter. He was alone among the Group f.64 members in seeking to create enhanced drama in his finished prints.

Following the de Young exhibition, Adams continued to expand his definition of straight photography. Adams contributed to Edwards's 1935 *Camera Craft* article: "I consider the production of Group f 64 as definitely transitional in character. . . . The variety of approach, emotional and intellectual—of subject material, of tonal values, of style—which we evidence in our respective fields is proof sufficient that pure photography is not a *métier* of rigid and restricted rule. It can interpret with beauty and power the wide spectrum of emotional experience."

Group f.64 continued to function actively only as long as it took to produce the de Young exhibition. It was amazing that so many independent and strongly opinionated artists came together even for so brief a time. The passion of their cause, the recognition of straight photography, united them.

During an interview in 1983, Willard Van Dyke, Adams, and the historian Beaumont Newhall were asked, "why was Group f.64 formed?" Van Dyke answered, "We had agreed to do our own thing and were surprised at the reaction by the Pictorialists and [William] Mortensen to what we were doing. We didn't have a sense of gospelizing." At which point Adams interjected, "I did! I had a sense of mission. A simple, straight print is one of the most beautiful expressions possible."[36] At another time Adams spoke of Mortensen, saying that "for us he was the anti-Christ. We stood for exactly the opposite of everything he represented."[37]

In response to the question during the interview of how being a member of the group affected his work, Adams replied, "It confirmed my own ideas—seeing other work and 'seeing' for the first time. I finally enjoyed and understood Edward Weston. The vibrations of the group increased my understanding and gave me confidence." Van Dyke recalled, "I was the youngest member. It was tremendously satisfying to come to Ansel Adams and Edward Weston and discuss prints—have them give [my work] serious consideration. Then Imogen Cunningham would make a wisecrack that would pare it right down."

During the Group f.64 exhibition, Virginia Adams

discovered she was pregnant with her first child.[38] Her father gave the young couple a gift of one thousand dollars so they could travel to the East Coast before being burdened with the responsibilities of parenthood. Adams hoped to show his work to Alfred Stieglitz, whom he saw as "the Emancipator of the new art,"[39] freeing photography from the slavery of pictorialism. Adams arrived at Stieglitz's New York gallery, An American Place, on or about March 31, 1933. Stieglitz was impressed by this very western man and his work. Though he did not offer Adams an exhibition until 1936, Stieglitz did accept him as a disciple. On his return to San Francisco, Adams wrote Stieglitz, "I trust you will believe me when I say that my meetings with you touched and clarified many deep elements within me. It has been a great experience to know you."[40]

Unfortunately for photography, Lloyd Rollins lost his position at the de Young, and San Francisco was bereft of a photography forum. Adams rented a space in downtown San Francisco on Geary Street and opened the Ansel Adams Gallery, dedicated to the exhibition of fine art photography, painting, and sculpture—the same combination that was found at An American Place. Opening this new business must have been seen as foolhardy by Adams's family and friends, because it was made in the depths of the Great Depression.

The inaugural show, September 1–16, 1933, was of Group f.64, the original seven plus Consuelo Kanaga. Adams wrote to Strand requesting an exhibition of his photographs, adding, "I can assure you there is enough interest in photography in San Francisco to provide a large and grateful attendance to a Strand show. Within eight days about 500 people have come to the F 64 show, and I am gratified that most of them evidenced a real interest and understanding in what the group is trying to do."[41] Strand, Stieglitz, and Charles Sheeler all declined exhibitions.

In addition to his own work, Adams showed that of the photographers Edward Weston and Anton Bruehl, the sculptor Ralph Stackpole, and the painters Jane Berlandina, Jean Charlot, Marguerite Thompson Zorach, and William Zorach. Sales were pitiful. Adams reported to Charlot that he had sold two oil paintings and two lithographs for a total of $135. Subtracting $46 for the expense of announcements and reproduction photographs and $29.66 for a commission, he rounded off the net total of $59.34 and sent Charlot a check for $60.[42] Adams gave up the gallery in the spring of 1934, unable to make a go of it and still have time for his own photography.

The Great Depression had hit the West Coast later than the East, and its effects challenged American political and social values. Many artists responded directly, choosing to document the grave effects on both the American people and lands. Van Dyke moved to New York and became a filmmaker, convinced that, "We had to change the world. We couldn't have people starving. I thought that film could promote change faster than still photography. I was wrong. Your [Adams's] photographs awakened a sense of wilderness. Dorothea [Lange] and Walker [Evans] increased the sensitivity of people. Motion pictures are ephemeral. One in 100,000 people can remember *The River* or *The City*. They're up there on the screen and then they're gone."[43] Preston Holder remembered, "I had hopes for that group, that it would activate some of those people to do some socially aware things. But I was the only one in the group who agreed on my plan of what f/64 should be."[44]

The work of Weston and Adams did not reflect the desperation of the times. Undaunted by criticism, they continued to photograph rocks and trees, and supported each other in this decision. Venting his frustration to Weston, Adams wrote, "You and I differ considerably in our theory of approach, but our objective is about the same—to express with our cameras what cannot be expressed in other ways—to trust our intuition in respect to what is beautiful and significant—to believe that humanity needs the purely aesthetic just as much as it needs the purely material."[45]

Though Adams's photographs did not overtly reflect the world's troubles, his personal actions did. He became deeply involved with the Sierra Club, was first elected to its board of directors in 1934 and served until 1971, becoming one of the great leaders of the American environmental movement. His role in the Sierra Club allowed him to be involved and responsible to society and man.

During the years immediately following the de Young Group f.64 exhibition, Adams, more than any of the others, continued to proselytize at every opportunity. He was hired by *Camera Craft* to write a series of articles that began in January 1934. This was a great victory for straight photography because *Camera Craft* had long been the platform of Group f.64's archenemy, Mortensen. In his first *Camera Craft* column Adams wrote, "The purpose of these articles is to present to the readers of *Camera Craft* the outlines of a technical procedure that is of the utmost simplicity and strictly photographic."[46] He then formulated his photographic aesthetic, an amalgam of Weston's "seeing plus" and his own concept of visualization. "The photographer who thoroughly comprehends

his medium visualizes his subject as a *thing in itself*. He does not impose qualities foreign to the actual quality of the subject, but he defines his own conception of the subject through his medium. He visualizes, before operating the shutter, the completed photograph."

The final salvo in his crusade in the wake of Group f.64 was the publication of his first book on photographic technique, *Making a Photograph*, in 1935. In ninety-six amply illustrated pages, Adams took the amateur by the hand and clearly demonstrated how to become a straight photographer. Stieglitz wrote to Adams, "I must let you know what a great pleasure your book has given me. It's so straight and intelligent and heaven knows the world of photography isn't any too intelligent—nor straight either."[47]

In 1936 an exhibition of Adams's photographs opened at An American Place, the first solo show by a photographer other than himself that Stieglitz had presented since Paul Strand's in 1916. Adams was now fully recognized as a leading artist of the world, not just the West. Forty-five Adams prints hung in the urban, sophisticated world of New York from October 27 to November 25, 1936.

In the late 1920s, Adams's vision had been molded by the Sierra and the needs of the Sierra Club. His photographs for the Group f.64 exhibition clearly reflected their parameters, just as the photographs at An American Place reflected Stieglitz as much as Adams. With that exhibition, he had achieved the pinnacle of success in creative photography: anointed before the world by Stieglitz, whose praise provided the deepest affirmation and whose intellectual reinforcement had been critical.

Following the Stieglitz exhibition, Adams found himself totally exhausted. He had done what he should do, supplying the "right" images for f.64 and the "right" ones for Stieglitz; but none of them was fully satisfying. Although he had found critical success, he was unhappy and frustrated with his work. It is just then that Virginia's father died, leaving them his studio. The way became clear. Adams moved his family to Yosemite in 1937. He returned to the valley, his spiritual home, believing Yosemite would heal and cure, and it did.

In an assured and confident style that spoke of no one's vision but his own, his camera now included, rather than excluded, revealing landscapes rich with complex juxtapositions of tone, texture, and form, unabashedly shifting the reality of the scene when he felt it necessary. During 1937 and 1938 he created such important images as *Clearing Winter Storm*, *Merced River, Cliffs, Autumn*, and *Dawn, Dolores River Canyon*, soon followed in the early 1940s with such masterpieces as *Moonrise, Old Faithful Series, Winter Sunrise*, and *Mt. Williamson*. What emerged was a grand, sweeping vision, triumphantly expressing the sentiments of Cézanne, "The landscape thinks itself in me. . . . I am its consciousness."[48]

Group f.64 purposefully inscribed on its members a self-limiting definition of photography. The photographer served as channeler for the reality of the world as revealed with light-sensitized paper. Painterly expressiveness and overt emotionalism were traits of the enemy camp, the pictorialist. Adams's greatest photographs bravely meld the strengths of these warring traditions, creating a reality dominated by his powerful emotions, yet produced using strictly photographic techniques. Adams expressed a more dramatic and eternal reality in which the earth's great beauty is beyond the sensitivity of normal eyes; where pale blue skies are parted to reveal a glimpse of the universe itself.

NOTES

The abbreviation "CCP" refers to the Center for Creative Photography, University of Arizona, Tucson.

1. Ansel Adams with Mary Street Alinder, *Ansel Adams: An Autobiography* (Boston: Little, Brown & Co., 1985), p. 73.

2. Nancy Newhall, *The Eloquent Light* (Millertown, N.Y.: Aperture, 1980), p. 47.

3. Newhall, *Eloquent Light*, p. 30.

4. Newhall, *Eloquent Light*, p. 60.

5. Adams with Alinder, *Autobiography*, p. 109.

6. Matte, textured papers absorb light, reducing the intensity of tonal values. Glossy papers, which reflect light, render more fully the qualities of each photograph.

7. Ruth Teiser and Catherine Harround, *Conversations with Ansel Adams* (Berkeley, Calif.: The Bancroft Library, 1978), p. 181.

8. The circumstances that led to the Smithsonian exhibition are unknown. In an interview on September 16, 1991, Virginia Adams had no recollection of events. It is possible that Francis Farquhar, who, as editor of the *Sierra Club Bulletin*, had championed Adams's photographs and used his connections in Washington, established when he worked there for Stephen Mather, the first director of the National Park Service.

9. "Pictorial Photographer Show," *Washington Post*, January 11, 1931.

10. Newhall, *Eloquent Light*, p. 69. From later vantage points, Adams can be found to recall more than one event that turned him toward straight photography.

11. Ansel Adams, "An Exposition of My Photographic Technique," *Camera Craft* 41 (January 1934): 20.

12. Using glossy papers was a total and final change, save for his *Sierra Club Outing* portfolios. The last of these was made to commemorate the 1932 expedition, for which he continued to use matte-surfaced Dassonville Charcoal paper.

13. Newhall, *Eloquent Light*, p. 69.

14. Ansel Adams, "Photography," *The Fortnightly* (November 6, 1931): 25.

15. Ansel Adams, "Photography," *The Fortnightly* (February 12, 1932): 26.

16. In his autobiography, Adams described her as "fearless, acrid, opinionated, capable, and, in her particular way, affectionate and loyal"; p. 176.

17. Mary Street Alinder and Andrea Gray Stillman, eds., *Ansel Adams: Letters and Images, 1916–1984* (Boston: Little, Brown & Co., 1988), pp. 48–49.

18. "All around the Town," *The Argonaut* (February 5, 1932): 10.

19. "Photograph Exhibit by Ansel Adams Interests Peninsula," *San Mateo Times and Daily News Leader*, February 15, 1932.

20. "Ansel Easton Adams," statement for solo exhibition, M. H. de Young Memorial Museum, February 1932.

21. In an interview with Virginia Adams, September 16, 1991, she remembered that Adams had commandeered the hands of friends and family as subjects and photographed her hands threading a needle and peeling potatoes. This explains why, as one weaves through the archives of Northern California photographers, there is an amazing number of images of hands made in 1932, most of which are object lessons in the futility of assigning a creative artist a subject.

22. Richard Dillon, "California Trees Revisited," exhibition statement, University of California, Berkeley, 1981.

23. Nancy Newhall, ed., *The Daybooks of Edward Weston: California* (New York: Horizon Press, 1966), pp. 264–65. This daybook entry was made on November 8, 1932.

24. Virginia Adams, interview with the author, August 16–18, 1991.

25. James Alinder, "The Preston Holder Story," *Exposure* (February 1975): 3.

26. Letter from Edward Weston to Ansel Adams, postmarked October 19, 1932; Edward Weston Archive, CCP.

27. Included in Craven's file was a photocopy of the final draft of the Group f.64 manifesto with corrections in Adams's hand. In addition, I found the original of this document at Adams's Carmel studio. It is now in the Ansel Adams Archives, CCP. Some differences of opinion exist regarding authorship of the f.64 manifesto. See, for example, Therese Heyman's essay in this volume, which attributes the work to Van Dyke and Holder.

28. Adams with Alinder, *Autobiography*, pp. 111–12.

29. Ansel Adams, "The New Photography," *Modern Photography, 1934–35* (London and New York: The Studio Publications, 1934), pl. 1.

30. Ansel Adams, *Examples: The Making of Forty Photographs* (Boston: Little, Brown & Co., 1983), p. 19.

31. As much as we remember the great clouds in his pictures, this is one of the first to emphasize them. Most of his earlier landscapes had cloudless skies, just as did those made by nineteenth-century photographers, due to the oversensitivity of photographic emulsion to the color blue. The film Adams had most commonly used in the past had been orthochromatic, which rendered pale, cloudless skies. *The Golden Gate before the Bridge* was one of his first 8-by-10-inch view camera images with Kodak Super-Panchromatic sheet film, an emulsion sensitive to the full spectrum of light. In addition, Adams also used a K3 yellow filter, which increased the contrast in the sky.

32. John Szarkowski, "Kaweah Gap and Its Variants," *Ansel Adams, 1902–1984* (Carmel, Calif.: The Friends of Photography, 1984), p. 15.

33. John Paul Edwards, "Group F:64," *Camera Craft* 42 (March 1935): 107–13.

34. Ansel Adams, *Making a Photograph* (London and New York: The Studio Publications, 1935), pp. 49–50.

35. Edward Weston, Foreword, in *Making a Photograph*, p. 11.

36. Willard Van Dyke, Ansel Adams, and Beaumont Newhall, interview with the author, June 21, 1983.

37. Teiser and Harround, *Conversations with Adams*, p. 121.

38. Michael Adams was born on August 1, 1933. Their second child, Anne, was born on March 8, 1935.

39. Adams, *Modern Photography*, p. 12.

40. Alinder and Stillman, eds., *Letters*, p. 50.

41. Alinder and Stillman, eds., *Letters*, p. 58.

42. Letter from Ansel Adams to Charlot, October 7, 1933; Ansel Adams Archive, CCP.

43. Van Dyke, Adams, and Newhall, interview.

44. Alinder, "Holder," p. 2.

45. Alinder and Stillman, eds., *Letters*, pp. 73–74.

46. Ansel Adams, "Exposition of Technique," *Camera Craft* (January 1934): 19–25.

47. Alinder and Stillman, eds., *Letters*, p. 77.

48. Diane Ackerman, *A Natural History of the Senses* (New York: Vintage Books, 1990), p. 267.

MARY STREET ALINDER is an independent scholar, curator, and lecturer on the history of photography, concentrating on the life and work of Ansel Adams. She collaborated with Adams on *Ansel Adams: An Autobiography* and coedited *Ansel Adams: Letters and Images.* Among many exhibitions, Alinder was co-curator of "Ansel Adams: One with Beauty." She selected and wrote biographies for the third edition of the *Focal Encyclopedia of Photography.*

50

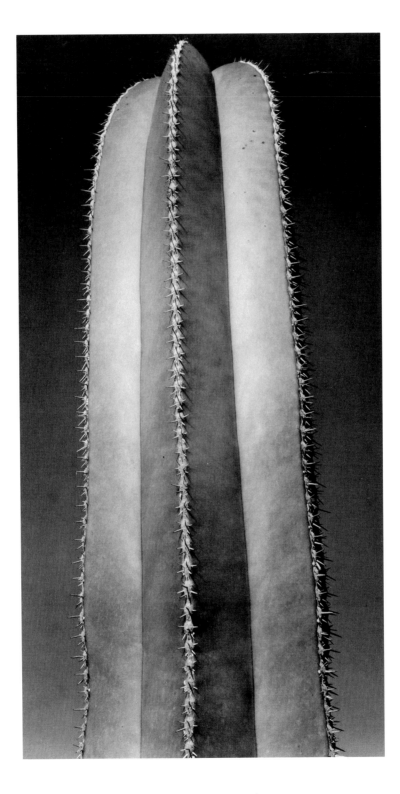

BRETT WESTON

Cactus, 1934

Collection of the San Francisco Museum of Modern Art, the Henry Swift Collection, gift of Florence Alston Swift

(Possible f.64 list 69)

52

Since many texts associated with f.64 exhibitions have not been reprinted since the 1930s, the pieces here were selected to allow the reader to consider the issues discussed at the time. Other texts, like the Edward Weston *Daybook* chapter on f.64, are cited in the footnotes and are widely available. Original spellings and punctuation, including the many variants of the name "f.64," have been retained throughout.

Clouds, torsos, shells, peppers, trees, rocks, smokestacks, are but interdependent, interrelated parts of a whole—which is life. Life rhythms, felt in no matter what, become symbols of the whole. The creative force in man recognizes and records—with the medium most suitable to him, to the object of the moment—these rhythms, feeling the cause, the life within the outer form.

Recording unfelt facts by acquired rule results in sterile inventory.

To see the thing itself is essential; the quintessence revealed direct, without the fog of impressionism—the casual noting of transitory or superficial phase.

This then: to photograph a rock, have it look like a rock, but be more than a rock. Significant representation—not interpretation.

The photographs exhibited, with the exception of the portrait studies, are contact prints from direct 8 x 10 negatives, made with a rectilinear lens costing $5—this mentioned due to previous remarks and questions. The portraits are enlarged from 3 1/4 x 4 1/4 Graflex negatives—the camera usually held in hands.

I start with no preconceived idea—discovery excites me to focus—then rediscovery through the lens—final form of presentation seen on ground glass, the finished print previsioned, complete in every detail of texture, movement, proportion, before exposure.

The shutter's release, which automatically and finally fixes my conception, allowing no after manipulation—the print, which is but a duplication of all that I saw and felt through my camera.

Statement written by Edward Weston for a forty-print exhibition at the Museum of Fine Arts, Houston, May 1930, exhibition wall label; *Houston Post-Dispatch*, May 4, 1930. Reprinted in *Edward Weston on Photography*, ed. Peter C. Bunnell (Salt Lake City: Gibbs M. Smith, Inc. and Peregrine Smith Books, 1983), p. 61.

I have no unalterable theories to proclaim, no personal cause to champion, no symbolism to connote. Too often theories crystallize into academic dullness,—bind one in a strait-jacket of logic,—of common, very common sense. To be directed or restrained by unyielding reason is to put doubt as a check on amazement, to question fresh horizons, and so hinder growth. It is essential to keep fluid by thinking irrationally, by challenging apparent evidence and accepted ideas,—especially one's own.

In a civilization severed from its roots in the soil,—cluttered with nonessentials, blinded by abortive desires, the camera can be a way of self-development, a means to rediscover and identify oneself with all manifestation of basic form,—with nature, the source.

Fortunately, it is difficult to see too personally with the very impersonal lens-eye: through it one is prone to approach nature with desire to learn from, rather than impose upon, so that a photograph, done in this spirit, is not an interpretation, a biased opinion of what nature *should be*, but a *revelation*,—an absolute, impersonal recognition of the *significance of facts*.

The camera controlled by wisdom goes beyond obvious, statistical recording,—sublimating things *seen* into things *known*.

"Self expression" is usually an egotistical approach, a willful distortion, resulting in over or understatement. The direction should be toward a clearer understanding through intentional emphasis of the fundamental reality of things, so that the presentation becomes a synthesis of their essence.

Edward Weston
Carmel, California: February 1932

From the announcement of an exhibition of photographs by Edward Weston, shown at the Delphic Studio, 9 East 57th Street, New York, from February 29 through March 13, 1932. Courtesy of Amy Conger, research files.

The name of this Group is derived from a diaphragm number of the photographic lens. It signifies to a large extent the qualities of clearness and definition of the photographic image which is an important element in the work of members of this Group.

The chief object of the Group is to present in frequent shows what it considers the best contemporary photography of the West; in addition to the showing of the work of its members, it will include prints from other photographers who evidence tendencies in their work similar to that of the Group.

Group F. 64 is not pretending to cover the entire field of photography or to indicate through its selection of members any depreciating opinion of the photographers who are not included in its shows. There are a great number of serious workers in photography whose style and technic does not relate to the *métier* of the Group.

Group F. 64 limits its members and invitational names to those workers who are striving to define photography as an art-form by a simple and direct presentation through purely photographic methods. The Group will show no work at any time that does not conform to its standards of pure photography. Pure photography is defined as possessing no qualities of technic, composition or idea, derivative of any other art-form. The production of the "Pictorialists," on the other hand, indicates a devotion to principles of art which are directly related to painting and the graphic arts.

The members of Group F. 64 believe that Photography, as an art-form, must develop along lines defined by the actualities and limitations of the photographic medium, and must always remain independent of ideological conventions of art and aesthetics that are reminiscent of a period and culture antedating the growth of the medium itself.

The Group will appreciate information regarding any serious work in photography that has escaped its attention, and is favorable towards establishing itself as a Forum of Modern Photography.

Manifesto prepared by members of Group f.64 and displayed in the exhibition held at the M. H. de Young Memorial Museum, November 15 through December 31, 1932. From the original held in the files of the M. H. de Young Memorial Museum.

54

The name of the organization was intriguing. The show was recommended to us as something new, not as individual work might go but as a concerted effort specifically aimed at exploiting the trend. We went with a determined and preconceived intention of being amused and, if need be, adversely critical. We came away with several ideals badly bent and not a few opinions wholly destroyed. We were not amused, we could not criticise adversely. This was the line of thought:

First, classic forms of beauty have been, to us, inalienable from the pursuit of art. The f.64 Group have shown that there is something to say in a 1933 way that still may react on the cultivated senses as expressive of the beautiful.

Second, that these workers are not militantly adverse to the old order of things. They are not trying to forcibly revolutionize this, that, or anything whatever but are doing what it pleases them to do without thought of the past, the present or the future. Just doing things their own way.

Third, that they are doing it darn well.

To appreciate sharp focus, strong contrasts, exaggerated highlighting, and bizarre subjects one must attune oneself to the key and the motif. For a listener to enjoy Stravinsky he must dismiss the Chopin mood and prepare with a course of raw meat diet. The f.64 prints are like that. Black, oh, very black and white! Angular. The accents are stentorian. These pictures do not sing. They shout. Stay your deductions. What they shout is as appropriately shouted as a tender ditty is lilted. The unities are preserved. . . .

The Group is creating a place for photographic freedom. They are in a position to do so for not one of them but has made a place for himself in the hitherto accepted Salon field and not one of them but could make real pictures again if he wished. In fact we are certain that outside of the wholly legitimate showmanship that actuates and entertains their mood in this f.64 business, they are still making real pictures, surreptitiously if not openly. . . .

In a word, you will enjoy these prints. You will be impressed, astounded. But you will not love them nor want to hang them in your home. The wilful taste still prefers the too sweet Whitehead and Misonne. Perhaps a generation or two of nothing else and a latter-day Soviet training will inure us to this novelty. For us the destruction of an older taste will be like unto a surgical operation. So thick-headed are our sort.

Even when old tastes shall have been overcome and new understanding developed, we foresee that the reasoning mind which it has taken the specie so many ages to cultivate will demand something more mental in pictures than ingenious arrangements, unusual combinations, purely rythmic composition. Now, right now, we will concede Weston's greatness in his field. We consider the field small. We estimate lowly the highest achievement in portraiture of Gourds and Peppers.

Excerpted from Sigismund Blumann, "The F. 64 Group Exhibition," *Camera Craft* (May 1933): 199–200. Sigismund Blumann was a prominent pictorialist photographer.

It is particularly difficult to write an unbiased estimate of the work of a friend; inhibitions arise,—the fear of praising unduly, which tend, if anything, to sober one's enthusiasm. So when I state that Willard Van Dyke is one of America's most promising young photographers, I write with conviction. I will qualify "most promising," by adding that he has gone beyond many workers already accepted. Not that I wish to say Van Dyke has "arrived;" nor, I am sure, does he so believe. He has many years ahead before reaching that goal, which is after all never reached.

Five years ago Van Dyke came to "study" with me. I found he had already an adequate technical foundation on which to build; that he had an intelligent approach to straight, unmanipulated photography; that he possessed a fine balance between intellect and emotion; that he would never be satisfied; which left me very little to teach! For after the necessary technical basis to start from, "nothing worth learning can be taught;" a teacher can only stimulate.

Since 1929, I have watched the maturing of Van Dyke's viewpoint and technique; and his ever sensitive reactions to life. A group of the resulting photographs are on display now at the Denny-Watrous Gallery, Carmel. I will not attempt to evaluate individual prints; this is a pleasure and privilege each one should have for himself.

In addition to his use of photography as an expression, Willard Van Dyke, with Mary Jeannette Edwards, maintains an unique gallery in Oakland, known as "683 Brockhurst." Here they present exhibitions, not only of the best known workers in straight photography, but also of the most promising "unknowns." Since the usual "Salon of Photography" is devoted to the cause of those photographers who use their medium to imitate the worst in other mediums, this little gallery has an important function in showing work which the general public might otherwise never see.

Edward Weston
Carmel – 3-2-34

Statement by Edward Weston about Willard Van Dyke's exhibition at the Denny-Watrous Gallery, Carmel. Courtesy the Center for Creative Photography, University of Arizona, Tucson.

There have always been purists in art just as there have been puritans in morals. Purists and puritans alike have been marked by a crusading devotion to self-defined fundamentals, by a tendency to sweeping condemnation of all who over-step the boundaries they have set up, and by grim disapproval of the more pleasing and graceful things in life. Both of them, in their enthusiastic zeal for putting down gross abuses, are prone, in Savonarola fashion, to throw everything onto the fire. So, instead of merely fulfilling their salutary function of clearing out rubbish and getting down to basic principles, they have set themselves perversely in the way of further progress. . . .

Here, surely, was opportunity for the reformer and his torch and a rousing "bonfire of vanities". Such a reformation movement was forthcoming in the work of the so-called purists. Rationalizing their prejudices into a definition of the aim of photography, they found it to consist in an objective rendering of fact free from any "conceptions reminiscent of other mediums". Manipulation or retouching of negatives or prints they shunned as the plague. They stressed the need of simplicity and sincerity, and the vital importance of solid technical knowledge. Their work is uniformly hard and brittle, shows technical competence, and consistently avoids any subjective interest. And after the perennial fashion of reformers, they have duly erected their reforms into a code, and have chosen to regard a good clean contact print as the end of the photography rather than as its indispensable beginning. . . .

Photography as a technique and an art is very young, much too young for any one to say just what is "photographic". So, even if it were desirable, it would be an exceedingly presumptuous act to fence in a narrow tract and label it "pure photography". Regarded merely as a means of objective representation, photography is a shallow medium possessing neither breadth nor emphasis. To confine oneself to this aspect of photography is to be guided by the weakness rather than the strength of the medium. . . .

"Staticism" in portraiture is another quality sought by the Realists. By this expression they mean photographing a head or figure in objective terms as if it were a piece of sculpture. Given appropriate subject matter, such impersonal handling may be very impressive; but here again the Realists are betrayed by their unselective and literal rendering of details. Accidental, temporary things thrust

themselves into the attention. A wisp of hair out of place, a skin imperfection, an assertive pattern in the dress—and the desired static, sculptured quality breaks down into a mere conglomerate of detail.

"Simplicity" is another excellent standard which the Realists have set themselves—simplicity in equipment and in rendering. Unquestionably such simplicity characterizes the best in art. But, with the Realists, simplicity in rendering is often lost through their passion for irrelevant detail. As to simplicity in equipment—three cameras and six lenses. Three very similar portraits are shown as the product of two cameras and three lenses. Simplicity of equipment is of value only because it enables one to be master of his tools and concentrate on the sole end of photography—the making of pictures. To thoroughly master three cameras and six lenses in all their permutations would require a considerably longer life-span than Providence has allotted to photographers. An imperfectly mastered tool is largely master of its user. So great is the technical obsession revealed by some of the purists that it seems not illogical to suggest that they keep their prints at home and send their cameras to the salons. . . .

So much for the inherent contradictions of the purist position. More serious are the deviations of the purist tenets from basic art principles. Especially fallacious is their assumption that artistic truth lies in a complete rendering of literal detail, in a "record of actuality". Truth in art lies in the rendering of *experience*—or rather in the rendering of things-as-they-are-experienced, not of things-as-they-are. Psychological truth, not scientific accuracy, is the species of veracity with which art is concerned—conformity not to fact, but to the mind's way of apprehending fact. . . .

The whole program of the purists inclines to overlook the basic truth that the final concern of art is not with facts, but with ideas and emotions. All who talk glibly of new art forms and new techniques must be prepared to cope with that laconically cruel of all questions: "And so what?" Or to put it less tersely: "What are you trying to tell with your forms and your techniques?" Technically speaking, photography is a matter of facts. The image produced by the lens is an optical fact; fixed on paper, it becomes a chemical fact. *A chemical fact can never become a picture unless an idea and an emotion are also present; and these are qualities that cannot be added to the developer. . . .*

The principal fruit of the purist movement so far has been a series of excellent finger exercises in technique.

This is well and good. Most aspiring pictorialists don't give themselves half enough hard, grinding work of this sort. But the purists (and here is my ultimate quarrel with them) insist emphatically that their finger exercises merit artistic consideration. Such consideration, I feel, cannot be given them until they are through with ostentatiously playing scales in the key of C.

Excerpted from William Mortensen, "Venus and Vulcan," *Camera Craft*, vol. 41 (June 1934): 257–65.

Fig. 15. William Mortensen, *The Spider Torture*, c. 1934. Collection of The Oakland Museum, gift of Mr. and Mrs. W. M. Nott.

A PURIST'S REPLY TO MR. MORTENSEN, 1934

June 8, 1934

Dear Mr. Young:

It is impossible for me to take issue with Mr. Mortensen on the subject of photography, for our definitions of the medium are too widely divergent to permit a common ground of discussion. I believe that an artist must express his time and place within the limitations of his medium; that every medium has its limitations; and that both in his work and in his writing, Mr. Mortensen has disregarded the exigencies of photography. However his article in your last issue is convincingly written, too convincingly, to let pass certain misconceptions Mr. Mortensen seems to have in regard to the purist, which might be misleading to someone who reads one side of the story only.

Mr. Mortensen says that the work of the purist lacks subjective interest. Either he must be unobservant, or he is unfamiliar with the work. Photography is an objective medium, true enough, but the most objective photograph is capable of arousing a profound subjective reaction in the mind of the spectator. In the infancy of any medium, there are produced examples which may be considered experimental, and important only as indications of a maturity of expression to come. Doubtless many of us are guilty of presenting photographs of this type. However, certain recent tendencies are away from mere pattern making toward photographs rendered in a straight manner, the interpretation of which may be considered definitely subjective. Furthermore this interpretation would be in the light of our time and our conditions, not in an escape from them into a nebulous past. . . .

Unfortunately, when the question of "staticism" in portraiture is considered, Mr. Mortensen takes Ansel Adams' remarks to represent the attitude of all the workers in the pure manner. Weston definitely disagrees with this point of view, and I am sure that John Paul Edwards and Imogen Cunningham also do not agree.

As to the subject of equipment: Ansel Adams is engaged in a variety of commercial jobs which necessitate the use of several cameras and lenses. The fact that he has mastered them is to his credit. Weston, on the other hand, uses one camera for portraiture and a view camera for all other work. Most of the men I know who work in pure photography use but one camera. It is far more usual to find "gadget hounds" among the users of miniature cameras. So much for the statement that we pay "lip-homage" only, to the doctrine of simplicity.

Mr. Mortensen objects to our complete rendering of detail, and says that our records of actuality are not artistic truth, because art "is things as they are experienced, not things as they are." The art of the purist *is* experienced. The experiencing of an emotional reaction to the subject is the impetus which causes him to make his photograph. The subject is "seen" however, within the confines of his objective medium, and he proceeds therefore, to make a photograph in a manner which best will convey to the spectator, the truth of the subject which has caused his emotional reaction. For after all the spectator has nothing from which to react but the photographic print. . . .

Yours truly,
Willard Van Dyke

Excerpted from a letter to the editor of *Camera Craft*, no. 41 (July 1934): 345–46.

60

The F:64 Group has prepared a group of 60 prints uniformly mounted on 14" x 18" mounts that will be available for exhibition by Camera Clubs or like organizations throughout the country beginning Feb. 1st, 1935. The show will be sent only to those who have facilities for exhibiting them under glass. This show affords a very unusual opportunity to see a very representative collection of the work of the leaders of the "Pure Photography" movement, and consequently should be of great interest. The F:64 group includes in its membership such well known names as, Edward Weston, Ansel Adams, Willard Van Dyke, John Paul Edwards, Imogene [sic] Cunningham, Consuela [sic] Kanaga, and several others. Requests for the exhibitions should reach Mr. Willard Van Dyke 683 Brockhurst St., Oakland, Calif., not later than January 5th, 1935, as the schedule will be made up at that time.

Excerpted from *Camera Craft*, no. 41 (December 1934): 257–65.

In August 1932 a group of photographic purists met informally at a fellow worker's studio for a discussion of the modern movement in photography.

All present had sympathetic ideas and ideals regarding the importance of the pure photography movement. It was felt that these kindred interests could be fostered to mutual advantage by the formation of a small active working group. Such a group was formed and given the significant, albeit provocative title, Group f.64. A group this, without formal organization or by-laws, officers, or titles, but strongly bound by appreciation of pure photography as a medium of personal expression.

The original membership of Group f.64 consisted of Edward Weston, Ansel Adams, Imogen Cunningham, Willard Van Dyke, Sonya Noskowiak, Henry Swift, and John Paul Edwards. Recently, Dorothea Lange, William Simpson, and Peter Stackpole have been added to the group.

The purpose of Group f.64 is not militant. It has no controversy with the photographic pictorialist. It does feel, however, that the greatest aesthetic beauty, the fullest power of expression, the real worth of the medium lies in its pure form rather than in its superficial modifications. Photography per se has inherent fine qualities which are never lost, though sometimes momentarily forgotten. The modern purist movement in photography, emphasized by the work of Group f.64, presents nothing essentially new, but is a definite renaissance. . . .

That we might view this subject from varied personal angles, I have requested and here present statements from . . . original members of the group regarding their individual approaches to photography:

EDWARD WESTON

To quote Edward Weston: (From "Photography", by Edward Weston, copyright 1934, Esto Publishing Co.) "Both the limitations and the potentialities of a given medium condition the artist's approach and the presentation of his subject matter. But limitations need not interfere with full creative expression; they may, in fact, by affording a certain resistance, stimulate the artist to fuller expression. The rigid form of the sonnet has never circumscribed the poet. In the so-called limitations of its means may be discovered one of photography's most important and distinguishing features. The mechanical camera and indiscriminate lens-eye, by restricting too

personal interpretation, directs the worker's course toward an *impersonal revealment* of the objective world. "Self-expression" is an objectification of one's deficiencies and inhibitions. In the discipline of camera-technique, the artist can become identified with the whole of life and so realize a more complete expression.

An excellent conception can be quite obscured by faulty technical execution, or clarified by faultless technique. Look then with a discriminating eye at the photograph exposed to view on the Museum wall. It should be sharply focussed [sic], clearly defined from edge to edge, from nearest object to most distant. It should have a smooth or glossy surface to better reveal the amazing textures and details to be found only in a photograph. Its value should be clear cut, subtle or brilliant, never veiled. This in brief is a pattern to work to."

WILLARD VAN DYKE

"I believe that art must be identified with contemporary life. I believe that photography can be a powerful instrument for the dissemination of ideas, social or personal. I believe that the photo-document is the most logical use of the medium."

ANSEL ADAMS

"I consider the production of Group F 64 as definitely transitional in character. I define *transitional* in regard to point-of-view—aesthetic and social. I believe we have obtained a fairly final expression of mechanical technique (in reference to the present development of the medium), and I think our next step should be the relation of this technique to a more thorough and inclusive aesthetic expression.

Our work has been basically experimental. In our desire to attain a pure expression in our medium we have made powerful attacks in various directions, stressing objective, abstract, and socially significant tendencies. These phases of our work should now be taken from the laboratory (along with our technical attainments) and functionally applied. I have always disagreed with an *obvious* approach to the above phases: I have argued that a basic aesthetic motivation was sufficient in all forms of art, and that this motivation, when applied to a definite functional problem, became in itself socially significant.

I feel we have taken upon ourselves an obligation to photography and to art in general, which we must always accept as a basis of our production. We have done truly important work in the re-establishment of the pure photographic medium as a form of Art; how important our contribution is [a question] only the future can reveal.

With this conviction in mind, I maintain that we can never lose sight of the transitional character of our present work. The comment I receive most often on Group F 64 is one of positive opinion that we have established a school—a technical ritual—and that we are active in maintaining the *Status quo*. We have become an *institution* in the mind of the photographic public; a rather disturbing and radical institution,—and our chief task at present will be to keep the prestige we have developed and at the same time expand in fresh and stimulating directions.

We have built up a host of imitators who, in the main, have merely extracted surface aspects—detail, glossy papers, white mount-boards, forced view-points, etc.—and are confident that they have achieved the quality of a Weston in so doing. Sad but true, most of this work is little better than average from any standards, and the most unfortunate element therein is the sense of false values established in the photographer himself. He seldom realizes that photography is not the result of any one, or of several, formulae or taboos; the ultimate aspect of the truly fine photograph is derived only from the comprehension of detailed elements in relation to basic conception. What photography seriously requires is adequate criticism on its own terms.

One of our major achievements is the exposition of the fact that diverse personal tendencies can be expressed through a similar approach to the medium (technically and intellectually). We have interpreted our respective points of view in a consistent purity of technique and aesthetic conception. Our ultimate objectives of expression are not identical by any means. The variety of approach, emotional and intellectual,—of subject material, of tonal values, of style—which we evidence in our repective fields is proof sufficient that pure photography is not a *métier* of rigid and restricted rule. It can interpret with beauty and power the wide spectrum of emotional experience."

Excerpted from John Paul Edwards, "Group F:64," *Camera Craft* (March 1935): 107–13.

62

. . . . The Eighties of last century witnessed great changes, revolutions, in photography. With the advent of the dry plate the cumbersome paraphernalia of the wet plate process passed, and a flock of amateurs entered. The late George Eastman's Kodak and roll film added to the flock, and thus photography became very popular. Meanwhile, many of the older professionals then were men who had entered photography in its earliest days, men who had been manual graph makers, draftsmen, painters and the like, who therefore knew what photography had done to the othergraphers; that it and the othergraphies were entirely different things, quite incomparable, for at their very best the capacities and intents of each are almost diametric opposites.

The newcomers however were unaware of that fact, so in looking around for new worlds to conquer they noted the art of the painters and draftsmen who, being creative artists as well as master craftsmen, depicted the spiritual as well as material qualities of objects, and decided that they, too, would do that. The outcome of their attempt is what is now called pictorialism. My description of its conception and birth is not quite correct and can be shot full of holes easily, but it must suffice herein. Anyway, that revolution created quite a stir and aroused tremendous popular interest in, and enthusiastic response to, photography.

After a while, however, some of the very men who had been most enthusiastic over pictorialism became satiated and, looking around them for another brand-new world to conquer, they ran into what is called "purism," which is . . . [what] all practical professional photographers have known and practiced for decades; though more or less well and intelligently.

The Latter Day Purist movement had little effect on insular England and left America almost untouched until recently when, just as the movement was half dead and forgotten—through being absorbed in and becoming part and parcel of current photography—in Germany where it originated, a handful of people residing mainly in Oakland and San Francisco, California, brought the carcass across the Atlantic and the continent, gave it a few shots in the arm to make it look alive and significant and, very recently, proclaimed it a "definite renaissance."

One of the greatest living purists is the German photographer, Moholy-Nagy, once dubbed, "The Inexorable" because in his talks, book and tracts published

years ago, he was uncompromising in his insistence for absolutely pure photography of microscopically fine definition, etc. In brief, what the handful of Belated American Purists are yelling now in Americanese is exactly what Moholy-Nagy and others yelled and wrote about in German long before them.

The foremost purist of the Pacific Coast is Edward Weston, a man of exceptional artistic talent and deep emotions, as his letters and works prove abundantly. Unquestionably he can stand on his own feet and, I believe, certainly is not an imitator of anybody and is unlikely to think that others are mere followers or imitators of himself exclusively. But, being an extraordinary photographer, Weston naturally intrigued other rather clever and bright but much lesser lights who, therefore, hitched their little wagons to his big, bright star.

In 1929 I was advised by a museum curator to ask Edward Weston for prints for the first Pacific International Salon of Photography. He replied saying that, though he had stopped entering salons years ago, he liked the rule of the Pacific Salon which would hang his print No. 1 regardless of jury action, and would make an entry. He sent five prints, all 8 by 10s printed on a slightly rough matte paper. . . .

[In] 1930, the second Pacific Salon was held, and in trying to have it exhibited elsewhere on the coast, I wrote to divers museums. The museum in Oakland, California, replied by saying that they could not exhibit any photographs again for some time, because they were just taking down an exhibit of German photography; ultramodern stuff, said the letter (which I still have), all showing unusual subject matters, treated unusually, and all on *glossy papers.* . . .

In August 1932 a group formed around Edward Weston, organized loosely, and christened itself "Group *f*:64," and almost immediately became so prominent on the photographic map that, when the museum here put two galleries at my disposal for the months of October and November, 1933, I decided to fill at least one of those galleries with "*f*:64" prints for a month. So I wrote to Weston and asked him to send me twenty of his prints and twenty by each of four other Group f:64 members. He agreed to do so providing that "you will let me pick 'the other,' so that the show will form a consistent whole." Thus I got one hundred prints in all, from Edward himself, his son Brett, Ansel Adams, Willard Van Dyke and

Sonya Noskowiak; but in an accompanying note Weston requested me not to connect that exhibition with "Group f:64...."

As that exhibition involved a lot of correspondence, mostly between Weston and me, one day in December I got a note from him saying:

> Dear Albert:
> A hurried note to thank you for the publicity and prints just received—my only regret *re* press notices is that the show was referred to as the "Weston Group." Possibly my influence can be noted,—I might say, quite naturally; but let me add that Ansel Adams is more under the influence of Paul Strand and Stieglitz and Brett made the rocks and pebbles before I did. But if I had seen them first I would have done them. So it's hard to trace *influence*.

I think so too, so was almost shell-shocked when I read, in a co-operatively written gospel compounded of platitudes by five members of Group f:64, that the young-ster whom his present master, Weston, told me is under the *influence* of Stieglitz and Strand as well as himself, had mounted his literary soap box and yelled ferociously:

> We have built up a *host of imitators* who, in the main, have merely extracted surface aspects—detail, glossy papers, white mount-boards, forced viewpoints, *etc.*,—and are confident that they have achieved the quality of a Weston in so doing . . . [My italics; A.J.]

. . . [B]eing something of a hog myself for grabbing everything in sight and grunting for more, and reckoning I have claims of my own regarding use of "detail, glossy papers, etc.," for exhibition prints, I deny the right of the Belated American Purists' to copyrights or patents on things which their admitted master, Weston, did not do himself till *after* a lot of German purist prints on *glossy papers* were exhibited in Oakland in 1930. . . .

But as for Weston himself, so far as I know he never made claims of originality based on "detail, glossy papers, forced viewpoints, etc.," but confined his remarks to aesthetic opinions and technical facts. Then his telling me that "it is hard to trace *influence*" indicates that he doesn't think anybody is likely to be imitating him exclusively. He is much more liberal than "the others," as is shown by a paragraph extracted from another note of his, of December, 1933:

> Your letter raised so many points which might be discussed with interest, that I despair—will make attempt to write what might end in a volume,—and then get nowhere. There are as many viewpoints and means of approach as there are individuals!

Thus like many Brahmins, who say that there are as many paths to Heaven as there are people on earth, so does Weston agree that there are innumerable paths into and through photography, and hence—so I deduce—also plenty of room for everybody without any of us becoming a "host of imitators" of a "childish bunch" who are "years behind the beginners of their movement . . . in Germany where it originated."

Excerpted from Albert Jourdan, "Sidelight #16, The Impurities of Purism," *American Photography* 29 (June 1935): 348–56.

63

64

Group f 64 has become a name synonymous with a certain type of photography, but few people know how the group by that title came into existence, what its aims and purposes were, and who were its founders.

For several years prior to 1932, various people on the Pacific Coast were working in straight photography as individuals. Their work was for the most part unknown, their ideas unformulated. Among these photographers were Edward Weston, Ansel Adams, Imogen Cunningham, and Willard Van Dyke. Weston had been doing photography since 1906. His work was internationally known, and he had a long list of salon medals and honors to his credit. But with the rise of pictorial photography, he refused to send his sharp, clean photographs to exhibitions. The term "pictorial" meant to him all that great amorphous mass of photography, commonly exhibited as "art," which made use of soft-focus lenses, control processes, and manipulation of negative and print to ends that were far from photographic.

In 1932, photography in the San Francisco Bay region was stimulated by the policy of Lloyd Rollins, who was director of the two municipal museums. He held a series of one-man shows by most of the world-famous photographers. At the same time, a gallery known as "683 Brockhurst" was opened in Oakland by Mary Jeannette Edwards and Willard Van Dyke. Here photographers met, talked over their problems, and formed the organization known as "Group f 64." The name was chosen because it designates one of the smallest openings commonly used on photographic lenses, and because that meant clarity of image, depth of focus.

The Group was not started as a cult, nor did it function as one. Around the fireplace at 683, over coffee and food from the corner Mexican restaurant, they found they had certain things in common. All of them believed that photography must use its own peculiar powers, acknowledge its own limitations, and that it should never be influenced by painting, or any other graphic art. Just as a sculptor uses different tools in working granite and carving wood, because his medium imposes its own limitations, so must the photographer recognize what his tools can do best, and use them to their fullest capacity. But he must never use them for purposes beyond their capacity.

In order to achieve their ends through the most photographic means, members of the Group used large cameras, usually making prints on glossy papers, from negatives that were sharp in definition and brilliant in tonal gradation. Enlargements tend to lose tonal gradation, and rough papers obscure detail. They believed that everything in the picture should be in focus, and to achieve this they used small lens openings, with their cameras on tripods, because of the necessarily long exposures. There is a law of physics which makes it possible to have objects close to the camera, as well as distant objects, both in focus at the same time only when the lens opening is small.

Their subject material, at first, was unconventional— eroded earth, worn wood, sections of vegetables, details of rocks. They photographed anything that seemed to them suitably photogenic, emphasizing detail. There was an unconscious effort to convince the spectator that photography could stand on its own feet, and that the rendition of textural qualities was all-important. Gradually, as this field became exhausted and the photographs began to assume a repetitious quality, new fields were explored, and the limited approach began to broaden. Adams did a fine series of mountain pictures and wrote a book called *Making a Photograph* which defined the f 64 method of approach. Weston was awarded a Guggenheim Fellowship, the first photographer so to be honored, and began making a photographic record of California. . . .

Group f 64 no longer exists as a unit of photographers exhibiting together with a common point of view, but their influence is being felt in all fields of photography. Commercial photographers, with their emphasis on detail, influenced the Group at first, but recently there has been a re-influence on the commercial and illustrative field as shown by the extensive use of the extreme close-up. Amateurs have improved their technique, having seen the technical excellence it is possible to attain, and which is attained by these men. Peter Stackpole, who was associated with the Group, has shown that it is possible to make fine prints from miniature negatives, and his high standards have raised the level of work in the picture magazines. The great tradition of photography, started by such men as Matthew [sic] Brady, who photographed the Civil War, Atget, who photographed Paris, and Alfred Stieglitz, the father of American photography, is being carried on. When one sees the large percentage of bad, derivative, unphotographic prints that still forms the bulk of photographic shows in this country, it is evident that photography has not yet come of age. But the way has been indicated.

Excerpted from Willard Van Dyke, "Group f64," *Scribner's* (March 1938): 55.

The Photographs

A Note on the Plates

The original checklist for Group f.64's 1932 exhibition at
the de Young Museum provided the organizing principle
for the selection of prints for both the exhibition and book
Seeing Straight. Throughout the process, every effort has
been made to locate vintage prints of the actual images
displayed at that time. The intervening sixty years, how-
ever, have raised formidable barriers to such a task; while
some group members' work is well documented, that of
others is now relatively obscure, and some works could
not be found. The problem is compounded by titles that
are often vague; it is by now impossible to know with any
certainty which *Portrait of a Negro* by Consuelo Kanaga
actually appeared in the 1932 show.

Works are generally presented in the order suggested
by the de Young checklist. Because print titles have changed
over the years, all titles given are those provided by the
lender of the work reproduced. The de Young checklist
number is also given, when applicable. In the few instances
when a work could not be located, another early-thirties
photograph by the same artist, considered typical of the
f.64 style, has been substituted. Quick cross-reference with
the de Young list will reveal any unavoidable discrepancies.

NO.	TITLE	ARTIST	PRICE
1.	Cactus	Henry Swift	$10
2.	Tools	Henry Swift	$10
3.	Mathematical Figure #1	Henry Swift	$10
4.	Mathematical Figure #2	Henry Swift	$10
5.	Mathematical Figure #3	Henry Swift	$10
6.	Cam	Henry Swift	$10
7.	Lucretia Van Horn	Henry Swift	$10
8.	Cactus Blossom	Henry Swift	$10
9.	Tree	Henry Swift	$10
10.	Wheel Block	John Paul Edwards	$10
11.	Boats and Rigging	John Paul Edwards	$10
12.	Belaying Pin	John Paul Edwards	$10
13.	Port Anchor	John Paul Edwards	$10
14.	Pulley Block	John Paul Edwards	$10
15.	Desert Skull	John Paul Edwards	$10
16.	Boats and Spars	John Paul Edwards	$10
17.	Pioneer Wagon	John Paul Edwards	$10
18.	Bull Wheel	John Paul Edwards	$10
19.	Hen and Chickens	Imogen Cunningham	$10
20.	Rubber Plant	Imogen Cunningham	$10
21.	Leaf Pattern	Imogen Cunningham	$10
22.	Agave	Imogen Cunningham	$10
23.	Water Hyacinth	Imogen Cunningham	$10
24.	Sedum Crestate	Imogen Cunningham	$10
25.	Blossom of Water Hyacinth	Imogen Cunningham	$10
26.	Umbrella Handle and Hand	Imogen Cunningham	$10
27.	Warner Oland	Imogen Cunningham	$10
28.	Bone and Sky, No. 2	Willard Van Dyke	$10
29.	Yucca Blossom— Cross Section	Willard Van Dyke	$10
30.	Bone and Sky, No. 5	Willard Van Dyke	$10
31.	Funnels	Willard Van Dyke	$10
32.	Fence Post	Willard Van Dyke	$10
33.	Death Valley	Willard Van Dyke	$10
34.	Eroded Sand	Willard Van Dyke	$10
35.	Plant Form	Willard Van Dyke	$10
36.	Bone and Sky, No. 4	Willard Van Dyke	$10
37.	Monterey Cypress	Edward Weston	$15
38.	Pelican's Wing	Edward Weston	$15
39.	Eroded Rock, Point Lobos	Edward Weston	$15
40.	Kelp	Edward Weston	$15
41.	Eroded Plank from Barley Sifter	Edward Weston	$15
42.	Egg Plant	Edward Weston	$15
43.	Rock and Shell Arrangement	Edward Weston	$15
44.	Artichoke—Halved	Edward Weston	$15
45.	Pepper	Edward Weston	$15
46.	Leaf	Sonya Noskowiak	$10
47.	Kelp	Sonya Noskowiak	$10
48.	Sand Pattern	Sonya Noskowiak	$10
49.	Sand Pattern	Sonya Noskowiak	$10
50.	Calla Lily	Sonya Noskowiak	$10
51.	Palm Blossom	Sonya Noskowiak	$10
52.	Cactus	Sonya Noskowiak	$10
53.	Hands	Sonya Noskowiak	$10
54.	Water Lily Leaves	Sonya Noskowiak	$10
55.	Cottonwood Trunks, Yosemite Valley	Ansel Easton Adams	$10
56.	Golden Gate	Ansel Easton Adams	$10
57	Nevada Fall, Yosemite Valley	Ansel Easton Adams	$10
58.	Lake and Cliffs, Sierra Nevada	Ansel Easton Adams	$10
59.	Portrait—Annette Rosenshine	Ansel Easton Adams	$10
60.	Portrait—Gottardo Piazzoni	Ansel Easton Adams	$10
61.	Portrait—Domenico Brescia	Ansel Easton Adams	$10
62.	Factory Building	Ansel Easton Adams	$10
63.	Boards and Thistles	Ansel Easton Adams	$10
64.	Pine Cone and Eucalyptus Leaves	Ansel Easton Adams	$10
65.	Portrait of a Colored Child	Alma Lavenson	$10
66.	Composition	Alma Lavenson	$10
67.	Gas Tank	Alma Lavenson	$10
68.	Easter Lily	Alma Lavenson	$10
69.	Cactus	Brett Weston	$10
70.	Abstraction	Brett Weston	$10
71.	Three Fingers and an Ear	Brett Weston	$10
72.	Leaves	Brett Weston	$10
73.	Portrait of a Negro	Consuela Kanaga	$10
74.	Portrait of a Negro	Consuela Kanaga	$10
75.	Portrait of a Negress	Consuela Kanaga	$10
76.	Portrait of a Negress	Consuela Kanaga	$10
77.	Kiln Parts	Preston Holder	$10
78.	Bridge Detail	Preston Holder	$10
79.	Gravel Loader	Preston Holder	$10
80.	Fence Post	Preston Holder	$10

Checklist for original Group f.64 exhibition, M. H. de Young Memorial Museum, San Francisco, November 15–December 31, 1932.

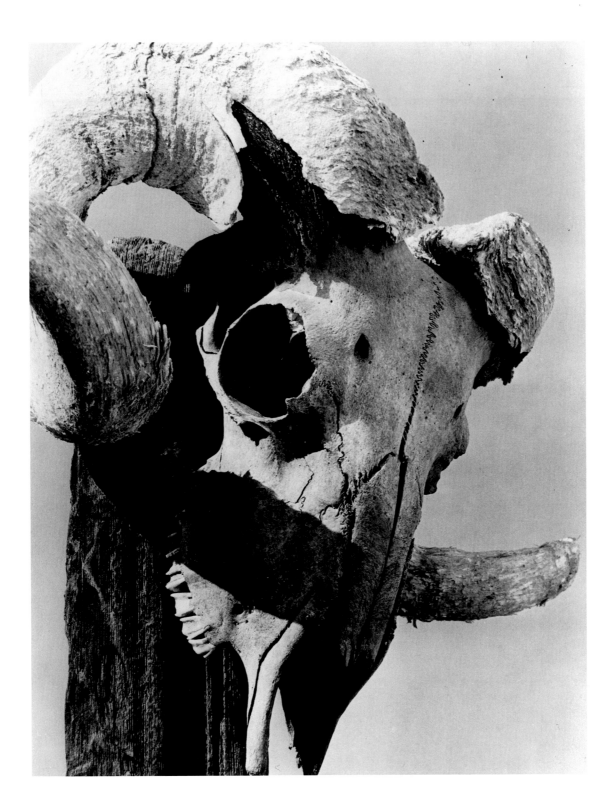

PLATE I

HENRY SWIFT

Ram's Head, c. 1932

Collection of the San Francisco Museum of Modern Art, the Henry Swift Collection, gift of Florence Alston Swift

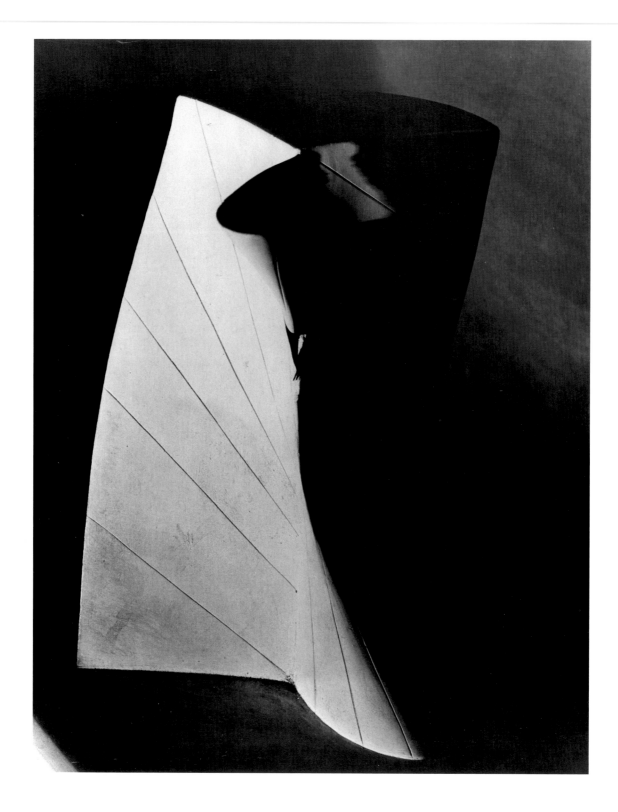

HENRY SWIFT

Mathematical Form, c. 1931

Collection of the San Francisco Museum of Modern Art, the Henry Swift Collection, gift of Florence Alston Swift

(Possible f.64 list 3, 4 or 5)

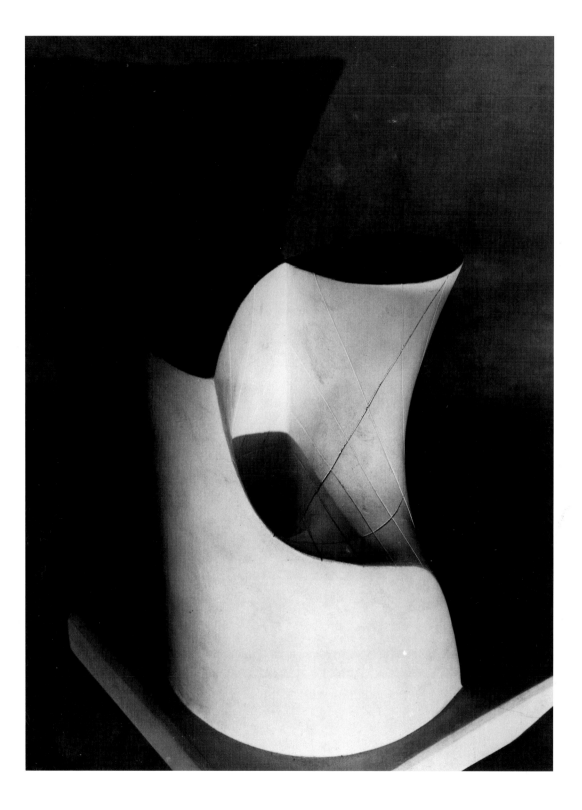

HENRY SWIFT

Mathematical Figure, c. 1931

Collection of the San Francisco Museum of Modern Art, the Henry Swift Collection, gift of Florence Alston Swift

(Possible f.64 list 3, 4 or 5)

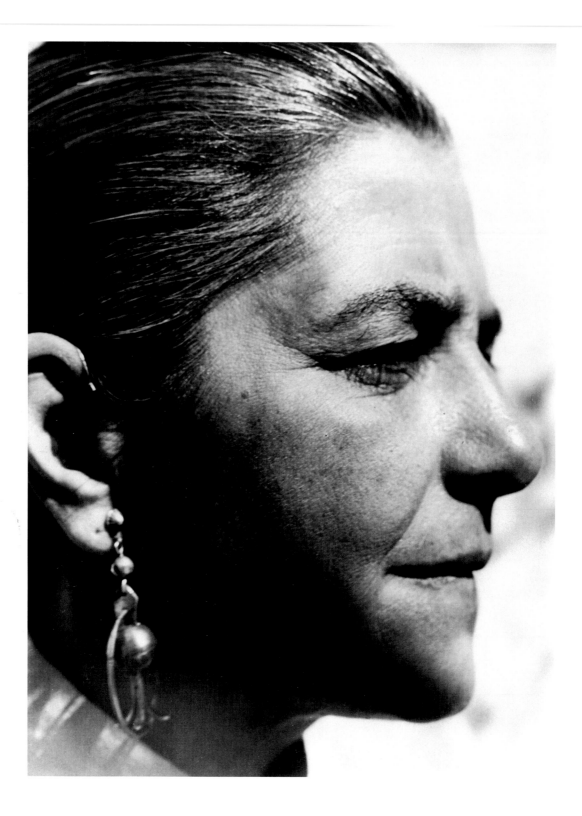

PLATE 4

HENRY SWIFT

Lucretia Van Horn, c. 1932

Collection of the San Francisco Museum of Modern Art, the Henry Swift Collection, gift of Florence Alston Swift

(Possible f.64 list 7)

PLATE 5

HENRY SWIFT

Plaster Forms, n.d.

Collection of the San Francisco Museum of Modern Art, the Henry Swift Collection, gift of Florence Alston Swift

PLATE 6

HENRY SWIFT

Banana Plant, n.d.

Collection of the San Francisco Museum of Modern Art, the Henry Swift Collection, gift of Florence Alston Swift

PLATE 7

HENRY SWIFT

Tree—Lobos, n.d.

Collection of the San Francisco Museum of Modern Art, the Henry Swift Collection, gift of Florence Alston Swift

(Possible f.64 list 9)

PLATE 8

HENRY SWIFT

Wooden Figure, Alameda, c. 1933

Collection of the San Francisco Museum of Modern Art, the Henry Swift Collection, gift of Florence Alston Swift

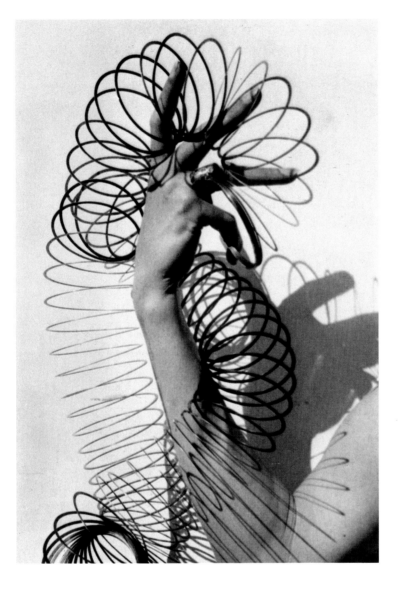

PLATE 9

HENRY SWIFT

Untitled (Hand and Toy), 1930s

Collection of the San Francisco Museum of Modern Art, the Henry Swift Collection, gift of Florence Alston Swift

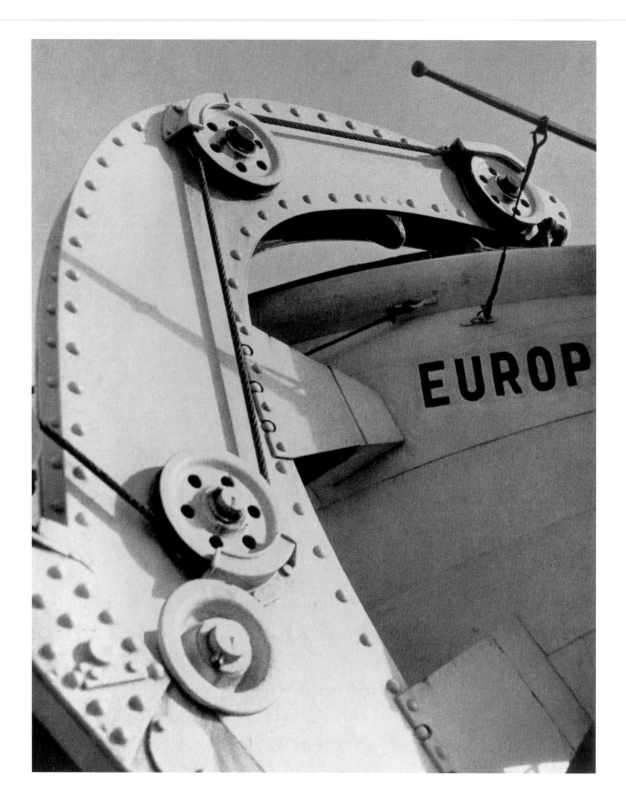

PLATE 10

JOHN PAUL EDWARDS
Detail of the "Europa," c. 1932
Collection of The Oakland Museum, gift of Mrs. John Paul Edwards

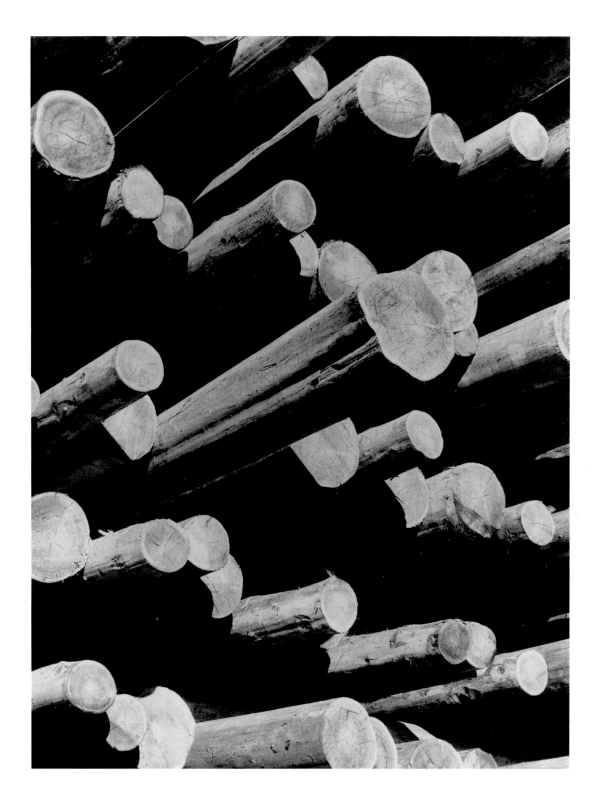

JOHN PAUL EDWARDS

Piling, c. 1932

Collection of The Oakland Museum, gift of Mrs. John Paul Edwards

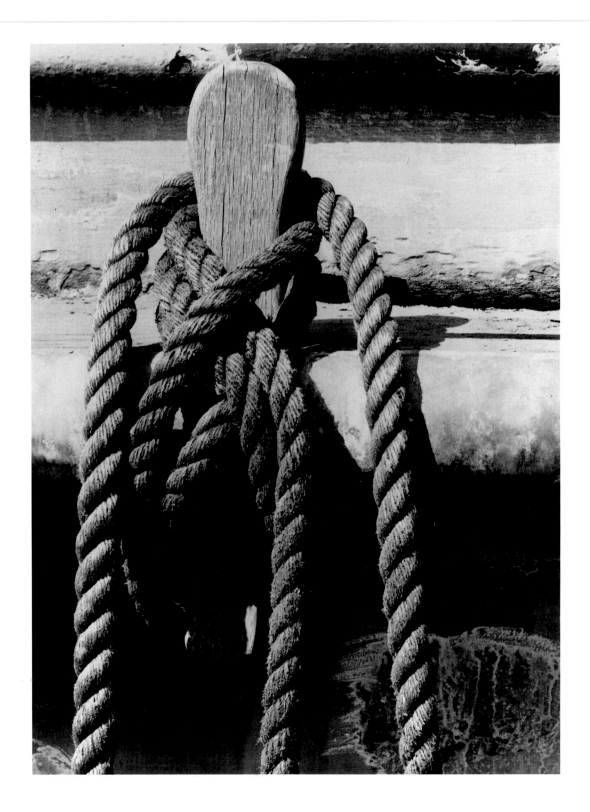

PLATE 12

JOHN PAUL EDWARDS
Study of Ship's Mooring Cable, c. 1932
Collection of The Oakland Museum, gift of Mrs. John Paul Edwards
(Possible f.64 list 12)

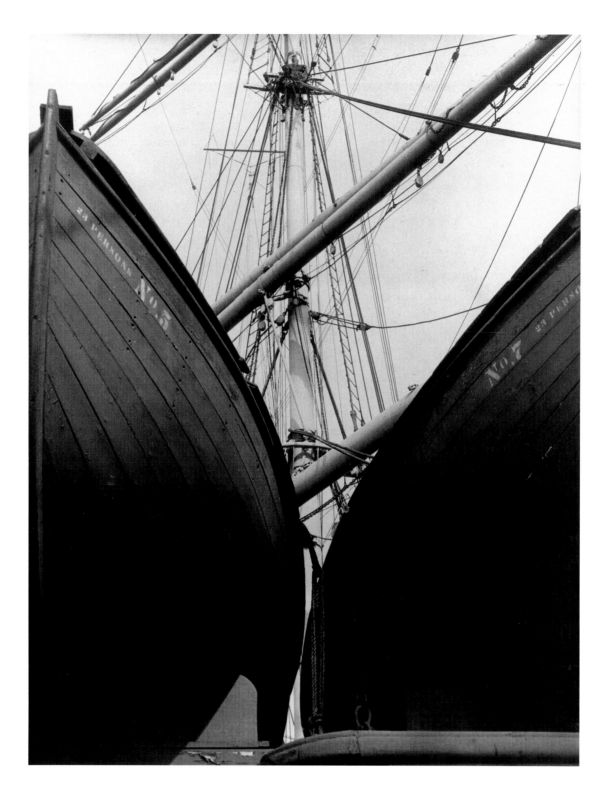

JOHN PAUL EDWARDS
Boats and Spars, n.d.
Collection of Mills College Art Gallery, Oakland, California
(Possible f.64 list 16)

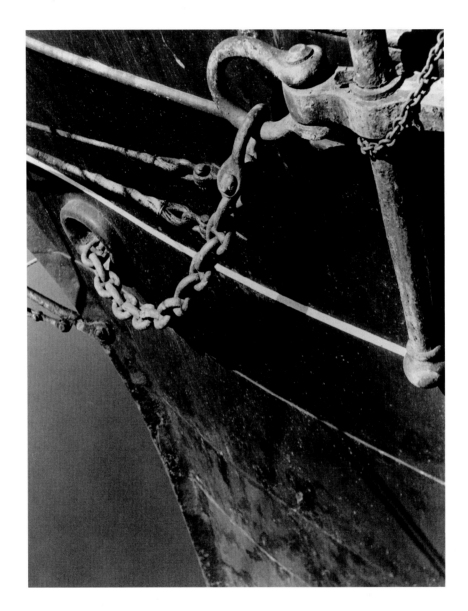

PLATE 14

JOHN PAUL EDWARDS
Port Anchor, c. 1932
Collection of Mills College Art Gallery, Oakland, California
(Possible f.64 list 13)

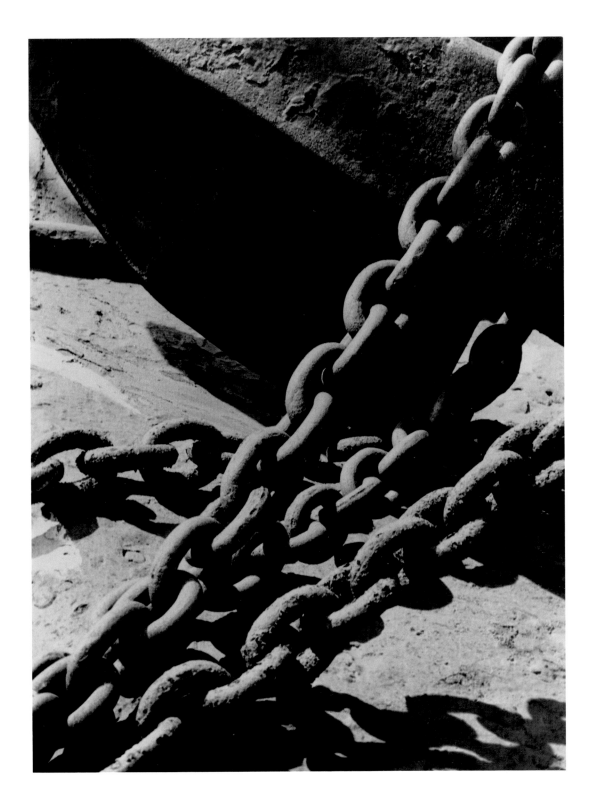

PLATE 15

JOHN PAUL EDWARDS
Anchor Fluke and Chain, c. 1932
Collection of The Oakland Museum, gift of Mrs. John Paul Edwards

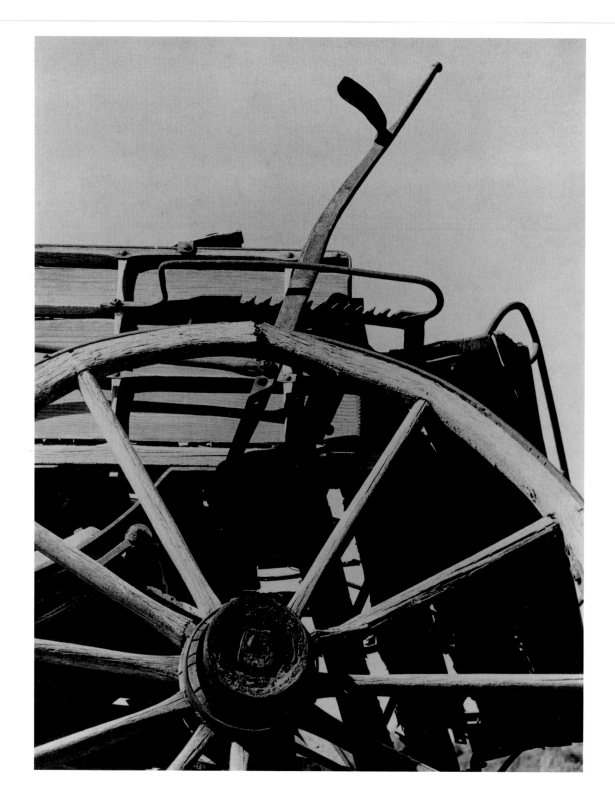

PLATE 16

JOHN PAUL EDWARDS
Pioneer Wagon, c. 1932
Collection of The Oakland Museum, gift of Mrs. John Paul Edwards
(Possible f.64 list 17)

PLATE 17

JOHN PAUL EDWARDS
Study of Wheels, c. 1932
Collection of The Oakland Museum, gift of Mrs. John Paul Edwards
(Possible f.64 list 18)

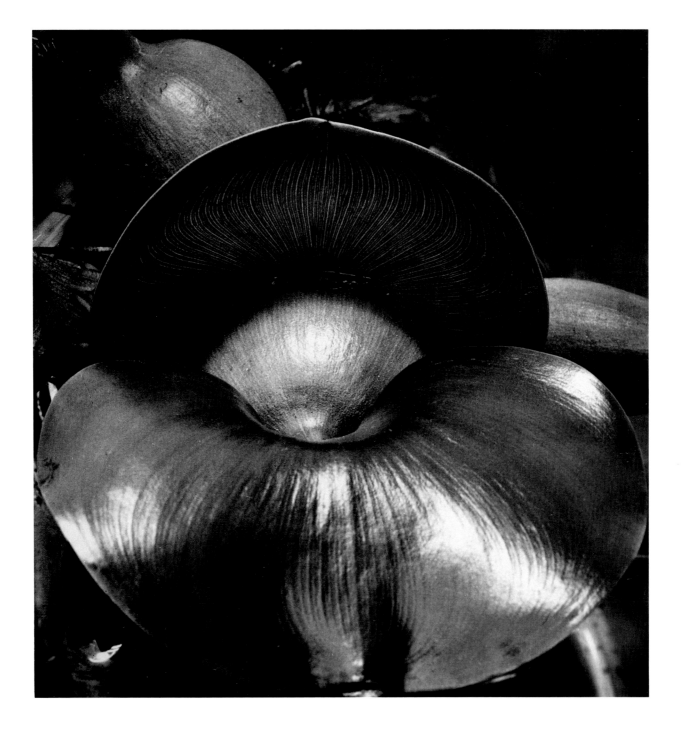

PLATE 18

IMOGEN CUNNINGHAM
Water Hyacinth 1, 1920s
Courtesy of the Imogen Cunningham Trust
(Possible f.64 list 23)

88

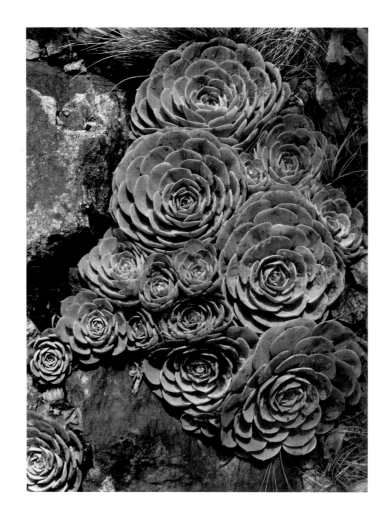

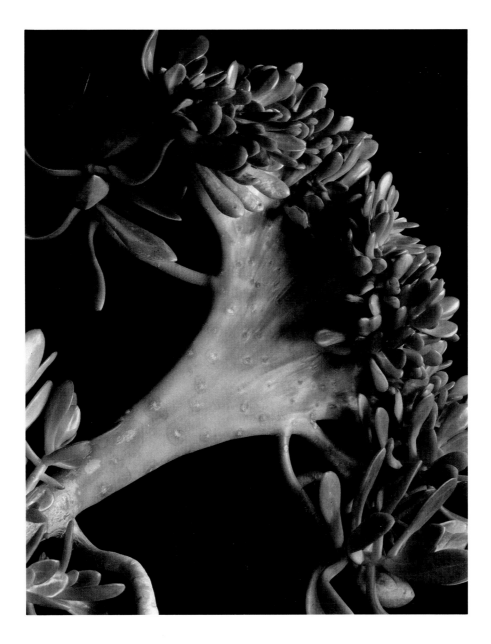

IMOGEN CUNNINGHAM
Succulent, 1920s
Courtesy of the Imogen Cunningham Trust
(Possible f.64 list 24)

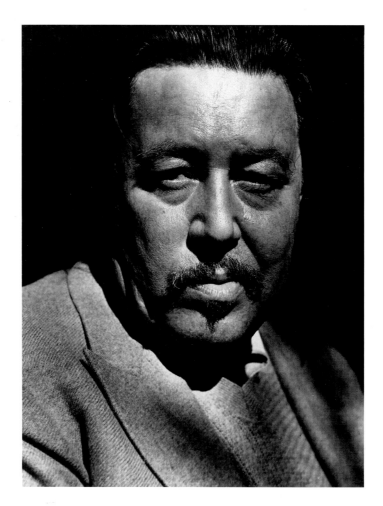

PLATE 21

IMOGEN CUNNINGHAM
Warner Oland, c. 1932
Courtesy of the Imogen Cunningham Trust
(Possible f.64 list 27)

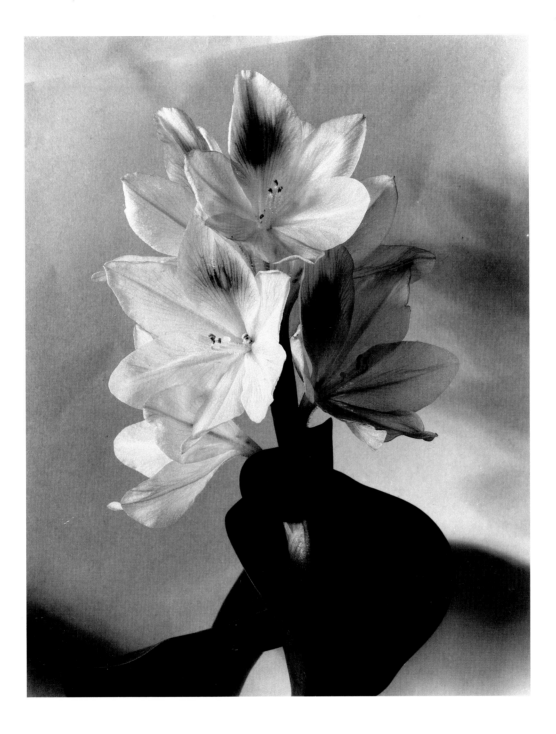

IMOGEN CUNNINGHAM
Blossom of Water Hyacinth 2, 1920s
Courtesy of the Imogen Cunnigham Trust
(Possible f.64 list 25)

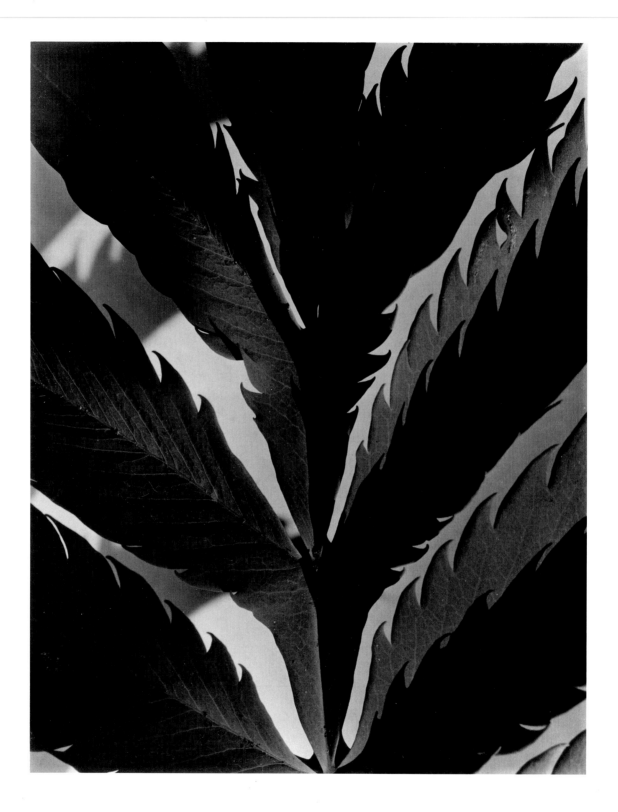

PLATE 23

IMOGEN CUNNINGHAM

Leaf Pattern, c. 1924

Collection of The Oakland Museum, gift of the Reva and David Logan Foundation.

(Possible f.64 list 21)

PLATE 24

IMOGEN CUNNINGHAM

Agave, 1920s

Courtesy of the Imogen Cunningham Trust

(Possible f.64 list 22)

94

PLATE 26

IMOGEN CUNNINGHAM
Rubber Plant, c. 1929
Courtesy of the Imogen Cunningham Trust
(Possible f.64 list 20)

PLATE 27

WILLARD VAN DYKE

Sand Dunes, 1931

Collection of Barbara M. Van Dyke

(Possible f.64 list 34)

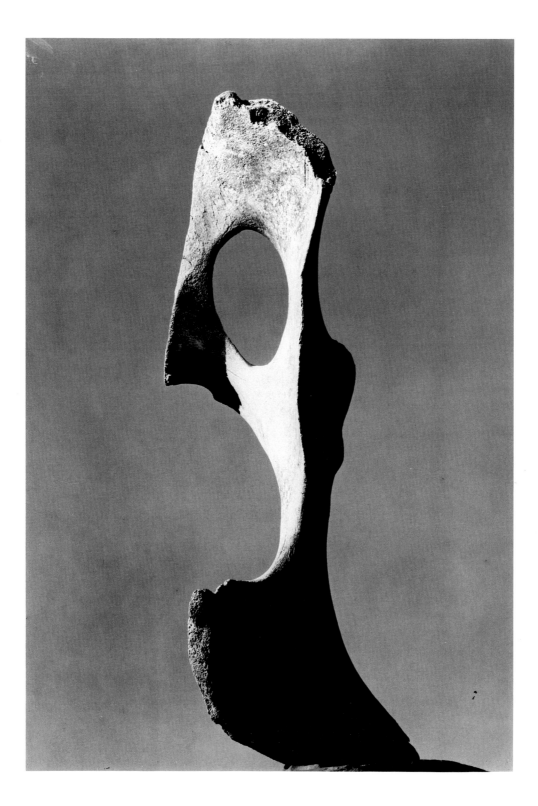

PLATE 28

WILLARD VAN DYKE

Bone and Sky, c. 1932

Collection of the San Francisco Museum of Modern Art, the Henry Swift Collection, gift of Florence Alston Swift

(Possible f.64 list 28, 30, or 36)

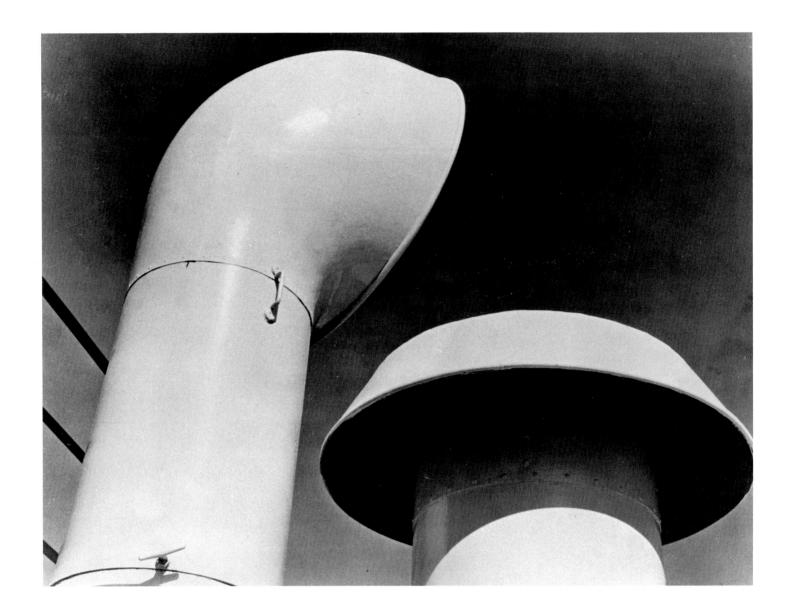

PLATE 29

WILLARD VAN DYKE

Funnels, c. 1932

Collection of the San Francisco Museum of Modern Art

(Possible f.64 list 31)

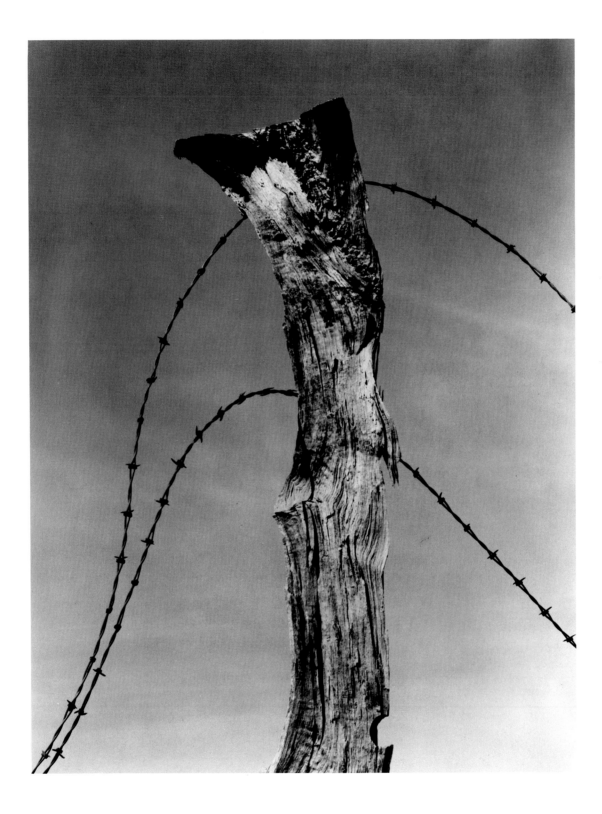

PLATE 30

WILLARD VAN DYKE

Fence Post and Barbed Wire, c. 1930

Collection of the San Francisco Museum of Modern Art, the Henry Swift Collection, gift of Florence Alston Swift

(Possible f.64 list 32)

PLATE 31

WILLARD VAN DYKE
Boxer's Hands, 1932
Collection of Barbara M. Van Dyke

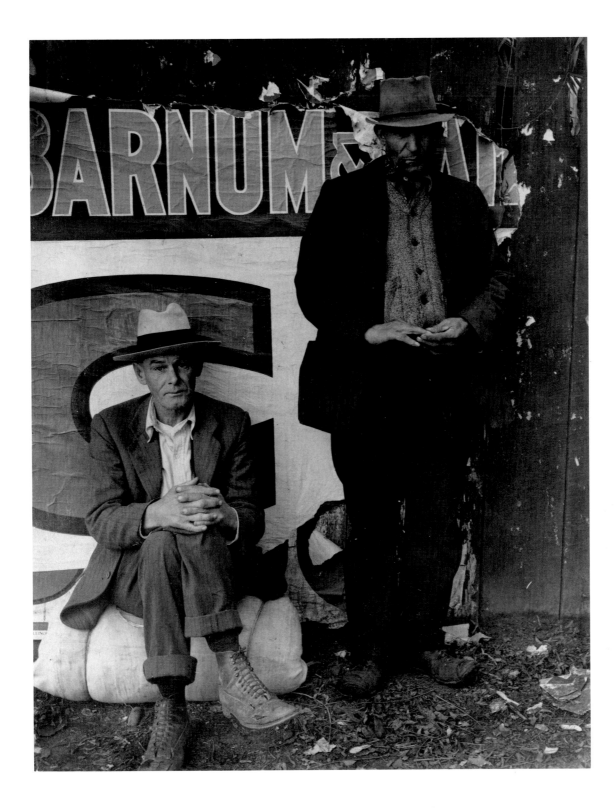

PLATE 32

WILLARD VAN DYKE

Barnum, c. 1934

Collection of Barbara M. Van Dyke

PLATE 33

WILLARD VAN DYKE
Berkeley Store Front, 1934
Collection of The Oakland Museum

PLATE 34

WILLARD VAN DYKE

American Scene #4, 1933

Collection of Barbara M. Van Dyke

PLATE 35

WILLARD VAN DYKE

Oakland Store Front, C. 1934

Collection of The Oakland Museum

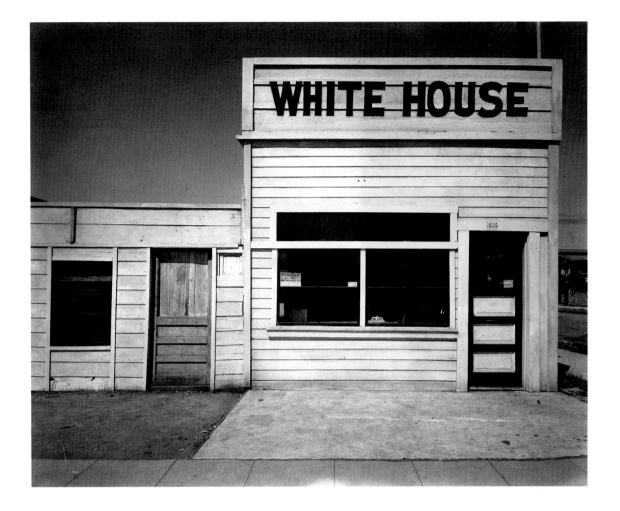

PLATE 36

WILLARD VAN DYKE
Untitled ("White House"), c. 1935
Collection of The Oakland Museum

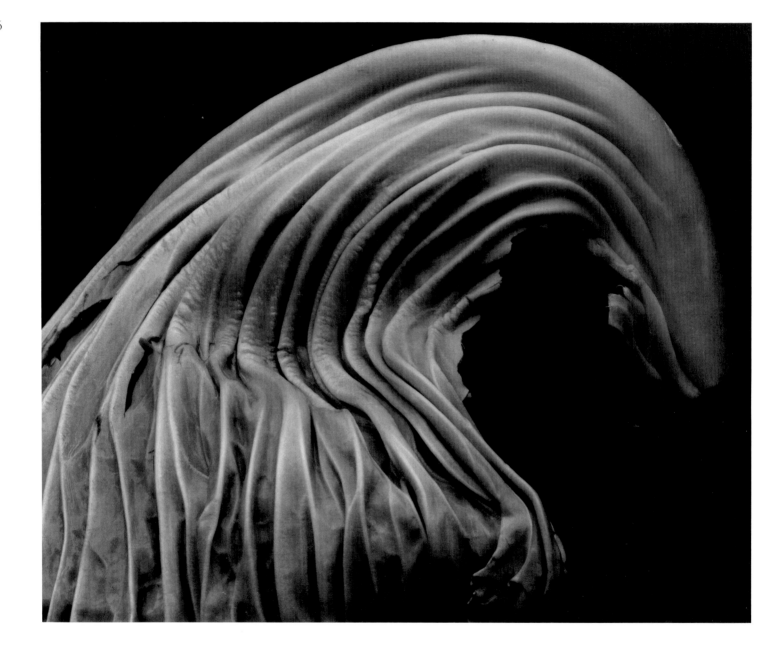

EDWARD WESTON
Cabbage Leaf, 1931
Collection of The Oakland Museum

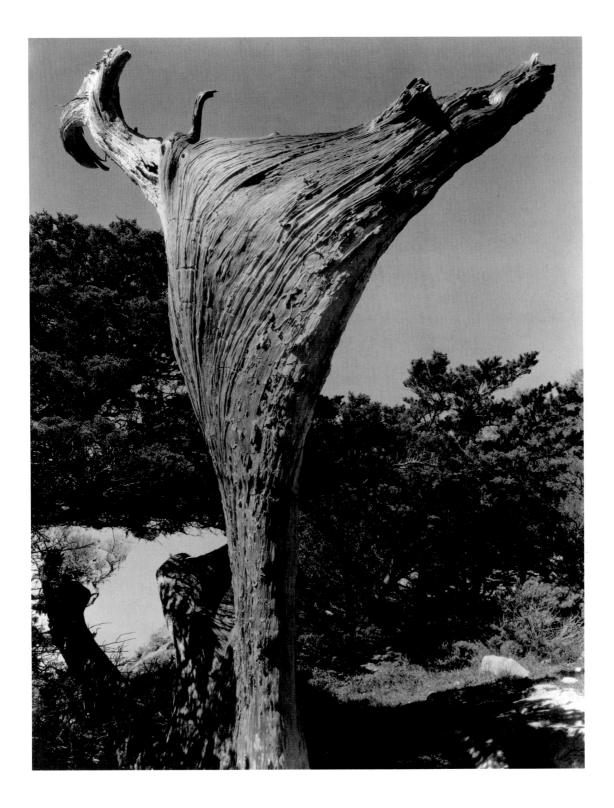

PLATE 38

EDWARD WESTON
Cypress, Point Lobos, c. 1932
Collection of The Oakland Museum
(Possible f.64 list 37)

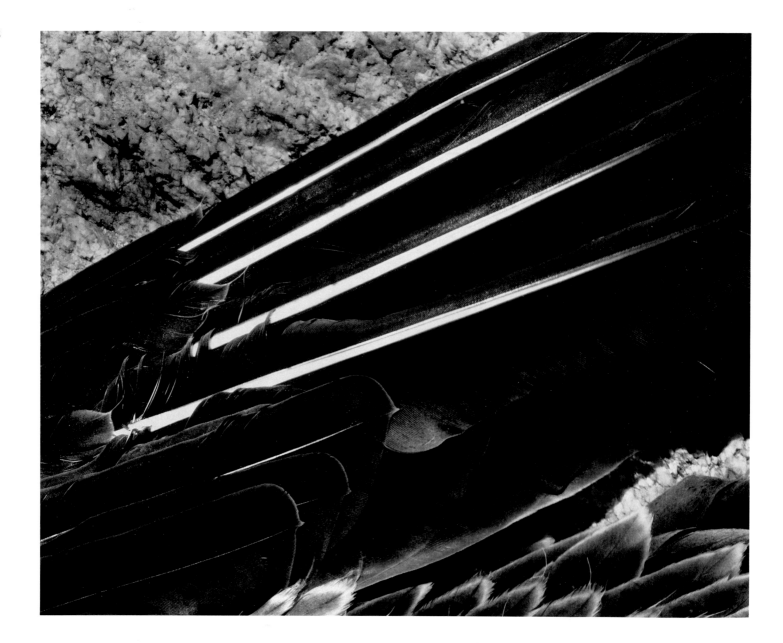

PLATE 39

EDWARD WESTON
Pelican's Wing, 1931
Collection of the Center for Creative Photography, University of Arizona, Tucson
(Possible f.64 list 38)

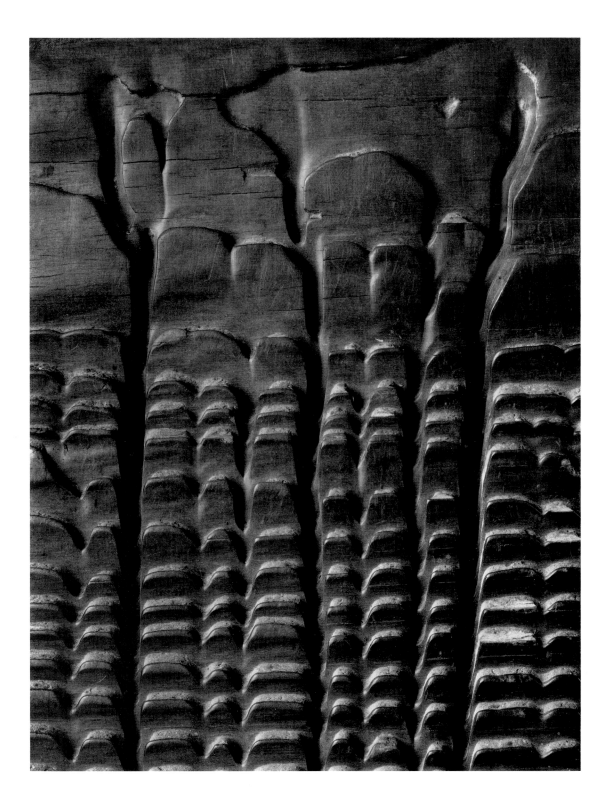

PLATE 40

EDWARD WESTON
Eroded Plank from Barley Sifter, 1931
Collection of the Center for Creative Photography, University of Arizona, Tucson
(Possible f.64 list 41)

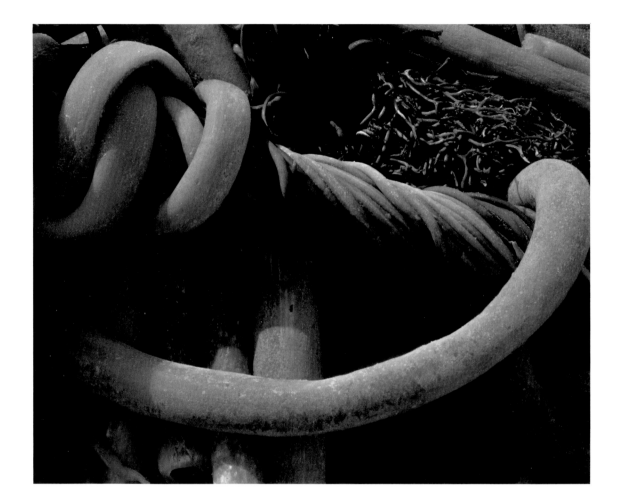

PLATE 41

EDWARD WESTON

Kelp #3, 1930

Collection of the Center for Creative Photography, University of Arizona, Tucson

(Possible f.64 list 40)

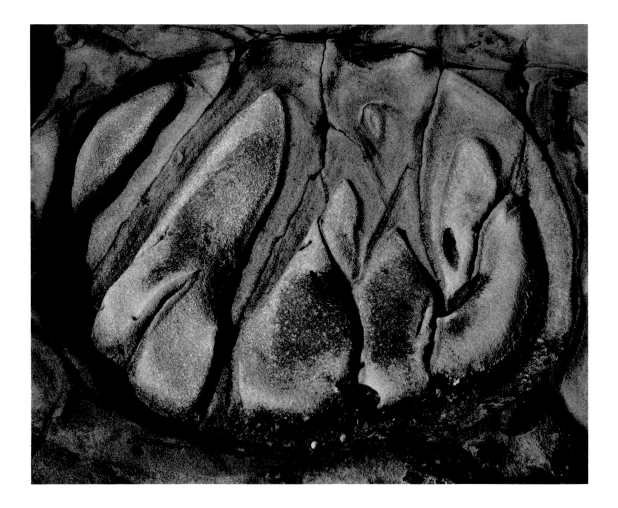

PLATE 42

EDWARD WESTON
Eroded Rock, Point Lobos, 1929
Collection of the Center for Creative Photography, University of Arizona, Tucson
(Possible f.64 list 39)

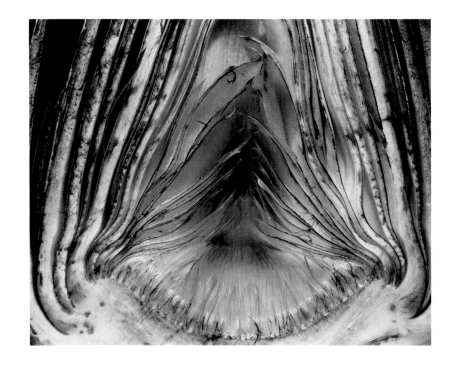

PLATE 43

EDWARD WESTON

Artichoke Halved, 1930

Collection of the J. Paul Getty Museum, Malibu, California

(Possible f.64 list 44)

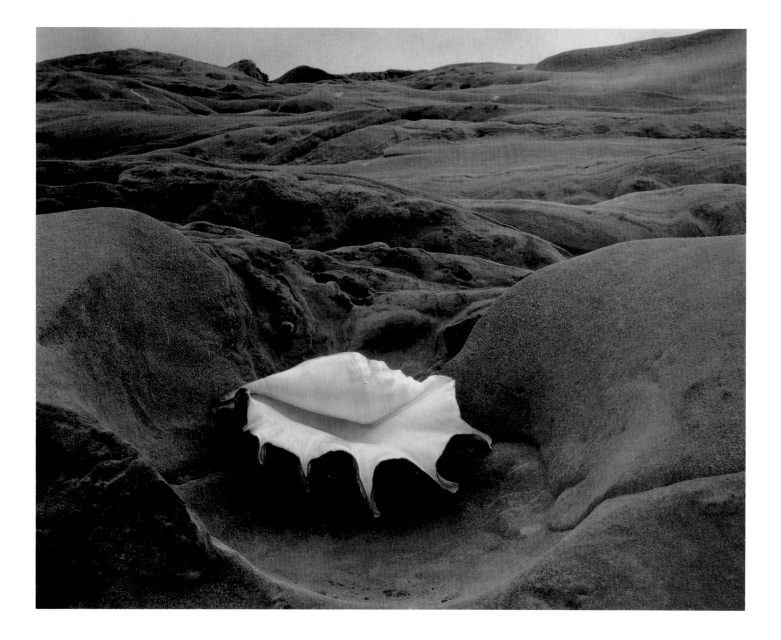

PLATE 44

EDWARD WESTON

Rock and Shell Arrangement, 1931

Collection of the Center for Creative Photography, University of Arizona, Tucson

(Possible f.64 list 43)

114

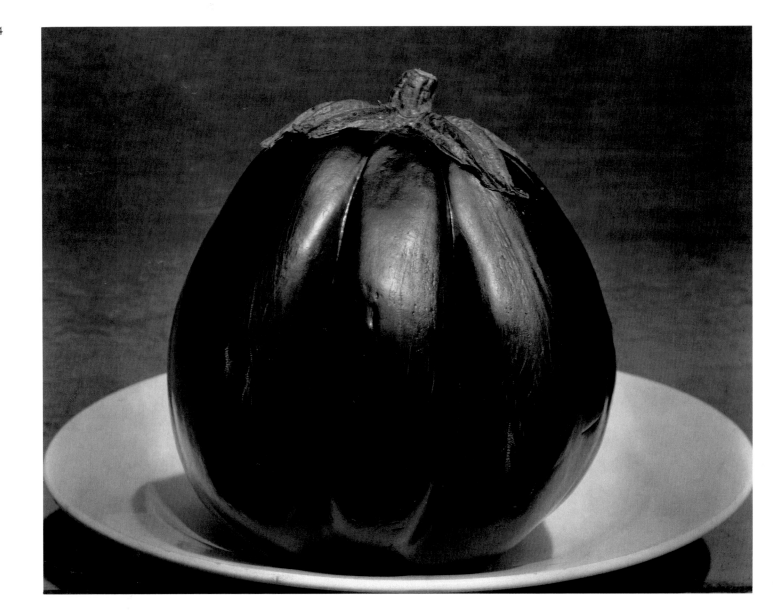

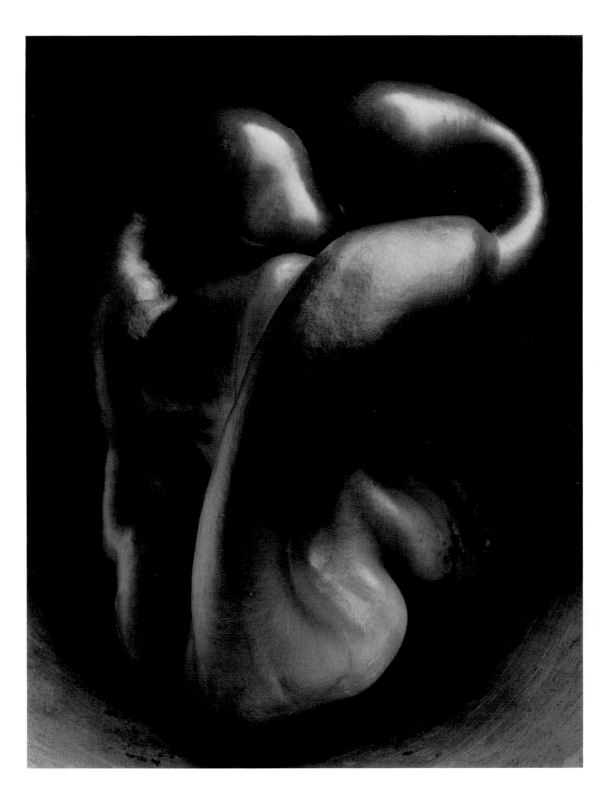

PLATE 46

EDWARD WESTON

Pepper No. 30, 1930

Collection of the Center for Creative Photography, University of Arizona, Tucson

(Possible f.64 list 45)

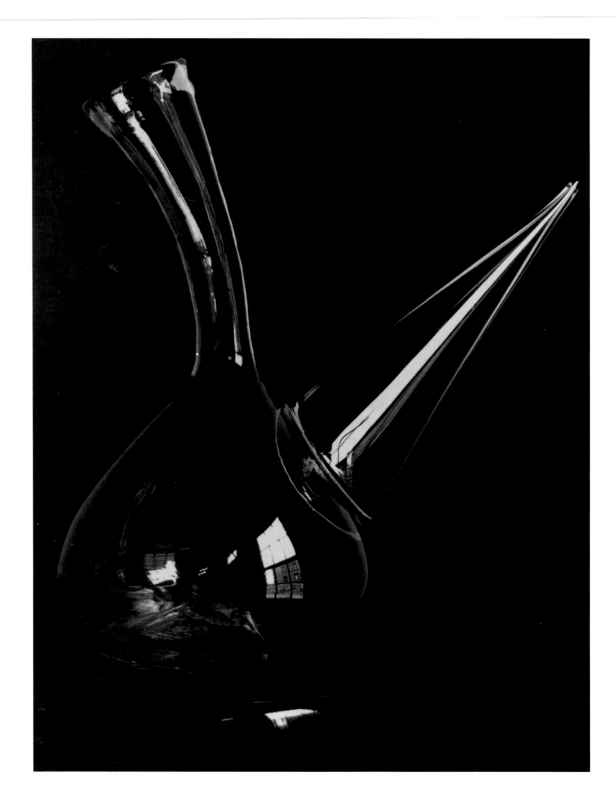

PLATE 47

SONYA NOSKOWIAK
Basque Glass Bottle, 1938
Collection of Mills College Art Gallery, Susan L. Mills Fund

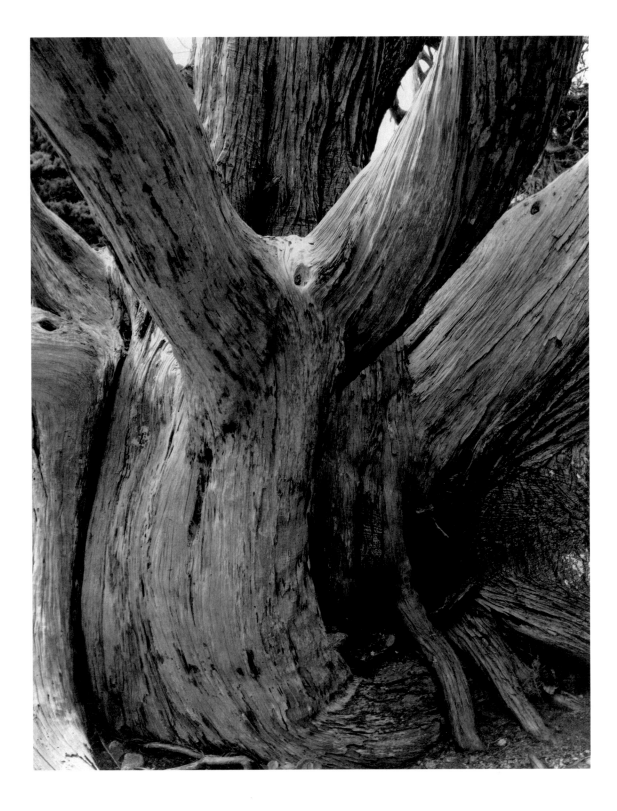

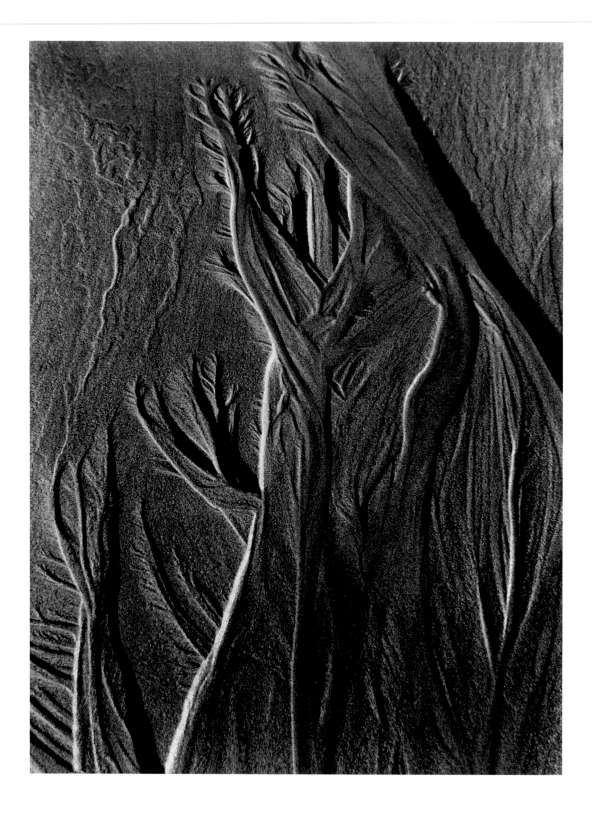

PLATE 49

SONYA NOSKOWIAK

Sand Pattern, 1932

Collection of the San Francisco Museum of Modern Art, the Henry Swift Collection, gift of Florence Alston Swift

(Possible f.64 list 48 or 49)

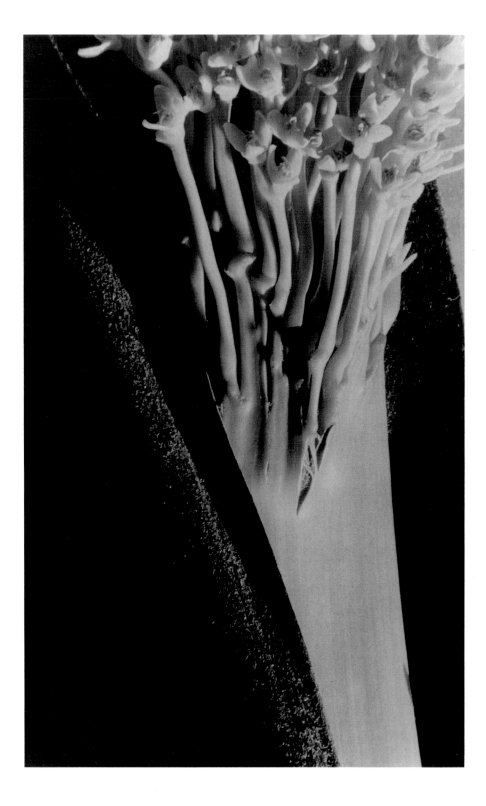

PLATE 50

SONYA NOSKOWIAK

Blossom, 1931

Collection of Michael Wilson

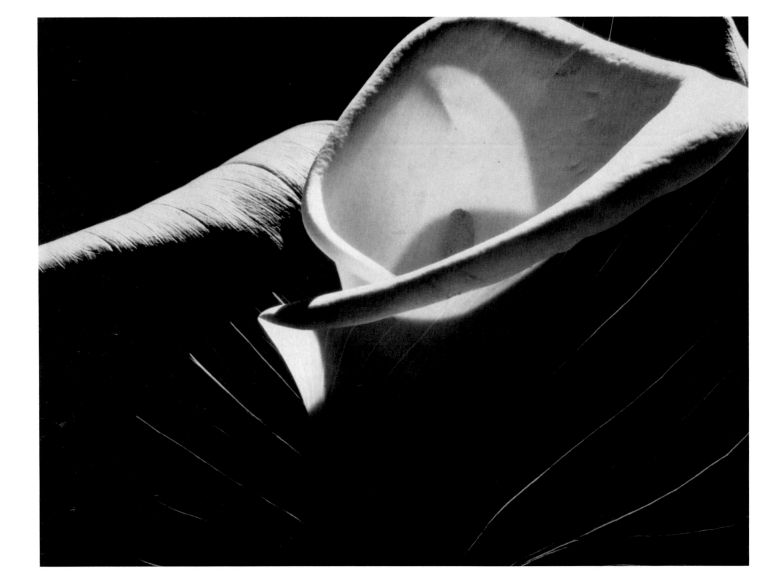

PLATE 51

SONYA NOSKOWIAK

Calla Lily, 1930

Collection of the Center for Creative Photography, University of Arizona, Tucson

(Possible f.64 list 50)

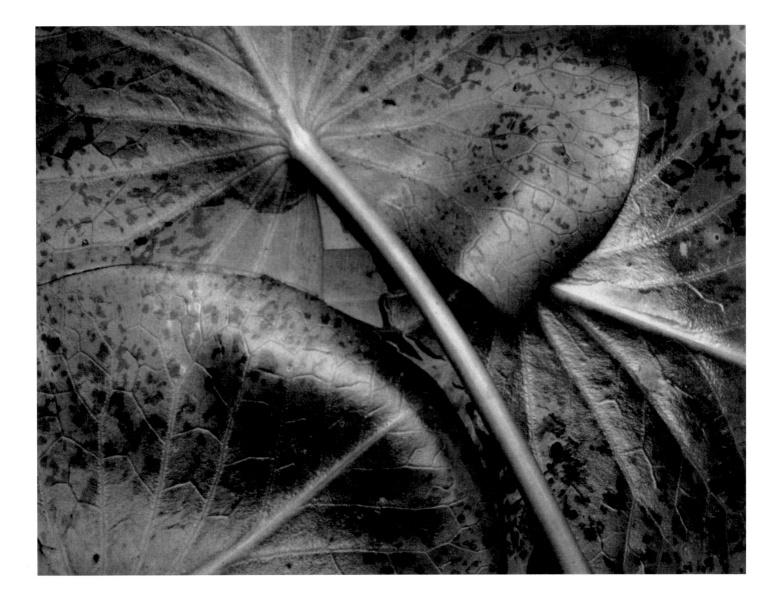

PLATE 52

SONYA NOSKOWIAK

Water Lily Leaves, 1931

Collection of the Center for Creative Photography, University of Arizona, Tucson

(Possible f.64 list 54)

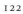

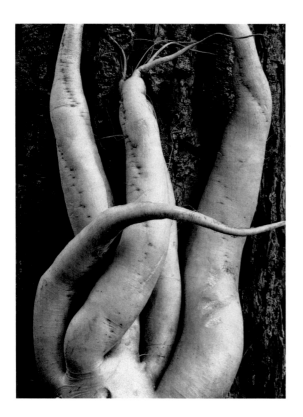

<div align="center">

PLATE 53

SONYA NOSKOWIAK

White Radish, 1932

Collection of the Center for Creative Photography,
University of Arizona, Tucson

</div>

<div align="center">

PLATE 54

SONYA NOSKOWIAK

Cactus, n.d.

Collection of The Oakland Museum, gift of John Paul Edwards
(Possible f.64 list 52)

</div>

PLATE 55

Sᴏɴʏᴀ Nᴏsᴋᴏᴡɪᴀᴋ

F. F.'s Hand and Guitar, 1933

Collection of the Center for Creative Photography, University of Arizona, Tucson

(Possible f.64 list 53)

PLATE 56

ANSEL ADAMS

The Golden Gate before the Bridge, San Francisco, 1932

Collection of The Oakland Museum

(Possible f.64 list 56)

PLATE 57

ANSEL ADAMS
Nevada Fall, c. 1932
Collection of James and Mary Alinder
(Possible f.64 list 57)

PLATE 58

ANSEL ADAMS

Cottonwood Trunks, Yosemite Valley, 1932

Collection of the Center for Creative Photography, University of Arizona, Tucson

(Possible f.64 list 55)

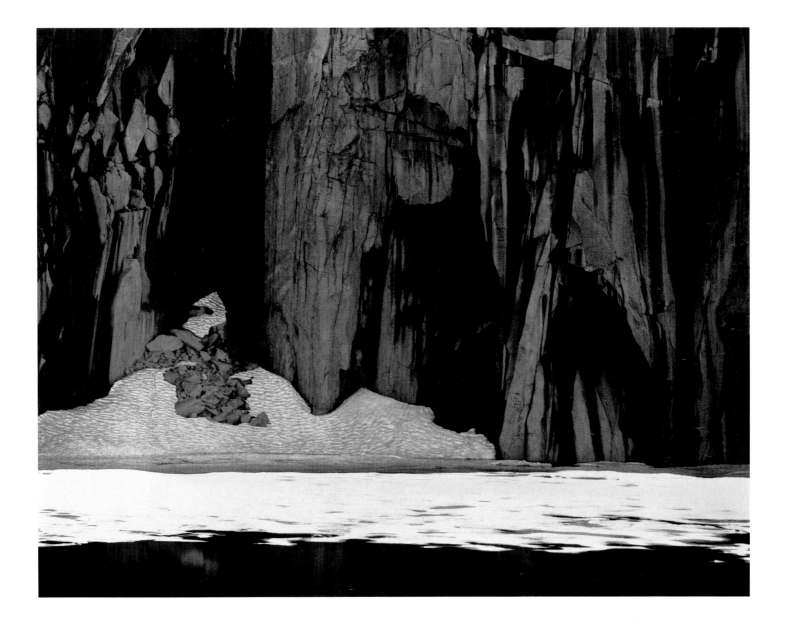

PLATE 59

ANSEL ADAMS

Frozen Lake and Cliffs, Sierra Nevada, 1932

Collection of the Center for Creative Photography, University of Arizona, Tucson

(Possible f.64 list 58)

PLATE 60

ANSEL ADAMS

Annette Rosenshine, c. 1932

Collection of the Center for Creative Photography, University of Arizona, Tucson

(Possible f.64 list 59)

PLATE 61

ANSEL ADAMS

Domenico Brescia, c. 1932

Collection of the Museum of Fine Arts, Museum of New Mexico, gift of Mrs. Margaret McKittrick, 1968

(Possible f.64 list 61)

ANSEL ADAMS

Pine Cone and Eucalyptus Leaves, San Francisco, 1932

Collection of the Center for Creative Photography, University of Arizona, Tucson

(Possible f.64 list 64)

PLATE 63

ANSEL ADAMS

Boards and Thistles, San Francisco, c. 1932

Collection of The Oakland Museum, gift of Mrs. John Paul Edwards

(Possible f.64 list 63)

PLATE 64

ANSEL ADAMS

Factory Building, San Francisco, 1932

Collection of the Museum of Fine Arts, Museum of New Mexico, gift of Mrs. Margaret McKittrick, 1968

(Possible f.64 list 62)

PLATE 65

ANSEL ADAMS
Gottardo Piazzoni in His Studio, C. 1932
Collection of The Oakland Museum
(Possible f.64 list 60)

PLATE 66

ALMA LAVENSON

Composition f/64, 1931

Collection of The Oakland Museum, gift of the artist

(Possible f.64 list 66)

PLATE 67

ALMA LAVENSON
Gas Tank, 1931
Courtesy Alma Lavenson Associates and Susan Ehrens
(Possible f.64 list 67)

· PLATE 68

ALMA LAVENSON
Easter Lily, 1932
Courtesy Alma Lavenson Associates and Susan Ehrens
(Possible f.64 list 68)

PLATE 69 ·

ALMA LAVENSON
Portrait of a Child, c. 1932
Courtesy Alma Lavenson Associates and Susan Ehrens
(Possible f.64 list 65)

PLATE 70

BRETT WESTON

Three Fingers and an Ear, 1929

Collection of the Center for Creative Photography, University of Arizona, Tucson

(Possible f.64 list 71)

PLATE 71

BRETT WESTON

Untitled (Cypress Trunk), 1929

Collection of Ronald and Kathy Perisho

PLATE 72

BRETT WESTON

Untitled (Driftwood), 1929

Collection of Ronald and Kathy Perisho

PLATE 73

BRETT WESTON
Eroded Rock & Stones, Point Lobos, 1929
Collection of Ronald and Kathy Perisho

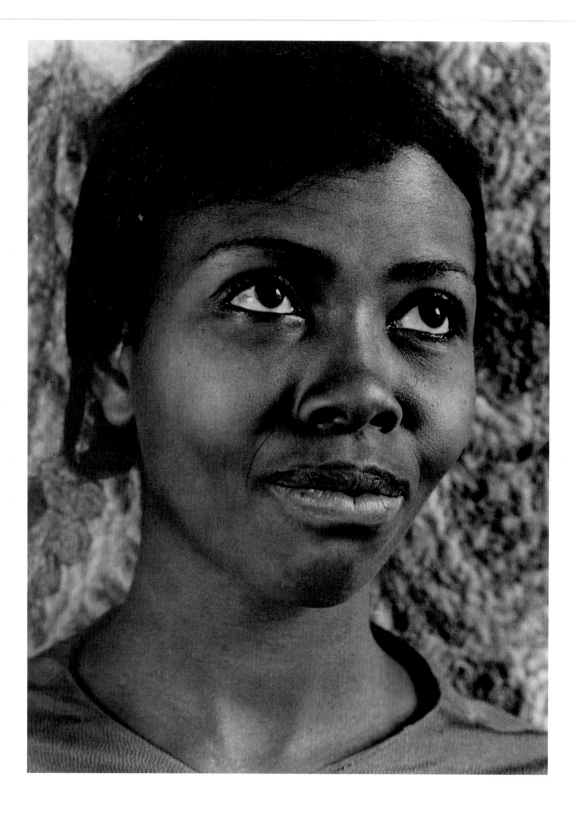

PLATE 74

CONSUELO KANAGA

Annie Mae Merriweather, 1935

Collection of The Brooklyn Museum, gift of the Estate of Consuelo Kanaga through the Lerner-Heller Gallery

(Possible f.64 list 75 or 76)

PLATE 75

CONSUELO KANAGA

Elvard Luchell McDaniels, 1931

Collection of The Brooklyn Museum, gift of the Estate of Consuelo Kanaga through the Lerner-Heller Gallery

(Possible f.64 list 73 or 74)

PLATE 76

CONSUELO KANAGA

The Girl with the Flower (Frances), 1928

Collection of Richard Lorenz

(Possible f.64 list 75 or 76)

PLATE 77

CONSUELO KANAGA

Untitled (Hands), n.d.

Collection of The Brooklyn Museum, gift of the Estate of Consuelo Kanaga through the Lerner-Heller Gallery

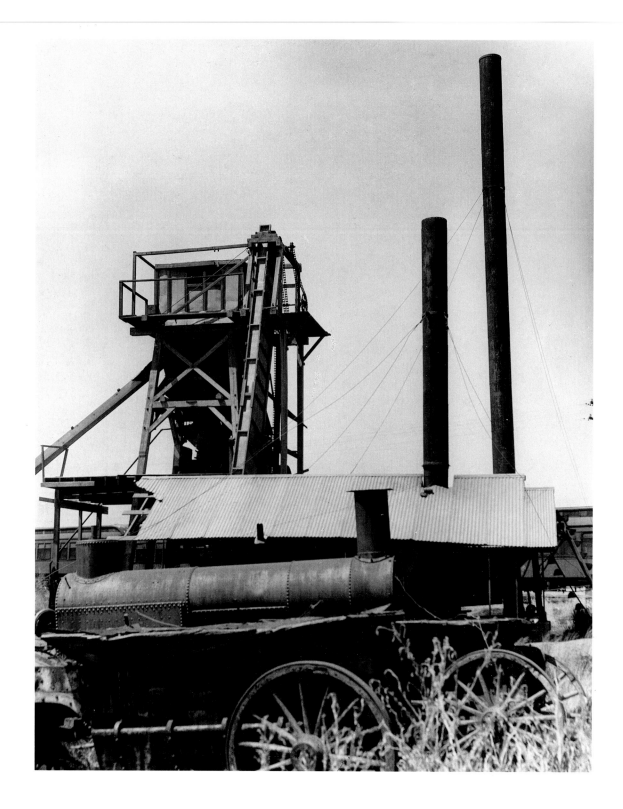

PLATE 78

PRESTON HOLDER
Gravel Loader, c. 1932
Collection of Jon P. Fishback
(Possible f.64 list 79)

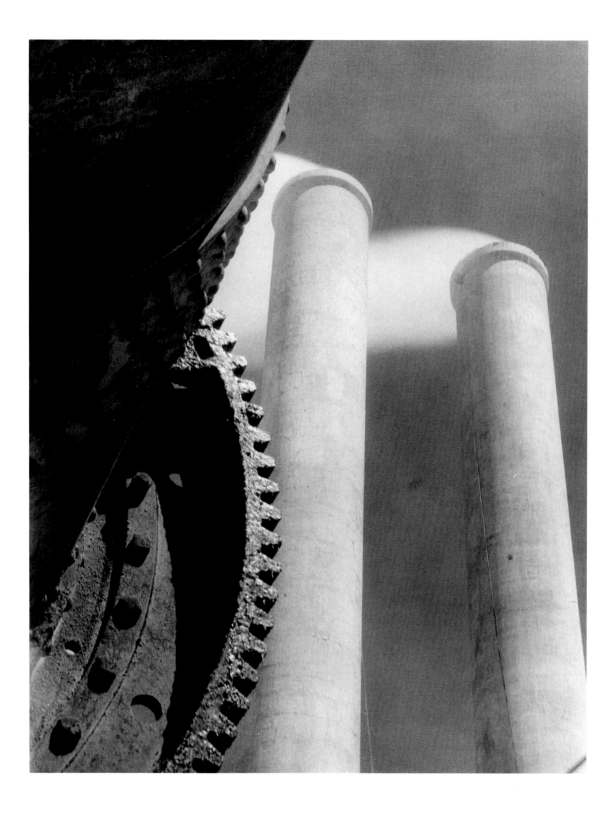

PLATE 79

PRESTON HOLDER

Rollers and Stacks, c. 1932

Collection of Jon P. Fishback

PLATE 80

PRESTON HOLDER

Fence Post, 1930

Courtesy of Jean S. Tucker. Location of original unknown.

(Possible f.64 list 80)

PLATE 81

PRESTON HOLDER
Bridge Detail, c. 1932
Collection of Jon P. Fishback
(Possible f.64 list 78)

ARTISTS' BIOGRAPHIES

ANSEL ADAMS

1902 Born Ansel Easton Adams, February 20, in San Francisco.

1916 Photographs with his first camera on a family trip to Yosemite National Park.

1927 Publishes first portfolio of original prints, *Parmelian Prints of the High Sierras*.

1928 Marries Virginia Best in Yosemite.

1930 Sets aside promising career as a concert pianist to devote full energies to his work in photography. Publishes *Taos Pueblo*, with text by Mary Austin.

1931 Writes photography column for the *Fortnightly*; reviews exhibitions by Eugène Atget, Imogen Cunningham, and Edward Weston at the M. H. de Young Memorial Museum. Sixty-print solo exhibition at the Smithsonian Institution, Washington, D.C.

1932 Becomes founding member of Group f.64. Participates in Group f.64 exhibition at de Young Museum.

1933 Travels to New York City and visits Alfred Stieglitz at An American Place. Opens Ansel Adams Gallery at 166 Geary Street, San Francisco. Presents Group f.64 exhibition there in September.

1934 Publishes a series of technical articles, "An Exhibition of My Photographic Technique," in *Camera Craft*.

1935 Publishes *Making a Photograph*. Publishes his "Personal Credo" in *Camera Craft*.

1936 Solo exhibition at Alfred Stieglitz's gallery, An American Place.

1940 Helps to found photography department at New York's Museum of Modern Art.

1946 Receives fellowship from the John Simon Guggenheim Memorial Foundation to photograph the national parks; renewed in 1948.

1962 Moves to Carmel Highlands, California. Continues active publishing career with both technical and fine art books.

1979 Major exhibition, *Yosemite and the Range of Light* presented at the Museum of Modern Art, New York, and The Oakland Museum.

1980 Receives the Presidential Medal of Freedom, the nation's highest civilian honor, from President Jimmy Carter.

1984 Exhibition, *Early Ansel Adams: Photographs from the Collection*, The Oakland Museum.

1984 Dies in Carmel, April 22.

IMOGEN CUNNINGHAM

1883 Born April 12, in Portland, Oregon. Later moves with her family to Seattle.

1901 Makes first photographs in Seattle.

1903 Attends University of Washington, studying chemistry and botany.

1907 Begins work in the studio of Edward S. Curtis.

1909 Studies photographic chemistry at the Technische Hochschule in Dresden, Germany, supported by a scholarship.

1910 Returns to Seattle and opens a studio.

1912 First solo exhibition of her soft-focus pictorial images at the Brooklyn Institute of Arts and Sciences, New York.

1915 Marries artist Roi Partridge.

1917 Moves with Partridge to San Francisco and opens a portrait studio.

1920 Begins making series of close-up studies of plant forms.

1929 Included by Edward Weston in the influential *Film und Foto* exhibition in Stuttgart.

1932 Solo exhibitions at both the Los Angeles County Museum and the M. H. de Young Memorial Museum in San Francisco. Becomes a member of Group f.64 and participates in the Group f.64 exhibition at the de Young Museum. Photographs for *Vanity Fair* in San Francisco and Los Angeles.

1934 Divorced from Partridge; supports herself doing portrait photography, commercial assignments, and teaching.

1935 Solo exhibition at Dallas Art Museum, Texas.

1957 Solo exhibition at The Oakland Museum, California. Exhibits work extensively throughout the United States during the 1950s and 1960s.

1967 Elected Fellow of the National Academy of Arts and Sciences.

1970 Is subject of Ann Hershey film, *Never Give Up*, made over a four-year period. Awarded a Guggenheim fellowship.

1975 Begins last major portrait project, photographing people over ninety years old. Published posthumously.

1976 Dies in San Francisco, June 23.

JOHN PAUL EDWARDS

1884 Born June 5, in Minnesota.

1902 Moves to California.

1921 Makes first serious photographs, soft-focus bromoil prints, following established pictorial practices.

1920s Becomes a member of pictorial photographic associations such as the Oakland Camera Club, the San Francisco Photographic Society, and the Pictorial Photographers of America.

1930s Begins exploring straight photography with the encouragement of his daughter, Mary Jeannette.

1932 Becomes founding member of Group f.64. Participates in the initial Group f.64 exhibition at the M. H. de Young Memorial Museum.

1930s Continues to work in photography using the straight approach advocated by Group f.64.

1935 Contributes an article on Group f.64 and its members to the magazine *Camera Craft*.

1967 With his wife, gives an important collection of photographs to The Oakland Museum.

1968 Dies in Oakland, California.

Preston Holder

1907 Born in Wabash, Indiana, on September 10.

1920s Works as a telephone lineman.

1930 Laid off from his job in 1929; enters University of California, Berkeley.

1931 Meets Willard Van Dyke after writing an English-class assignment about an exhibition of Van Dyke's photographs.

1932 Participates in meetings that established Group f.64 and is invited to show with the group in their exhibition at the M. H. de Young Memorial Museum. Owning only small-format cameras, borrows Van Dyke's view camera to work with.

1934 Makes film with Van Dyke of the Unemployed Exchange Association Cooperative lumber camp at Oroville, California.

1935 Leaves Berkeley intending to get involved with documentary photography projects in the East, but takes job as telephone lineman in his Indiana home town.

1930s Works on an archaeological project in Florida.

1938 Begins work on a Ph.D. at Columbia University, in New York City. Works with Paul Strand and Leo Horowitz on the film *Nature Land*.

1940s Serves in Navy in the Pacific during World War II.

1958 Joins faculty of the anthropology department of the University of Nebraska as a leading expert in Native American cultures of the plains states.

1975 Retires from University of Nebraska.

1980 Dies in Lincoln, Nebraska, June 3.

Consuelo Kanaga

1894 Born May 25, in Astoria, Oregon.

1915 Works as reporter and feature writer for the *San Francisco Chronicle* and as a portrait photographer.

1926 Divorced from first husband and moves to New York; becomes photographer for the *New York American*.

1927 Travels in Europe with Louise Dahl-Wolf; moves back to San Francisco.

1932 Invited to participate in Group f.64 exhibition at the M. H. de Young Memorial Museum.

1934 Moves to New York; photographs for the *Daily Worker* and *New Masses*.

1936 Photographs on assignment for the Arts Program of the Works Progress Administration.

1940 Works for *Woman's Day* magazine. Marries the painter Wallace Putnam.

1950 Moves to Yorktown Heights, New York.

1963 Goes to Albany, Georgia, to photograph civil-rights demonstrators.

1976 Retrospective exhibition at the Brooklyn Museum.

1978 Dies February 28, in Mount Kisco, New York.

Alma Lavenson

1897 Born Alma Ruth Lavenson, May 20, in San Francisco.

1906 Following the April 18 earthquake, moves with her family to Oakland.

1916 Attends University of California, Berkeley; graduates in 1919.

1923 Learns to develop and print her negatives by watching a technician at an Oakland drugstore; builds a primitive darkroom in her childhood playhouse.

1926 Photographs boats, dock workers, and industrial buildings at the Oakland estuary. Travels to Mexico and meets Diego Rivera.

1927 Photographs in Zion National Park; one of her images is used as cover of *Photo-Era Magazine*.

1930 Makes her first photographic trip to the California Mother Lode country, an area she would visit throughout her life. Receives introductions to Edward Weston, Imogen Cunningham, and Consuelo Kanaga from Albert Bender.

1931 Prints continue to be included in national and international pictorialist salons.

1932 First solo exhibition at the California Camera Club in San Francisco. Prints included in two thematic de Young Museum exhibitions, *A Showing of Hands* and *California Trees*. Receives second prize ($75) in latter. Invited to participate in the Group f.64 exhibition at the M. H. de Young Memorial Museum.

1933 Receives first solo museum exhibitions at the Brooklyn Institute of Arts and Sciences and the de Young Museum. Marries Matt Warhaftig.

1934 Solo exhibition at 683 Brockhurst Gallery, Oakland.

1942 First of three solo exhibitions at the San Francisco Museum of Art; others in 1948 and 1960.

1979 Receives the Dorothea Lange Award, given by The Oakland Museum to an outstanding woman photographer. First retrospective exhibition organized by the California Museum of Photography, Riverside.

1989 Dies September 19, at age ninety-two, at her home in Piedmont.

Sonya Noskowiak

1900 Born November 25 in Leipzig, Germany.

1915 Settles in California after childhood in Chile.

1922 Becomes naturalized citizen of the United States.

1929 Meets Edward Weston at Johan Hagemeyer's studio in Los Angeles. Becomes romantically involved with Weston.

early 1930s Continues to photograph, becoming strongly influenced by Weston.

1932 Founding member of Group f.64; participates in exhibition at the M. H. de Young Memorial Museum.

1933 Photographs shown at the Ansel Adams Gallery in San Francisco, Denny-Watrous Gallery in Carmel, and 683 Brockhurst in Oakland.

1934 Separates from Weston.

1935 Opens studio in San Francisco. Begins work as a portrait and commercial photographer, which she continues throughout the 1940s.

1936 One of eight photographers hired by the California region of the Federal Arts Project to photograph California artists and their paintings, sculptures, and murals.

1965 Ceases active work in photography.

1975 Dies in Greenbrae, California.

Henry Swift

1891 Born, probably in Berkeley.

1912 Graduates from University of California, Berkeley.

1917
1918 Serves in World War I. Awarded French Croix de Guerre and Silver Star for bravery in action.

1920s Meets Edward Weston in Carmel. By profession a stockbroker, he begins working in photography as a hobby.

1930 Continues contacts with Weston and other photographers and begins to collect their work.

1932 Becomes founding member of Group f.64 and participates in exhibition at M. H. de Young Memorial Museum.

1935 Continues to work as a stockbroker. Following dissolution of Group f.64, interests in personal photography and collecting lessen.

1962 Dies in Berkeley. With help of the photographer Don Ross, Florence Swift, Henry's widow, organizes photograph collection, seeks donations of additional prints by original Group f.64 photographers, and donates collection to the San Francisco Museum of Modern Art.

1963 Henry Swift Collection exhibited at the San Francisco Museum of Modern Art.

Willard Van Dyke

1906 Born December 5, in Denver, Colorado. Later moves with family to Fort Collins, New Orleans, and Los Angeles.

1918 Given first camera. Family moves to Oakland, California.

1925 Buys 4 x 5 camera; uses John Paul Edwards's darkroom and reads his photographic literature. Attends University of California, Berkeley.

1927 Begins serious work in photography.

1928 Introduced to Edward Weston by Edwards; makes lantern slides for Anne Brigman.

1929 Photographs with Weston in Carmel for two weeks in November.

1930 Takes over Brigman's studio at 683 Brockhurst, in Oakland, with Mary Jeannette Edwards.

1932 Hosts founding meeting of photographers that becomes Group f.64 at 683 Brockhurst. Solo exhibition at M. H. de Young Memorial Museum in May. Participates in Group f.64 exhibition there in November.

1933 Travels with Weston, Sonya Noskowiak, and Mary Jeannette Edwards in New Mexico. Establishes gallery at 683 Brockhust and presents Edward Weston thirty-year retrospective there.

1934 Photographs for Public Works Art project. Travels with Dorothea Lange, Imogen Cunningham, Preston Holder, and others to photograph Unemployed Exchange Association Cooperative lumber camp in Oroville, California. Returns later with Holder to make his first movie there.

1935 Moves to New York City; photographs for *Harper's Bazaar*, *Life*, *Scribner's*, and *Architectural Forum*.

1937 Hired by Pare Lorentz as cameraman for the film *The River*. Travels with Edward Weston and Charis Wilson in California.

1938 Marries Mary Gray Barnett (divorced, 1950). Gives up still photography and becomes full-time filmmaker. Directs, produces, and photographs many award-winning films in succeeding years.

1943 Becomes chief of production and liaison with Hollywood writers from Office of War Information Overseas Motion Picture Bureau.

1950 Marries Barbara Millikin.

1965 Becomes director of the Department of Film, Museum of Modern Art, New York.

1974 Retires from MOMA film department and begins full-time teaching at State University of New York, Purchase.

1975 Organizes Edward Weston exhibition for the Museum of Modern Art, New York.

1977 Returns to still photography and begins to work in color for the first time.

1981 Subject of film *Conversations with Willard Van Dyke*, produced by Amalie Rothschild.

1986 Dies January 23 in Jackson, Tennessee, en route from Santa Fe to Cambridge, Massachusetts.

BRETT WESTON

1911 Born Theodore Brett Weston, December 16, in Los Angeles.

1925 Goes to Mexico with his father, Edward, and Tina Modotti. Makes his first photographs there.

1929 Moves to San Francisco; then moves to Carmel with Edward and sets up studio with him.

1930 Moves to Glendale, then Santa Barbara, to establish a portrait studio on his own.

1932 First major solo exhibition presented at M. H. de Young Memorial Museum, San Francisco. Later in year, is invited to be a part of the Group f.64 exhibition at the de Young.

1934 Works for one year with Edward in Santa Monica.

1936 Moves to San Francisco.

1941 Drafted into the U.S. Army and stationed in New York.

1947 Receives fellowship from John Simon Guggenheim Memorial Foundation.

1948 Returns to Carmel to aid with care of his father. Prints the Edward Weston *Fiftieth-Anniversary Portfolio* with help of Dody Warren (his third wife), Morley and Frances Baer, and brother Cole Weston.

1960 Begins extensive series of trips to photograph in Europe, Baja California, Japan, and Hawaii; exhibits this work widely.

1973 Receives fellowship from the National Endowment for the Arts to photograph in Alaska.

1980s Purchases home in Hawaii and begins to divide his time between Hawaii and Carmel.

1991 Eighty years old and feeling no one else can match his printing abilities, destroys his career-long collection of negatives.

1992 Continues to produce new work.

EDWARD WESTON

1886 Born Edward Henry Weston, March 24, in Highland Park, Illinois.

1902 Makes first photographs in Chicago, with a camera given him by his father.

1906 Visits California and decides to stay; becomes a professional portrait photographer.

1909 Marries Flora May Chandler.

1911 Opens a studio in Tropico (now Glendale), California.

1922 Solo exhibition at Academia de Bellas Artes in Mexico City received enthusiastically. Decides to move there.

1923 Goes to Mexico with Tina Modotti and son Chandler. Opens portrait studio and becomes associated with artists of the Mexican Renaissance.

1925 Returns to California and shares studio with Johan Hagemeyer in San Francisco. Returns to Mexico and travels extensively there with Modotti and second son, Brett. Returns to Glendale in November.

1927 Begins series of extreme close-ups of shells and vegetables.

1928 Moves to San Francisco and opens studio with Brett.

1929 Moves to Carmel; makes first Point Lobos photographs. With Edward Steichen, organizes the American section of the Deutsche Werkbund Exhibition, *Film und Foto*, in Stuttgart.

1930 Solo exhibition organized by José Clemente Orozco and Alma Reed at Delphic Studios in New York.

1932 Becomes founding member of Group f.64. Participates in Group f.64 exhibition at the M. H. de Young Memorial Museum. Publishes *The Art of Edward Weston*, designed by Merle Armitage.

1933 Photographs larger-scale landscapes and architecture in New Mexico and California.

1934 Applies personal standards of his creative work to his professional photography, refusing to make retouched portraits. Moves to Santa Monica, California, and opens studio with Brett.

1937 Becomes first photographer to receive fellowship from John Simon Guggenheim Memorial Foundation. Travels throughout California and the western United States.

1939 Marries Charis Wilson; returns to Carmel to a house built for him at Wildcat Hill.

1946 Major retrospective exhibition at Museum of Modern Art in New York City, with catalogue published by museum.

1947 Is subject of Willard Van Dyke film *The Photographer*.

1948 Makes final photographs at Point Lobos; progression of his Parkinson's disease makes continuing work impossible.

1958 Dies January 1, at Wildcat Hill.

155

SELECTED BIBLIOGRAPHY

Aiken, Roger. "Henrietta Shore and Edward Weston." *American Art* 6 (Winter 1992): 43–61.

Alinder, James. "The Preston Holder Story." *Exposure* 13, no. 1 (February 1975): 2–6.

Alinder, Mary Street and Andrea Gray Stillman, eds. *Ansel Adams: Letters and Images, 1916–1984*. Boston: Little, Brown and Company, 1987.

Adams, Ansel with Mary Street Alinder. *Ansel Adams: An Autobiography*. Boston: Little, Brown and Company, 1985.

Armitage, Merle, ed. *The Art of Edward Weston*. New York: Weythe, 1932.

Ehrens, Susan. *Alma Lavenson: Photographs*. Berkeley, California: Wildwood Arts, 1991.

Frye, L. Thomas and Therese Thau Heyman. *Peacetime, Wartime and Hollywood: Photography of Peter Stackpole*. Oakland, California: The Oakland Museum, 1992. Exhibition catalog.

Gray, Andrea. *Ansel Adams: An American Place, 1936*. Tucson: Center for Creative Photography, University of Arizona, 1982.

Heyman, Therese Thau. *Celebrating a Collection: The Work of Dorothea Lange*. Oakland, California: The Oakland Museum, 1978.

Imogen Cunningham Trust. *Imogen Cunningham: Frontiers, Photographs, 1906–1976*. Berkeley, California: The Imogen Cunningham Trust, 1978. Exhibition catalog.

Irmas, Deborah. *The Photographic Magic of William Mortensen*. Los Angeles: Los Angeles Center for Photographic Studies, 1979. Exhibition catalog.

Johnson, William. *Sonya Noskowiak*. Tucson: Center for Creative Photography, University of Arizona, 1979. Exhibition catalog.

Kanaga, Consuelo. *Consuelo Kanaga Photographs: A Retrospective*. Yorktown, New York: Yorktown Printing Corporation, Blue Moon Gallery and Lerner-Heller Gallery, 1974. Exhibition catalog.

Mann, Margery. *Imogen Cunningham: Photographs*. Seattle: The University of Washington Press, 1970.

Millstein, Barbara. *Consuelo Kanaga: An American Photographer*. Seattle: The University of Washington Press, 1992. Forthcoming.

Newhall, Nancy, ed. *The Daybooks of Edward Weston*. New York: Aperture Foundation, 1981.

Oren, Michel. "On the Impurities of Group f64 Photography." *History of Photography* 15 (Summer 1991): 119–27.

Santa Barbara Museum of Art. *Watkins to Weston: 101 Years of California Photography, 1849–1950*. Santa Barbara, California: Santa Barbara Museum of Art, in cooperation with Roberts Rinehart Publishers, 1992. Exhibition catalog.

Tucker, Jean S. *Group f. 64*. St. Louis: The University of Missouri–St. Louis, 1978. Exhibition catalog.

Weston, Brett. *Photographs from Five Decades*. Millerton, New York: Aperture Foundation, 1980.

Index